PLAIN AND ORNAMENTAL FORGING

FORGING

BY

ERNST SCHWARZKOPF

SECOND EDITION
REPRINTED

ASTRAGAL PRESS
MENDHAM, NEW JERSEY
2000

FOREWORD

At the time this book was authored and first published, blacksmithing was an honorable and common profession. The blacksmith was the person one turned to for tools to be made or repaired, horses shod, gates made and hung, and other ironwork done. Sadly, well before the middle of the 20^{th} century, blacksmithing had fallen into a slump and was almost forgotten as a craft. Since the 1970s, however, it has made a remarkable comeback, and increasing interest is now being shown in the craft.

This volume by Ernst Schwarzkopf is one of the finer books teaching the skills needed to become a blacksmith. Beginning with a description of the materials used by the smith, continuing through a description of the tools and their usage, and finishing with a series of forging exercises, Schwarzkopf has crafted a course that will give one the knowledge needed to become a blacksmith. Applying that knowledge through the forging exercises will gain one the skills needed to become a working blacksmith.

As described by the author, smithing is both a humble craft and a challenging profession. It is humble in that it deals, primarily, with a very common material, iron. It is also humble in the kinds of things one learns to make – simple tools, common hardware, and farm-related items. But there are several challenges in smithing. One is to design and make items to be both functional and aesthetic. Another is to cause the metal to flow smoothly under your ministrations whether those be hammering, twisting, welding, or any other. Finally, one's work must produce the satisfaction of a job well done.

All in all, this book does what it sets out to do. It will equip the diligent student with the tools and skills needed to be a blacksmith. Read carefully and enjoy!

<div align="right">Mark E. Williams</div>

NOTE

In 1976 I graduated from the original Stuyvesant High School in New York City. As one of the few students in the school who actually liked shop, I was chatting with my teacher in the hallway as he got some textbooks out of one of the many old locked closets that lined the hall. Randomly I picked up a book; it was a moldy copy of *Plain and Ornamental Forging*, and I saw that there were piles of identical books in the closet. As my grandfather was an ironworker and I always wanted to try my hand, I asked the teacher if I could have a copy. He said "Sure," because he had hundreds of copies and foundry hadn't been taught in 20 years. The forge room had become a girls' gym. We picked through several copies before we found one that wasn't moldy.

Twenty four years later I lent my copy to The Astragal Press to make this reprint. While I never have had the opportunity to do ironwork, I still read the book in awe-struck admiration of the craft and how it is taught by Schwarzkopf.. I am very honored that my copy will help another generation of ironworkers perfect their art. My grandfather would have been proud.

Joel Moskowitz
New York City
August 2000

PREFACE TO THE SECOND EDITION

Great changes in metal working have been made in the past few years. New compositions of metal, with the hitherto unknown use of alloying materials in irons and steels, have produced new properties of structural and machine steels. Continued scientific investigation has discovered new ways of extending the applications of former methods of working metals.

In recent years this progress in the metal industry has been very rapid. Where formerly only the larger and more completely equipped shops were prepared to undertake the newer processes of metal working, almost all shops are now using the modern methods of welding. To adapt the earlier text to the present-day needs of progressive metal workers, therefore, new material on oxy-acetylene welding has been added in the appendix. This new instruction is adapted to the requirements of both the beginner and the more advanced worker.

Flower and leaf work for interior decoration are now made entirely of sheet metal. Prior to the use of the oxy-acetylene method of welding they were generally made from solid stock by a process requiring much more hand labor. Many modern pieces of metal work could not be attempted without the aid of the acetylene torch. This modern tool is indispensable for the metal worker, and it has opened new fields in the metal industry. While the instructions for the proper use of this modern labor saving device, as given in

this second edition, are necessarily brief, it is believed that they will be found adequate and that, because of the use of frequent illustrations, they will be readily understood even by the inexperienced worker.

E. S.

New York,
April, 1930.

PREFACE TO THE FIRST EDITION

AMONG the many treatises on technical subjects, few of a really practical and helpful character are to be found on the general subject of art metal and blacksmith work. The author of this book has endeavored to meet this need and to furnish a richly illustrated and fully explained work on the science and art of plain and art metal forging. Much time and effort have been expended in arranging material, in preparing the text and illustrations and in selecting from among many samples of work those suited to every grade of ability. In particular, the attempt has been made to furnish simple and detailed drawings illustrating each important operation, as it is felt that the successive steps may often be shown more clearly in this way than by any amount of discussion.

The book is designed primarily to assist the beginner in learning both the theory and practice of forge work through self-instruction. On this account, the first chapters are purposely elementary and simple. A large number of examples of work are furnished which are suitable for technical high schools and vocational schools, from which the instructor may select to meet his needs. The author does not expect the examples of work to be slavishly copied, nor to be performed in their exact order. They may be selected according to adaptability and necessity, and will serve as suggestions making clear the details of similar pieces of work.

To awaken and maintain the enthusiasm and even the

interest of the student one must select work and tools which are of regular or standard shop type, so that he is spurred on by the knowledge that he is performing useful work. His enthusiasm dies out and his interest is gone when he learns that the results of his labor are consigned to the scrap heap.

In the chapters on Advanced Forging and Art Forging, the ambitious worker will find directions for more difficult types of work which he may undertake as his skill increases, for art-craftsmanship knows no bounds. The author has attempted to weave together the artistic with the plainer work, as well as to present in clear form that information needed for all the various general work that may occur in the machine shop, in the tool-making plant, in the repair shop and in decorative, ornamental or art work.

A good blacksmith will frequently be called on to do many kinds of work besides his regular iron work. He is expected to bend pipes of iron, brass, copper or bronze. He may be called on to do hammered metal work. This work requires an absolutely controlled hand, and control comes only from experience. Suggestions are, therefore, included for these operations, and tables of weights, sample calculations, and shop problems are given for the use of the estimator with little or no experience. A brief discussion of recent accomplishments of science in technical metal working, such as welding with oxyacetylene, thermit, electric welding, etc., is also included.

The language will be found simple, and, it is hoped, easily understandable throughout the text. Obscure technical terms and mathematical formulas and processes are avoided.

The author has had over twenty-two years of practical experience as blacksmith, artsmith and general metal worker in Europe and America. He served as foreman and estimator for eleven years in general and ornamental iron, and in iron and bronze shops. For a number of years

he has been instructor in forge work and in art and ornamental iron and metal work in the Stuyvesant High School and the Stuyvesant Evening Trade School, New York City.

ERNST SCHWARZKOPF.

NEW YORK,
April, 1916.

CONTENTS

CHAPTER I

CHAPTER II

CHAPTER III

CHAPTER IV

APPENDIX

PLAIN AND ORNAMENTAL FORGING

CHAPTER I

GENERAL PROPERTIES OF IRON

1. Early Use of Iron. Iron is the most abundant and most extensively distributed metal found in the earth. It is for man the most important of all the metals, for there is hardly a branch of human endeavor whose present development could have been reached without iron. One may trace the use of iron tools in China to the year 2300 B. C. The ancient Greeks knew the use of iron and many methods of treatment. Glaucus of Chios (600 B. C.) is generally recognized as the inventor of the process of welding iron and of brazing metals. Doubtless the ancient Egyptians knew of and used iron and steel tools in the building of the pyramids. There is in the British Museum an iron sickle found under a Sphinx at Karnak, which must be over 5000 years old. Iron, therefore, was known in the most remote historical times.

Another very interesting piece of iron work is the famous column of Delhi (India). This column is made of wrought iron 50 feet in height and 16 inches in diameter. It still stands in the place it has occupied since about the year 1000 B. C.

In western Europe, the iron industry developed much later. About 1800 years ago the Emperor Hadrian founded a large manufacturing plant for weapons in Sussex County,

England. Piles of ashes and slag are still found there, affording ample proof that those works flourished during the time of the Roman Empire.

Iron was first produced in America in 1622.

2. Sources of Iron. Iron is obtained from various iron ores, usually oxides of iron. It is rarely found in nature in the metallic state, except in the form of meteoric iron, of which only insignificant quantities fall to the earth from interstellar space. A single deposit of native or metallic iron, large in quantity, has been found in Greenland, near Ofivak. This is not meteoric iron and the quality does not warrant its use for commercial purposes.

Meteorites or aerolites consist of iron more or less alloyed with nickel. This meteoric iron is malleable, but is generally extremely difficult to manipulate. In the New York Museum of Natural History there is exhibited a large mass of meteoric iron which, together with a couple of smaller ones, was brought by Commander Peary from Greenland. The large meteor weighs 36.5 tons and analysis shows the following content:

Iron	91.48	per cent.
Nickel	7.79	"
Cobalt	.53	"
Undetermined	.20	"

100.00 per cent.

3. Other Elements Present with Iron. Iron is seldom obtained chemically pure, nor is it generally used chemically pure. The iron used in construction always contains carbon. The percentage of carbon determines its most important properties. The presence of other elements, often useful in producing particular characteristics, influences largely the usefulness of the material.

Iron is classified according to its content of the various

elements or compounds. The principal classification is under three heads:

1. Pig Iron or Cast Iron.
2. Wrought Iron.
3. Steel.

The presence of various quantities of carbon determines the hardness, fusibility and toughness. Cast iron contains the largest percentage of carbon, 2 to 6 per cent; wrought iron the least percentage, .04 per cent. Machine steel, open-hearth and Bessemer steels 0.2 to 0.6 per cent, belong to a classification point between wrought iron and tool or crucible steel. They are put on the market under the general name of *steel* and practically have replaced wrought iron in all construction work, because of their higher tensile strength and elasticity. Tool or crucible steel contains 0.6 to 2.0 per cent of carbon.

4. Wrought Iron. Wrought iron has a fibrous structure and is light gray in color, approaching silvery whiteness. Silicon and phosphorus impart a lighter tint, while sulphur, manganese and carbon make the iron somewhat darker. While cold, wrought iron can be bent, hammered out, twisted or stretched. By cold manipulation it becomes denser, harder, more elastic and brittle. It may be brought to its original condition by *annealing*, that is, by heating it to a " red heat " and allowing it to cool slowly. Excessive cold hammering makes wrought iron easily breakable, splits it and renders it useless. In the proper red hot condition it may easily be forged, and while hot it is so soft that it may be worked, bent, stretched and forged into various forms or shapes with ease. At the white heat, two or more pieces of wrought iron may, by hammering or pressure, be united physically, that is, " welded " together.

Wrought iron is to be obtained in practically no other stock forms than bars, rods or sheets of various cross-

sections, and as tubes or pipes. The qualities to be had are *common* or refined wrought iron and *Norway iron.* Norway iron is of a distinctly better grade and is naturally much higher in price. It is advisable to use Norway iron in schools if best results are to be obtained.

The wrought iron of trade is of very varying quality due to the presence of various impurities or to the different methods of production. *Hot short iron* usually contains sulphur. Its undesirable characteristics may be due to insufficient treatment of the iron mass in the manufacture from pig iron or in the careless working of the mass in the rolling mills. Copper, if present, also lessens in an appreciable degree the cohesiveness of the iron. Hot short iron is long fibred, of dark color and dull appearance. It welds with great difficulty and breaks and splits and tears apart in forging at a red heat. The cause may be the presence of an extremely small portion (.01 per cent) of sulphur, or a trace of copper.

FIG. 1.—Fibrous Fracture of Wrought Iron.

Cold short iron contains phosphorus. In its cold condition it is less cohesive and more brittle than hot short iron. It has a more silvery white color and is more easily welded. If the phosphorus content is over 0.5 per cent, the structure is scaly rather than fibrous.

Short iron contains silicon. As small an addition of silicon as 0.3 per cent makes wrought iron harder and more brittle and decreases its tenacity.

Wrought iron is an alloy, but is the purest form of iron. When broken it shows high tensile strength at the fracture. (See Fig. 1.)

5. Production—Puddling. The universal process for the production of wrought iron is known as " puddling."

This takes place in a puddling furnace, a reverberatory furnace using a coal fire, in which, because of its sulphur and other impurities, the coal must not come in direct contact with the iron.

The method of production consists in melting pig or cast iron on the hearth of the furnace. The burning gases roll back and forth over the metal and some oxygen from the excess air, some added iron oxide, and the cinder formed on the iron surface hasten the process of transformation. The silicon, manganese, sulphur and phosphorus unite with oxygen and form a *slag*, while the oxides of carbon escape.

The puddling process is one of purification and decarbonization and takes place in four distinct stages.

1. The melting down.
2. The mixing.
3. The boiling.
4. The balling.

The first stage requires a high temperature to melt the cast iron or pig iron and takes approximately 30 to 35 minutes.

The mixing stage lasts 6 to 8 minutes and takes place at a temperature somewhat lower, for the damper in the stack is partly closed. An oxidizing mixture, iron oxide and cinders, is added and the mass is stirred and mixed, or " rabbled " with a long iron poker or rabble. In this way the phosphorus, sulphur, carbon and other foreign materials are removed. The rabbling is continued until the iron stiffens to a pasty condition and begins to separate and appear through the slag as small lumps of various sizes.

The boiling or *third stage* requires again a high temperature, therefore the damper is opened. By the admission of highly heated air, a powerful reaction takes place between the oxygen and the carbon, causing the release of carbon

dioxide. The gases escape through the layer of molten slag,
giving the appearance of boiling, whence the name of this
stage. A large portion of the remaining manganese, sul-
phur and phosphorus are removed in this operation, which
requires perhaps 20 minutes.

The balling stage or fourth step lasts from 15 to 20
minutes. In this operation the metal becomes more and
more compact or stiff and, after kneading and squeezing,
is divided into from four to six more or less rounded por-
tions. These balls weigh from 40 to 80 pounds. They are
taken from the furnace by special tongs, hammered by means
of a power hammer, or compressed for the purpose of
squeezing out the scale and slag that is distributed through-
out the mass. The iron becomes denser, and, if possible
with the same heat, it is rolled out to its final bar or sheet
form.

6. The Puddling Furnace. The furnace, which is of
a reverberatory type (see Figs. 2 and 3), is constructed of
fire-resisting materials. The outer portions are of iron or
steel supporting plates. Coal is fed to the fire chamber
grate *A* by the feed door *B*. The flames pass over the fire
and flue bridge *C–D*, which is cooled by a current of water or
air. The flames are driven back upon the iron on the hearth
of the iron chamber by the peculiar form of the roof, which
slopes toward *D*. The hot gases are carried off by means
of the stack and are sometimes used to heat steam boilers,
or more frequently to preheat the charges of pig iron.
The fire bridge *C* is usually cooled with water, which is led
in through the pipe *F*. The flue bridge *D* is usually cooled
by air in order not to cool down the hearth more than
necessary. Air enters by way of the channel *G*, connected
to a draft chimney or to a fan. The hearth *H* is lined with
slag or scale and a fusible silicate known as " blue billy "
is also frequently used. The linings are known as *fettlings*.
The door through which charging and working is per-
formed, that is, the *stock-hole*, is marked *I*.

Several mechanical stirring or rabbling devices have been invented as substitutes for the manual method, which is very fatiguing. Various systems have from time to time

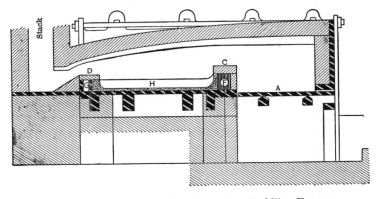

Fig. 2.—Longitudinal Section Through a Puddling Furnace.

been used and discontinued, for none of them has been productive of continuously successful results.

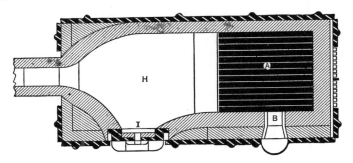

Fig. 3.—Plan of Puddling Furnace.

Puddling furnaces are of various sizes, ordinarily of from 500 to 1500 pounds capacity. The entire puddling process occupies from $1\frac{1}{4}$ to 2 hours time, depending upon

the quality of pig iron used and the quality of product
desired.

7. Calculating Weights of Iron. The practically schooled
estimator does not always carry about with him his tables
of weights of stock, when consulting his architect or con-
tractor. He becomes familiar with a number of frequently
used weights of plate and bars of standard dimensions *per
running foot.* They serve as his basis of rapid calculation
of weights of pieces of iron, bronze, copper, etc.

Cast iron is lighter, and bronze and copper are heavier than
wrought iron.

A plate of wrought iron $12'' \times 12'' \times \frac{1}{4}''$ weighs 10 pounds. This
may be carried as a convenient mental constant.

In estimating it is customary to add according to the size of
the job, an allowance for " waste." This covers the losses caused
by approximate calculation or by dropping fractions and simplifies
the calculation. Thus in many cases it becomes unnecessary to
use pencil or paper.

EXAMPLE. A plate of wrought iron $12'' \times 12'' \times \frac{1}{4}''$ weighs
10 pounds. If cut into two plates, they are $6'' \times 12'' \times \frac{1}{4}''$; if laid
end to end it becomes $6'' \times 24'' \times \frac{1}{4}''$ and is of the same weight.
Cut again endwise and laid end to end, we have $3'' \times 48'' \times \frac{1}{4}''$,
and again repeated, the same iron becomes a standard strip $1\frac{1}{2}''$
$\times \frac{1}{4}'' \times 96''$. By reducing or adding the width and thickness in
this way, one may quickly determine the weights of many standard
sizes of stock per running foot, as in the following table:

Weight of a bar........$1\frac{1}{2}'' \times \frac{1}{4}'' \times 96''$	10 pounds	
$1\frac{1}{2}'' \times \frac{1}{2}'' \times 96''$	20	"
$1\frac{1}{2}'' \times \frac{3}{8}'' \times 96''$	15	"
$1\frac{1}{2}'' \times \frac{1}{8}'' \times 96''$	5	"
Wrought-iron plate.....$12'' \times 12'' \times \frac{1}{4}''$	10	"
$12'' \times 12'' \times \frac{3}{8}''$	15	"
$12'' \times 12'' \times \frac{1}{2}''$	20	"
$12'' \times 12'' \times \frac{5}{8}''$	25	"
$12'' \times 12'' \times \frac{3}{4}''$	30	"
$12'' \times 12'' \times \frac{7}{8}''$	35	"
$12'' \times 12'' \times 1''$	40	"

$$6'' \times 12'' \times 2'' \qquad 40 \text{ pounds}$$
$$3'' \times 12'' \times 4'' \qquad 40 \quad ''$$
$$12'' \times 24'' \times \tfrac{1}{8}'' \qquad 10 \quad ''$$
$$12'' \times 48'' \times \tfrac{1}{16}'' \qquad 10 \quad ''$$
$$12'' \times 24'' \times \tfrac{1}{16}'' \qquad 5 \quad ''$$

In order to calculate the weights of cast or wrought-iron columns, this method is the simplest, if no tables are at hand. Cast iron is lighter than wrought iron. The difference is approximately as follows:

Wrought iron plate $12'' \times 12'' \times 1''$ weighs 40 pounds
Cast iron plate $\quad 12'' \times 12'' \times 1''$ weighs $37\tfrac{1}{2}$ ''

Consider a 10-inch hollow cast-iron column with walls 1 inch thick. The diameter of the hollow is 8 inches. The working diameter to the middle of the material is 9 inches. To calculate exactly the weight per running foot, multiply the working diameter by 3.1416 or $\tfrac{22}{7}$. Since $9'' \times \tfrac{22}{7}$ equals 28.28 inches, or 28 inches approximately, the column is equivalent to a plate $28'' \times 12'' \times 1''$. Twenty-eight inches equals $2\tfrac{1}{3}$ feet, and since a cast-iron plate $12'' \times 12'' \times 1''$ weighs $37\tfrac{1}{2}$ pounds, one $2\tfrac{1}{3}$ feet wide weighs $37\tfrac{1}{2}$ pounds$\times 2\tfrac{1}{3}$, or 88 pounds. The column therefore weighs 88 pounds per running foot. To obtain the weight of the column, multiply 88 by the height of column and make proper additional allowance for top and bottom flanges. For a 10-inch ordinary column, 60 pounds added will be sufficient. If girder brackets or other connections are required, allowance must be made accordingly. The allowances vary with the size of the column.

The practical estimator simplifies his calculations by multiplying the *external diameter* by 3, and to this approximation adding only half as much for the top and bottom flanges. In this case, that is, he adds 30 pounds instead of 60 pounds.

For bar iron, the following method also may be used:

A $1'' \times 1''$ square bar weighs 3.33 pounds per lineal foot.

For flatter sizes, the lineal foot weights may be determined by dividing for smaller thickness and multiplying for greater widths.

Examples.

Square bar	$1''\times1''\times12''$ long weighs	3.33	pounds		
Flat	$2''\times\frac{1}{2}''\times12''$	"	"	3.33	"
	$4''\times\frac{1}{4}''\times12''$	"	"	3.33	"
	$8''\times\frac{1}{8}''\times12''$	"	"	3.33	"
	$2''\times1''\times12''$	"	"	6.66	"
	$3''\times1''\times12''$	"	"	9.99	"
	$4''\times1''\times12''$	"	"	13.33	"

If a $1''\times1''\times12''$ bar weighs 3.33 pounds, a bar $\frac{1}{2}''\times\frac{1}{2}''\times12''$ weighs 3.33 pounds divided by 4, or .83 pound per running foot.

PROBLEMS

Find the weights for the following plates and bars, using the tabulated formulæ on page 8 and page 9.

1. What is the weight of a wrought-iron plate $12''\times30''\times\frac{3}{8}''$?
2. What is the weight of a wrought-iron plate $24''\times63''\times\frac{7}{8}''$?
3. What is the weight of a wrought-iron plate $36''\times50''\times\frac{1}{8}''$?
4. What is the weight of a wrought-iron bar $2''\times\frac{1}{4}''\times6'$?
5. What is the weight of a wrought-iron bar $4\frac{1}{2}''\times\frac{1}{2}''\times8'\text{-}4''$?
6. What is the weight of a *cast-iron* plate $18''\times30''\times1''$?

CHAPTER II

THE FORGE

8. The Forge. In the smaller concerns and in the country, the forge is usually built of brick. The blast is obtained from a bellows driven by hand or foot power or from a centrifugal blower. In the large concerns or in schools where many forges are in use, the "downdraft" system is almost universal. Here a pressure blower furnishes the blast to each forge and an exhaust ventilator fan removes the smoke and gases. The essential feature of the downdraft system is that there are no overhead tubes, shafts, air-

Fig. 4.—Portable Forge.

ducts or chimneys. These would darken the shop and make it uncomfortable, especially in warm weather. Present day forges are nearly all built of cast and wrought iron.

11

The forge serves to heat the iron and steel for the hands of the smith, but legitimately extends its usefulness to other

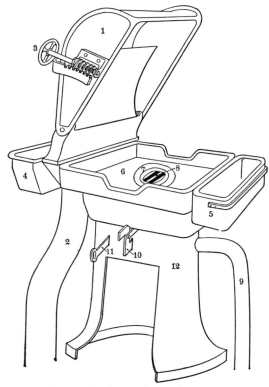

FIG. 5.—Stationary Down-draft Forge.

(1) Hood; (2) exhaust pipe for smoke; (3) wheel to operate hood; (4) coal tank; (5) water tank for cooling, tempering, etc.; (6) pan; (7) fire pot (the blast enters the middle of this fire pot); (8) tuyere or wind box; (9) blast pipe from blower; (10) blast lever to control air supply; (11) lever to control position of the grate; (12) base, ash dump in center.

purposes, such as brazing, melting babbitt metal or lead, heating soldering irons, etc.

Besides the ordinary forges in a large shop, there is

often a somewhat larger forge, which may be used in turn by any workman who has an unusually large piece of stock to be heated. For odd jobs the so-called **field forge** or portable forge serves. It is perhaps most seen in use in construction work as a rivet-heating forge. The blast is obtained by either a bellows or blower, worked by either hand or foot power. (See Fig. 4.)

Fig. 5 shows a **stationary down-draft forge,** which is

Blast Pipe

Fig. 6.—Lindwurm Regenerative Forge.

very much used in the shops of schools for general purposes.

Fig. 6 illustrates the cross-section of a new type of patent forge, called the **Lindwurm Regenerative Forge.** This kind of forge is more advantageous than any other, due to its double bottom, which permits the blast to be heated before it passes the tuyeres. For this reason a piece of round iron two inches in diameter can be brought to a welding heat in three minutes.

This forge uses less coal, hence is more economical. Another advantage of the double bottom is that it prevents explosions and makes the cleaning of clinkers more easy.

9. Forge Tools. In Fig. 7 are shown the fire tools used in connection with the forge. The poker, A, is used to clean the coals and pull out slag or clinkers. The rake, B, serves to remove clinkers and build up the fire. C is the coal shovel and D the dipper or sprinkler, to sprinkle the

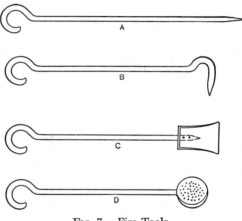

Fig. 7.—Fire Tools.

edges of the fire to prevent burning through and to cool the clinkers.

10. The Blower. The blower found on the more recent forges consists of a cast-iron housing containing a fan-wheel which drives air from its circumference by centrifugal force. The axle and wheel with vanes are of wrought iron or Bessemer steel.

In the earlier forges, the bellows was more frequently employed. The blower allows a wider range of wind pressure and takes up very little room. The drive employs

a fly-wheel and often is by means of foot power or a small motor. Fig. 8 shows a modern type of blower directly connected to an electric motor. The axle runs at high speed, almost noiselessly, in ball bearings.

11. Fuels. (*a*) *Coal.* Coal is more or less impure carbon. Its purpose is to furnish heat energy, which is set free when the coal unites with oxygen. Only bituminous or " soft coal " is used in forge-shops, therefore soft coal is often also called **blacksmith's coal.** The best qualities only should be used, especially that which is as nearly free from sulphur

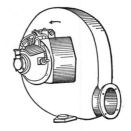

Fig. 8.—Modern Type of Blower.

and phosphorus as possible, since these two elements are absorbed by iron and influence its value in a harmful way. A bituminous coal contains from 15 to 30 per cent of volatile matter.

TABLE I

Analysis of a Specimen of Blacksmith's Coal.

Moisture.................	1.09 per cent.
Volatile matter............	17.00 "
Fixed carbon.............	73.75 "
Ash.....................	7.42 "
Sulphur..................	0.74 "

(*b*) *Coke.* When bituminous coal is heated or " coked," the volatile matter is driven out, leaving a spongy, porous mass of dark gray color and firm texture. Coke is highly important for the smith and as needed must be renewed by the addition of more green coal.

(*c*) *Charcoal.* In the manufacture of steel charcoal plays no small part. It is the best fuel for tool steel because

it is especially free from impurities. Hardwoods furnish the best charcoal.

(d) *Hard Coal.* Anthracite or hard coal is not a practicable fuel for forge purposes. Geologically, hard coal is the oldest and has undergone most change in the earth. It is much purer than soft coal, but because of its greater density, it does not burn so freely and burns to ash without forming coke, which is necessary in the forge.

(e) *Gas.* Fuel or illuminating gas is often used to heat iron and steel for the smith, for case-hardening, for heating soldering irons, etc.

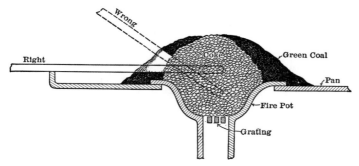

Fig. 9.—Proper Arrangement of Fuel and Bar to be Heated.

12. The Building and Care of the Fire. Soft coal is to be used to heat the iron for the smith. It should be free from sulphur and other undesirable constituents, which separate and form clinkers at the tuyeres or windbox. In building the forge fire, the clinkers and other foreign substances, such as stone, slate, etc., must first be removed from the forge. This is done by pushing the coal and coke to the sides and exposing the tuyeres. A big handful of shavings, straw or paper is then lit at the bottom. The burning kindling is covered with pieces of coke, and then the sides with green coal, as soon as the other has kindled. At the beginning, one may use only a little blast. More

coke is added when the fire is well under way, and the sides ringed or banked up with previously dampened green coal, except toward the front, where coke is used. This is to prevent drawing heated iron through green coal, which would partially cool it and make it more difficult to forge and weld.

It is a mistake to keep continually poking the fire or disturbing its banks. A rake is used to keep the fire in order, a coal shovel to clean it and to put on new coal. From time to time the sides of the coal ring are sprinkled, using a dipper for the purpose.

In heating a bar of iron, the bar should be laid horizontally in the fire, as in Fig. 9, and must have enough burning coals under it and sufficient coke to cover it to prevent great oxidation.

TABLE II

DIFFERENT WORKING HEATS

Dark blood red (black heat).
Dark red, low red (finishing heat).
Full red.
Bright or light red (scaling heat).
Yellow heat.
Light yellow heat (good forging heat).
White heat or welding heat (beyond this heat
 the iron will burn).

Finish all forgings at a dark red heat (known as finishing heat) in order to attain a smooth surface. Iron heated to a bright cherry red heat blisters and scales off, leaving a rough surface.

CHAPTER III

THE BLACKSMITH'S TOOLS

THE tools of the smith as well as their uses must be explained clearly and repeatedly to the beginner. Not only the name, but the use and the proper method of holding each tool and manipulating the work, must be learned. The production of a good job requires good tools. A glance

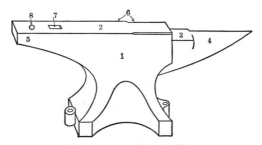

FIG. 10.—English Anvil.

(1) Body; (2) face; (3) base of horn; (4) horn; (5) heel; (6) round and sharp edges; (7) tool hole; (8) Pritchel hole.

at the tools of a journeyman or helper is sufficient to enable the experienced and skilled workman to judge the kind of a man his helper is.

13. The Anvil. Anvils are often made of wrought iron with an upper surface or face of steel welded on and tempered to a straw-yellow. The anvil is the heaviest and most important tool and serves as the support of the forged and welded work. It should be manufactured with greatest care, and must therefore be purchased, set up, and used with intelligence.

18

The anvil most in use (Fig. 10) has a conical horn on one end and is known as the **English anvil.** The **French anvil** (Fig. 11) has a conical horn on one end and a wedge-shaped or pyramidal horn on the other. Nowadays, anvils are usually made wholly of cast steel or of cast iron, with a steel face which is welded or incorporated upon it by a special process. The smaller and cheaper sorts are made almost entirely of cast iron.

The base for the anvil is usually a hard wood block, which is set into the earth or rests upon a special foundation.

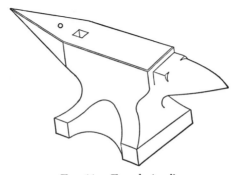

Fig. 11.—French Anvil.

In schools and in large shops a cast-iron base is used for the smaller work. A base for the anvil may be obtained by sawing in two a large cask or oil barrel, filling one of the halves with clay or sand, into which is fitted a heavy timber for the anvil to rest upon.

Anvils are used not only by blacksmiths and iron-workers but in almost every branch of metal industry as well. For the precious metals, anvils are necessarily smaller. Anvils are made of weights from $\frac{1}{2}$ to 1200 pounds. The smith's anvil for general use in ornamental iron shops, where various kinds of work are handled, weighs from 300 to 500 pounds. In schools the usual custom is to use lighter

anvils, weighing from 130 to 200 pounds. These anvils are satisfactory for Evening Continuation or Trade Schools, but for heavier work the school should be equipped with a power hammer.

14. The Hand Hammer. The hammer is the most important tool of the blacksmith. It requires much time and practice to be able to handle a hammer with precision and success. Blacksmiths' hammers are no playthings, and unnecessary blows upon the anvil should be avoided. A clumsy but heavy blow on the edge of the anvil often causes dents in the face or edge, or the edge is made to project. These dents and deformed edges affect the work of the smith and, besides, flying splinters are dangerous.

Hammers are made of cast steel or of tool steel. For-

Fig. 12.—Hammer.

Fig. 13.—Straight-peen Hammer.

merly many hammers, especially the heavier ones, were made of wrought iron, with a steel plate for a face welded on one end and a wedge-shaped piece of steel at the other, forming the *peen.*

Hammers are of many forms and weights. The weights most frequently used in forging lie between $1\frac{1}{2}$ and 4 pounds. The **cross-peen hammer** can be used more advantageously by the skillful hand, and therefore is to be preferred to the ball-peen. In Europe it is used almost universally. Artsmiths prefer it above all others. The face and peen of a hammer should be slightly oval or rounded, as shown in Fig. 12. A flat face leaves marks. Both face and peen are tempered.

The **straight-peen hammer,** Fig. 13, is used to advantage in stretching metal out lengthwise, that is, in " drawing " it out.

The **ball-peen hammer,** Fig. 14, is recognized more as a machinist's than as a smith's hammer. In order to use the ball-peen hammer for the smith's work, it becomes necessary to grind the face (always flat for machinists' use) to a convex or oval surface, as shown in the face in Fig. 12. The straight-edged flat face cannot be used with success by the beginner or the experienced hand.

Fig. 14.—Ball-peen Hammer.

15. The Sledge Hammer. The sledge is a heavy hammer weighing from 5 to 18 pounds, and nearly always is provided with a long handle. The sledge is used by the smith's helper while assisting in heavy work, for the various purposes of drawing out, upsetting, cutting off, bending, straightening, and in connection with fire tools, dies, etc.

16. Tongs. Tongs are for the purpose of holding work, and for inserting or removing short pieces from the fire.

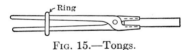

Fig. 15.—Tongs.

They are of very many forms and sizes, and are made of wrought iron, with long handles called *reins*. For the tighter gripping of large pieces of work, **spanning rings,** round or oval, are usually used. These are frequently bent cold of round iron. (See Fig. 15.)

Tongs are purchasable, as are other tools, but it is advisable to forge them from stock to fit one's own hand and grip. If it be desirable to change the form of the tongs. it should not be done by cold bending, but after heating, The fitting should be done by the practiced hand, not by the beginner.

The common types of tongs are:

Common **flat-jawed tongs** for light, flat, round and square stock, Fig. 16(A).

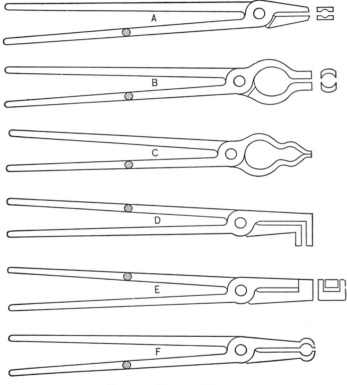

FIG. 16.—Types of Tongs.

Hollow bit tongs for heavier round and square, or rectangular stock, Fig. 16(B).

Anvil or pick-up tongs, which serve principally to pick up hot pieces and for holding short pieces of heavy round or rectangular stock while upsetting, Fig. 16(C).

Bill tongs, advantageously used in scroll-work, and in forging hammers and other punched or pierced tools, Fig. 16(*D*).

Clip tongs, used advantageously in forging steel tools, because the bent back jaws furnish a side protection, Fig. 16(*E*).

Link tongs, used in forging chains (links) and round iron rings, Fig. 16(*F*).

Tongs for short pieces, which must fit accurately, that is, the jaws should lie parallel to the piece they hold, are shown in Fig. 17.

FIG. 17.—Tongs for Short Pieces

17. Top and Bottom Fuller. Fig. 18 shows two tools called the *top* and the *bottom fuller,* which are often employed

at the same time. They have convex, semi-circular edges and are used chiefly to form shoulders, grooves or depressions. These tools are made of various sizes. The top fuller is attached to a wooden handle, while the bottom fuller has a square shank, which fits into the tool hole of the anvil. When so used, it should be placed so that its sides are parallel with those of the anvil.

To form a depression on one side in a piece of iron only the top fuller is used. These tools are used also to lay off work and draw certain sections without disturbing the remainder of the stock.

To " draw " any material lengthwise, the top and bottom fuller are used either singly

FIG. 18.—Top and Bottom Fuller.

or in pairs, the working edge of the fuller being placed at a right angle to the length of the stock. To " spread " any material, the fuller should be placed lengthwise with the metal. Metal can be drawn and spread very effectively in this manner.

18. Top and Bottom Swage. The top and bottom swage, shown in Fig. 19, like the top and bottom fuller, are used

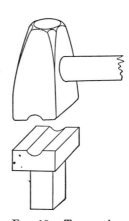

FIG. 19.—Top and Bottom Swage.

in pairs. They have semicircular grooves and are used mainly to finish or smooth round stock after the latter has been drawn approximately to the desired thickness.

The edges of both the top and the bottom swage should be slightly rounded to prevent the metal from becoming lodged in the swages, thus making it difficult to revolve it and to remove the marks made by sharp edges. Swages should not be used to draw material, but all stock should be drawn first, as already described, and then finished by using these tools.

To obtain a smooth surface, the finishing should be done at a dark red heat instead of at a bright red or scaling heat, as a good deal of scale will collect in the bottom swage, leaving a rough finish.

19. The Set Hammer. The set hammer shown in Fig. 20(A) is used to form sharp shoulders or to draw material between narrow spaces or shoulders. A variety of set hammers should be on hand with working faces having sharp and rounded edges.

20. The Flatter. The flatter, Fig. 20(B), is also a finishing tool, but is used only on flat surfaces. The tool should be used while the work is at a dark red heat and not at a scaling heat, in order to obtain smooth surfaces. The

anvil must be free from scale, and if the face of the flatter is dipped into water and then the wet surface of the flatter is rubbed on the face of the anvil, a smoother surface is obtained.

21. Blacksmith Punch. There are a variety of punches, such as *round*, *square*, *flat* and *hammer punches*, which are all used for the same purpose. Fig. 20(*C*) shows a round blacksmith punch which is used more than any other. To use the punch properly on hot metals, drive the punch about two-thirds through the metal from one side, then turn the work over and repeat the same process from the other side. The burr is driven through while the work is

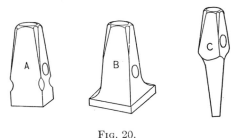

Fig. 20.

held over the pritchel hole or the tool hole of the anvil, or by blocking the work with a bore large enough to receive the burr and the projecting end of the punch.

For punching heavy stock, use a small piece of green coal, which is put into the hole after the punch has been started. This will prevent the punch from sticking and also make punching easier, provided the punch is tapered towards the end.

While punching hot stock, the punch becomes hot also, hence it is necessary to cool it often.

22. The Heading Tool. The heading tool is used in different sizes and for various purposes, such as forming sharp shoulders on tenons, forging bolt heads and nails,

etc. It is particularly used by the artsmith in forging the blanks for flower work. (See Chapter XII.)

Fig. 21 shows a heading tool made of tool steel. The tool consists of an oblong plate in which four holes of dif-

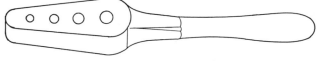

Fig. 21.—Heading Tool.

ferent sizes are drilled and a handle forged on the other side. The bore of the holes is wide or tapered at the bottom, making it more convenient to remove the metal. The use of this tool is explained in the directions for forging nails and bolts.

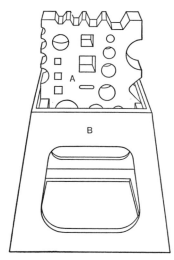

Fig. 22.—Swage Block.

23. Swage Block. The swage block is illustrated in Fig. 22. It is made of cast iron, and is a very useful tool. The base, *B*, made of cast iron, supports the block, *A*, on lugs cast on the base. The swage block may be used either flat or upright for various purposes.

As there are a variety of different sizes of round, square and oblong holes in the block, it is used for punching round, square and oblong holes in heavier stock. To form shoulders on round, square and oblong tenons, it is used in place of the heading tool.

The edges of this block have semicircular, " V " and

rectangular grooves of the various standard sizes. The semicircular grooves are used in place of bottom swages, and for this purpose the block is used in an upright position.

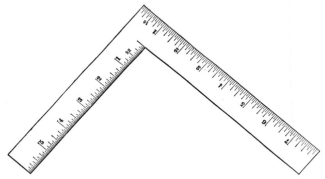

Fig. 23.—The Square.

The large round holes in the block may be used to hollow out sheet metal, etc. The "V" and rectangular grooves may be used for various kinds of work.

24. Measuring and Marking Tools.
(a) *The Square.* For accurate work the square is necessary in truing right angles and in marking out and truing surfaces.

(b) *Bevel Gauges.* Bevel gauges are used to measure oblique angles. The gauges are adjustable.

(c) *The Compass.* The compass, Fig. 24, is used as dividers to lay off or take off dimensions, to mark out sheet metals and plates for round work, etc.

(d) *The Caliper.* The caliper shown in Fig. 25 is used to measure diameters or dimensions and to test thicknesses.

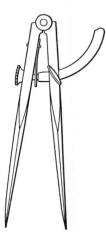

Fig. 24.—Compass.

(e) *The Scriber.* A scriber is a slender steel or brass pointed tool of needle shape, Fig. 26, used to mark lines on work.

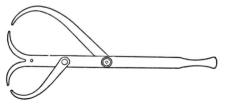

Fig. 25.—The Caliper.

(f) *The Rule.* The ordinary *footrule* serves to measure lengths and widths. A folding wooden or metal rule,

Fig. 26.—The Scriber.

such as shown in Fig. 27, is to be preferred to a straight one, and one of metal is better than one of wood.

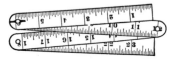

Fig. 27.—A Convenient Folding Rule.

A *tape-measure* is used to measure large dimensions. Steel tapes are obtainable in a variety of lengths, subdivided into either inches or centimeters, or both.

25. The Hardie. The hardie or cutting off tool is made of tool steel with the cutting edge tempered. The smith usually has two hardies for continual use, one for cold cutting and one for hot cutting. The square shank of the

hardie fits the tool hole of the anvil, holding the hardie cutting edge up and with the length of its face parallel to the length of the anvil. The hardie is used to cut off a finished piece of work or to trim off extra stock. Round and rectangular iron is nicked or cut all around, either warm or cold, and sometimes with the assistance of the sledge. It is then broken off by bending it back and forth

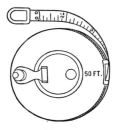

FIG. 28.—Tape-measure.

FIG. 29.—The Hardie.

over the edge of the anvil. Flat iron is usually cut only on its two flat faces.

A skillful smith can cut off hot iron directly on the hardie without transferring it to the anvil's edge, but the last blow must be accurately judged so that the hammer *does not touch the cutting edge of the hardie,* otherwise the edge will be dulled. For this "shearing-off" blow, see Fig. 46.

26. Chisels. The hot chisel, Fig. 30(a), is used to cut off heavier pieces while hot. It is set upon the work and driven through by hammer blows. The hot chisel and the hardie are very often used together for cutting off or splitting.

(a) (b)

FIG. 30.—Hot Chisel.

The hot chisel and the hardie must be worked to a slender and sharp edge, the edge being slightly curved or bowed

from end to end, in the grinding, as shown in Fig. 30(*b*). This makes it stronger and more durable. Where chisels and hardies are ground with a straight edge, the iron stock often binds fast, but the curved

edge frees itself from the stock.

Cold chisels are necessarily made stronger, as in Fig. 31(*a*), to withstand a heavier blow. The edge is tempered and is ground convex in both edge-length and face or cross-section as shown in Fig. 31(*b*).

(*a*) (*b*)

FIG. 31.—Cold Chisels.

The cold chisel and hardie are often used to mark scroll-work, but this should be done only when the mark will later disappear, because of a cut-off or because of a weld. Under no circumstances should this marking be done at the location of a bend. The chisel cut weakens the stock, and also spoils or at least affects the appearance of the work. Chisel marks are difficult to eradicate, and if at the location of a bend, often cause a break; this does not happen with a center-punch mark.

27. Mandrels. Mandrels are tapered tools. The large sizes are often made of cast iron, the smaller of wrought iron, to fit into the anvil or swageblock. Mandrels are used for truing rings, bands, washers, links of

(*a*) (*b*)

FIG. 32.—Mandrels.

chain, etc., or for anything that is to have a perfect circular or semicircular form. For work of this character in round iron, mandrels serve very nicely. In making flat iron rings, the wider the material, the greater the care that must be taken in working it. Thus the band or ring must be turned fre-

quently, otherwise it will assume the tapered form of the
mandrel. Many mandrels in use are provided with a
longitudinal groove, as in Fig. 32(a), which makes it easier
for the smith to use his tongs. By slipping the tongs down
into the groove between the mandrel and ring, he more
conveniently and firmly grips the ring.

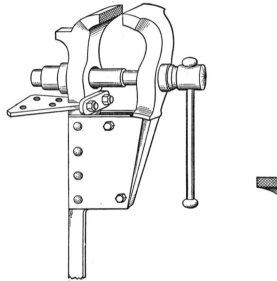

FIG. 33(a).—Solid Box Blacksmith's
Vise.

FIG. 33(b).—Vise with
Projecting Jaws.

28. The Vise. The vise serves to hold work for opera-
tions performed either hot or cold. The so-called **solid
box blacksmith vise,** Fig. 33(a), serves best for general
and ornamental work. The most convenient vise for the
smith, especially for bending wide iron, is the vise with one
end of the jaws projecting toward the left, as shown in Fig.
33(b). This grips the full width of the iron, thus saving
the time of turning or moving.

The solid box blacksmith's vise is made wholly of wrought iron with welded-in steel face plates in the jaws. Vises are to be had in many sizes, and it is advisable, where various kinds of work are to be performed, to use heavier rather than smaller or lighter vises.

In Technical, High or Vocational schools, there are used many smaller cast-iron vises, which serve well enough for the lighter work of boys in day classes, but are too light for the heavier work usually performed in Evening or Trade School Classes.

Vises must be fastened to the work bench very firmly, must be level and true in alignment, and, if convenient, should be located in a well-lighted place.

CHAPTER IV

PRACTICE EXERCISES

Hammer Wedges—Drawing and Forming Iron—Meat Hook—
S Hook—Staples—Nails—Straightening and Twist-
ing Iron.

29. General Directions. In forging, the apprentice or
student must first of all become thoroughly familiar with
the various working heats. The great tendency among
beginners is to attempt to work the iron entirely too cold.
Learn to judge when your piece is heated properly.

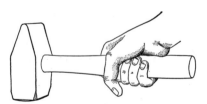

Fig. 34.—Correct Grip of the Hammer.

The first exercise should be simple, but the lightest
material is not necessarily selected. This first exercise is
particularly to teach proper heating, and to give familiarity
with the use of the hammer and anvil. To handle a forge
hammer with advantage and precision requires years of
practice.

Fig. 34 illustrates the correct grip of the hammer. The
handle is grasped about two-thirds of its length from the
inner face; this gives sufficient length for a good swing,
and also good control. The actual length of the hammer

handle is governed by the size of the hammer. The wrist, forearm and arm must be limber and the whole muscular system must have great freedom of action. Beginners usually get an incorrect hold or grip and use the hammer more in pushing than in striking, which is both useless and tiresome.

For cutting off material, use is made of power shears, hand shears, or where these are not available, the cold chisel. For this latter method the cutting in is done on the anvil and the breaking is done over the anvil's edge. Heavy stock is cut hot, using the hot chisel.

Exercise 1. Hammer Wedges

Stock: $\frac{1}{2}'' \times \frac{3}{8}''$. *Operations:* Drawing and cutting off.
(Notice that the stock selected is much heavier for the beginner than usually is necessary in making hammer wedges of this size.)

Use a short bar or scrap stock. Apply a good forging heat (light yellow heat) to the end of the bar, narrow the stock at the end to $\frac{1}{4}$ inch square, flatten and draw the extreme chisel point first on the outside edge of the anvil, as shown at *A*, Fig. 35, then draw to the desired length.

Hold up the wide side of the stock for drawing the point in order to have the portion on the anvil in line or on the same level with the point hit by the hammer. Control the length and width of the wedge, using a rule or square, heat to a red heat and cut off the finished wedge on the hardie. In cutting off, cut one-third through from one side, striking upon the metal so that the center of the hammer will fall directly upon the hardie, then turn the work over and repeat the same operation from the opposite side, as shown at *B*, Fig. 35. Break the wedge off on the outside edge of the anvil as in Fig. 35(*C*.) In this bend the wedge down, turn the metal and continue to bend back and forth until the metal breaks.

In cutting off stock on the hardie, do not cut it all the way through. Deliver the last blow with care to prevent the face of the hammer from striking upon the cutting edge of the hardie.

Exercise 2. Drawing and Forming Iron

Operations: Shouldering, forming, drawing and pointing.

Shear or cut off $4\frac{1}{8}$ inches from $\frac{1}{2}$-inch round stock. Lay off $1\frac{3}{4}$ inches from one end, using a rule or square, and mark the length with a center-punch mark. In marking round stock, which is

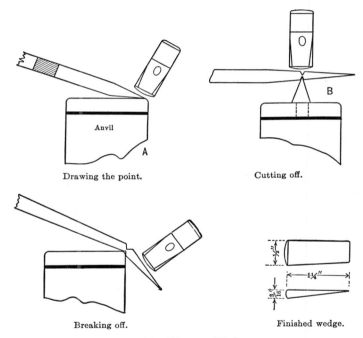

Drawing the point. Cutting off.

Breaking off. Finished wedge.

FIG. 35.—Hammer Wedge.

rather difficult on the face of the anvil, place the stock on the neck of the horn, as in Fig. 36(*b*), and use the center-punch at an angle of about 45°, against the shoulder of the anvil. Marked in this manner, the stock will not turn.

Select a pair of tongs that will fit your stock and heat the piece to a good forging heat (light yellow heat) beyond the center-punch

mark. Place the work upon the anvil as in Fig. 36(c), the center
punch mark even with the inside edge of the anvil, form the shoulder
and draw the $\frac{3}{8}$-inch square shank. In drawing the square shank,
keep turning the metal through a right angle, right and left, to

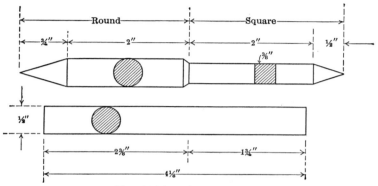

Fig. 36(a).—Finished Piece.

keep it square; if turned more or less than a right angle, the work
will assume an irregular or diamond shape.

To form the shoulder strike in such a manner that the left
side edge of the hammer will meet the center-punch mark, and will

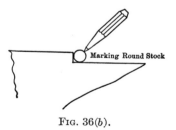

Fig. 36(b).

be vertical with the inside edge of the anvil, as shown in Fig. 36(c).
Blows delivered in this manner form a depression on the upper side
and the anvil forms one on the bottom side of the metal. Lay off
$2\frac{5}{16}$ inches from the shoulder to the square end of stock and cut
off any extra stock on the hardie

Apply a good forging heat to the end of the square shank and draw the square point on the outside edge of the anvil, the extreme point first and then back to the desired length as in Fig. 36(d). Hold up the work while drawing the point in such a way that the portion on the anvil will be in line or on the same level with the point hit by the hammer. Avoid hammering the metal cold, or striking too heavy a blow at the extreme point, or the iron will split.

Heat the second end and draw the round point. In making a round point, always draw the point square first, then form it to an octagonal section and, finally, to a round.

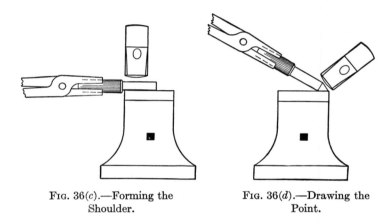

FIG. 36(c).—Forming the
Shoulder.

FIG. 36(d).—Drawing the
Point.

Examine your work carefully so as to correct the measurements and be sure that the work is straight and the points central. Straighten your work across the tool hole of the anvil. The finished piece is shown in Fig. 36(a).

Exercise 3. Meat Hook

Stock: ½-inch round. *Operations:* Drawing and bending. To find the length of stock, divide the drawing into straight and semi-circular sections as shown in Fig. 37.

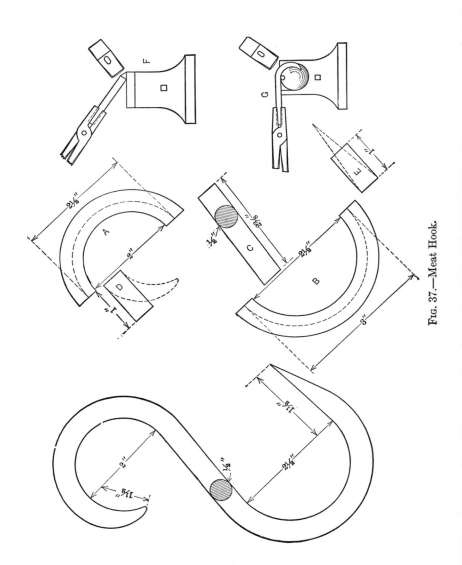

Fig. 37.—Meat Hook.

Semicircle A. Inside diameter, $2'' + \frac{1}{2}'' = 2\frac{1}{2}''$, calculating diameter.

$$2\frac{1}{2}'' \text{ or } \frac{5}{2} \times \frac{11}{7} = 3.92'',$$

required length of stock for semicircle *A*.

Semicircle B. $2\frac{1}{2}'' + \frac{1}{2}'' = 3''$ calculating diameter.

$$\frac{3 \times 11}{7} = 4.71'',$$

required length of stock for semicircle *B*.

Semicircle *A*, $3.92'' + 4.71''$, semicircle $B + 2\frac{3}{8}'' + 1'' + 1''$ for straight sections *C*, *D* and $E = 13''$, the length of stock required for the hook.

Shear or cut off the proper length of stock. Apply a good forging heat to one end and draw the extreme point first on the outside edge of the anvil, as in Fig. 37(*F*). Draw a square point first, then form it to an octagonal section and finally to a round section. For bending, apply a uniform red heat, bending the larger side of the hook over the horn first, as illustrated in Fig. 37(*G*). *Care must be taken not to burn the point.* While bending, strike *over* the horn and not directly upon it, to avoid reducing or disfiguring the metal.

Repeat the same operation from the other end. Examine your work carefully, make sure the measurements are correct and that the work is straight and the points central.

NOTE. A uniform heat is essential while bending stock. If a section is heated too much or too little, it will bend accordingly. For bending, do not apply a scaling heat, which will leave a rough surface.

Exercise 4. S Hook

Stock: $\frac{1}{4}$ inch round. *Operation:* Bending.

To calculate the length of stock, add one thickness or $\frac{1}{4}$ inch to the inside diameter and multiply by $\frac{22}{7}$ or 3.14. $1''$ (inside diam.)

$+\frac{1}{4}'' = 1\frac{1}{4}''$, the calculating diameter for the larger side of the hook.

$$1\frac{1}{4}'' \text{ or } \frac{5}{4} \times \frac{22}{7} = 3.92'',$$

the proper length of stock for the larger ring of the S hook.

$$\frac{3}{4}'' \text{ (inside diameter)} + \frac{1}{4}'' = 1'',$$

the calculating diameter for the small side of the hook.

$$\frac{1'' \times 22}{7} = 3.14'',$$

the length of stock required for the smaller side of the hook.

$$3.92'' + 3.14'' = 7.06'' \text{ or } 7'',$$

the length of stock for the hook.

Apply a uniform red heat from the center of the stock, and commence bending at the *extreme end* first, working backward and striking *over* the horn to avoid flattening or reducing the stock.

Bend the large circle first and repeat the same operation on the other end. S hooks are often used in connection with chains. To connect the same, they are twisted open (see Fig. 38, *B*) to allow the link to be slipped in and then closed; this may be done in the vise, using a pair of tongs for the purpose. In making many of these at one time, special forms or gauges may easily be made to hasten the work. In factories where this type of work is a specialty, S hooks are bent cold by machinery.

Exercise 5. Staples

Stock: $\frac{1}{4}$ inch round. *Operations:* Drawing and bending. To find the length of stock, add one thickness, $\frac{1}{4}$ inch, to the inside diameter and multiply by $\frac{11}{7}$ to get the right length for the curve or semicircle.

$$\frac{3}{4}'' + \frac{1}{4}'' \text{ or } \frac{1'' \times 11}{7} = 1.57''.$$

$1\frac{3}{8}'' + 1\frac{3}{8}'' = 2\frac{3}{4}''$ for the straight section and chisel point. Length of stock for semicircle, $1.57'' + 2.75'' = 4.32''$ or $4\frac{1}{4}''$, the correct length of stock.

NOTE. For a nail point staple, subtract $\frac{1}{2}$ inch, as less material is needed. The right length for a nail point staple would be $3\frac{3}{4}$ inches.

Apply a good forging heat to one end and draw to $\frac{1}{8}$ inch square first on the outside edge of the anvil, before flattening to $\frac{1}{4}$-inch chisel point as shown in the figure.

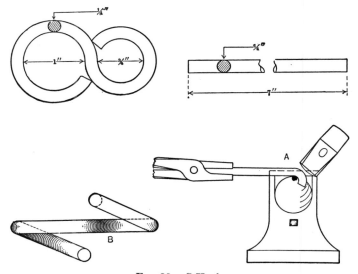

Fig. 38.—S Hook.

In drawing a point of this type, it is best to draw the point shorter first, then back to the desired length. Repeat the same operation on the other end. While drawing two flat or square points on opposite ends of round stock, it often happens that the points are not exactly in line with each other. To remedy this, heat the stock in the center (round section), then fasten one end in the vise or use two pairs of tongs and twist the piece right or left, so that the ends will be in line or parallel to each other.

Apply a uniform heat to the center section of the stock and bend the piece over the horn, the narrow edge up, striking *over* the horn as in Fig. 39 to prevent flattening or reducing the stock in the center. Make a true semicircle, straighten the ends of the staple on the side of the hardie, as shown in Fig. 39, and see

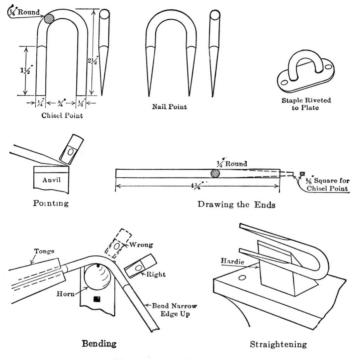

Fig. 39.—Forging Staples.

that the ends are even after bending. Control the measurements and be sure to have the ends straight and parallel.

Staples are frequently used on small gates in connection with gate hooks, door hasps, etc., to hold these in place. The ends of these staples must be drawn out straight; if concave, they will bend when driven into the wood; if convex, they will split the wood.

To fasten a staple securely, it is necessary to drive it through the wood, bending the ends right and left on the inside. Another method of attachment is to rivet the staple to a plate and fasten the plate to the wood by means of screws or nails.

Exercise 6. Forging Nails.

Stock: $\frac{3}{8}$ inch round. *Operations:* Pointing, drawing, shouldering, forming and chamfering.

Cut off a short bar of $\frac{3}{8}$-inch round stock and heat it to a good white heat (almost welding heat). Draw the extreme point on the outside edge of the anvil first as at A, Fig. 40; turn the metal right and left while doing so and strike at first heavier, then lighter and quicker blows. Do not strike too heavy a blow at the extreme end after the metal has been drawn to a sharp point, or the metal may split. Draw the point backward on the horn or face of the anvil. Shoulder in as shown at B, Fig. 40, forming the shoulder in such a manner that the left side edge of the hammer will be vertical with the inside edge of the anvil. (Notice the proper position of the hammer as shown in the figure.)

Make allowance for the head; in this case, add $\frac{1}{2}$ inch from the shoulder, then cut in straight on the hardie, turning the metal (do not cut off) as shown at C, Fig. 40.

Slip the point into a $\frac{5}{16}$-inch heading tool and bend the piece back and forth until it breaks off as illustrated at D, Fig. 40. Place the heading tool on top of the tool hole on the anvil and hammer the nail head down straight to about $\frac{1}{4}$ inch thickness, then chamfer, forming the head as shown at E. To remove the nail from the heading tool, strike the point of the nail straight on the face of the anvil.

There is no necessity for having an exactly true circular form for the heads of ordinary nails. They may also be chamfered in three or four parts as illustrated in Fig. 40, which shows the finished nail.

With a little experience a blacksmith should be able to forge a nail of ordinary size under one heat. If more heats are required, great care must be taken not to overheat the point. For many purposes, hand-forged nails are preferred and they are extensively used for fastenings and ornamentation in work of Gothic design.

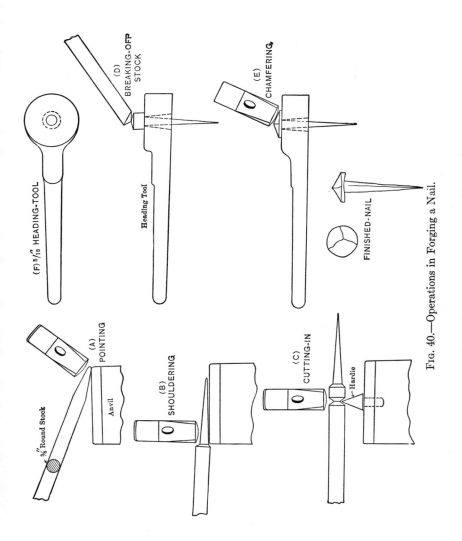

FIG. 40.—Operations in Forging a Nail.

30. Straightening Iron. The student or apprentice may now be expected to have acquired skill in handling the hammer, anvil and forge. The next work of great importance is his instruction in the straightening of iron. Bends are most frequently found in square and flat stock. A job which is practically completed, and whose details bear inspection as to finish may yet be unsymmetrical as a whole. Its angles may not be accurate, its surface may not be straight or in true curves, or its parts may have bends and warped surfaces. A job having these faults is only half " fit " and may truly be termed " unworkmanlike."

Iron and structural steel or soft steels are straightened cold in the lighter and medium weights. Heavy stock sizes are heated unless power or drop hammers are available. At first one must determine whether the piece of stock is *twisted* or *bent*. For this, the square or flat piece is clamped in the vise and two or three squares are applied as shown at *A* and *B* in Fig. 41. Or, carefully straightened piece of stock may be used as straightedges and applied in various directions across the face of the piece and along its length. In this manner, one may readily determine if the faces of the angled-edge lie in their respective planes. If this is not the case, the stock is twisted and must be twisted back to a true form by means of a pair of tongs or a monkey-wrench, where the piece is light enough. In heavy stock, a special wrench may be used which can be quickly made and used on the stock hot or cold, at the necessary points. Frequently, a piece of material has several independent twists.

The real work of straightening follows the preceding operation, and in this there is needed not only the necessary skill, but the " estimating eye." In testing with the eye, one eye is closed as when aiming a gun and a sight is taken along the piece with the other. Beginners often have trouble doing this and frequently must be assisted.

Iron bars must be "eye-tested" along two different edges, for it not infrequently happens that while the bar is being straightened in one direction it is being bent in another, as shown at C, Fig. 41. The straightening is best performed on an elevated surface, such as the top of a cast-

Fig. 41.—Straightening Iron.

iron block, shown at D, Fig. 41, or on the anvil as in E, F and G, Fig. 41, where one makes use of a wedge-shaped base, F, a rectangular projection of which fits the tool-hole of the anvil.

The straightening blow must be carefully calculated, taking into account the amount of deformity, the strength

of the iron bar, and the weight of the hammer. The bar must be laid properly upon the support and anvil, so that the bend is placed upward if possible, but just above the hollow of the support beneath.

Flat and band iron when bent may be straightened by the preceding method or by striking hammer blows on the inner curve of the iron as shown at *H*, Fig. 41. This will stretch or lengthen the metal and straighten it. However, if the piece is much bent, this method wastes time and the work may be done better with the iron hot. The sledge may be used with heavy stock. In jobs where flat surfaces must be kept and hammer marks avoided, it is better to use the *flatter* in connection with the sledge. In coarser jobs, where external appearance is of no consequence, the *top fuller* is very useful. This is the case with work which may be imbedded in masonry or in recesses in construction work or buildings. Short and slender or thin pieces are straightened over the tool hole of the anvil, for this has the necessary hollow beneath.

In straightening angle, tee or channel iron, the flatter should be used to protect the raised edges, and because in this way the force of the blow reaches the desired point, which otherwise is not always the case. Helpers often strike somewhat to the right or left of the proper point, and this must be watched and corrected.

31. Twisting Square and Flat Iron. The twisting of square or flat iron means twisting these bars about their own axes. This is often done to give a finer finish to work. In the lighter sizes of stock, it is often done cold. Soapstone or chalk is used to mark the section to be turned, *not the center punch in cold twisting*, for center punch marks are difficult to efface and mar the work. Slender bars are gripped by means of tongs or a monkey-wrench, unless a number of similar pieces are to be twisted, in which case it is highly desirable to make and use a special wrench that fits the work.

Short, flat and square pieces are usually clamped vertically in the vise for twisting. It is desirable to keep the twisted section as straight as possible, therefore it is a good plan to cut off a piece of iron pipe the length of the twist, which easily slips over the metal but is not too wide. Fig. 42 shows at A the vertical bar with the tube slipped over it and the wrench properly placed to twist.

To twist long bars, it is preferable to clamp the stock horizontally, as shown at B, Fig. 42. To preserve straightness, a pipe is used and this is supported near the end to prevent the twisting from bending the stock. Cold twisting is preferable because the job is more uniform, especially in long twists. Of course the greater the number of turns in a given length, the closer together will be the twists. If a number of bars are to be twisted, one must count the turns, marking the starting edge or face with chalk.

Twisting machines are used to twist heavy bars. These consist simply of several geared wheels with a gripping device in the middle of the large central wheel. The train of gears is set in motion by means of a crank. The opposing head of the twisting machine is also provided with a clamping device which is adjustable. Wherever space is available, it is possible to set up a clamp to twist heavy iron cold by hand. In this case, the wrenches used for turning must be extended by slipping on long pieces of pipe as extension handles at both ends of the twisting wrench stocks. The hole in the wrench must not be over large, in order that the edges of the iron may not be damaged. Large lathes are also very efficient in twisting iron.

32. Twisting Iron when Hot. Wherever it is impossible to have special tools, the larger sizes of iron must be heated. To twist iron when hot requires a special procedure, the first requirement of all being a uniform temperature throughout. This should be, preferably, a red heat, but not a scaling heat.

Wrench

(A)

Pipe

Vise

Wrench

Pipe

(B)

Round Iron

(C)

Lead or Hard Wood Block

Anvil

Top Fuller

(D)

Lead or Hard Wood Block

Anvil

Fig. 42.—Twisting Iron.

49

A tube cannot be used while twisting iron hot; the twisted material must be visible. If the iron twists irregularly it is irregularly heated, or else the irregularity is to be attributed to defective spots in the material. The difficulty is frequently remedied by local cooling with water kept handy in a flask or bottle.

33. Straightening Twisted Stock. To straighten twisted stock, either hot or cold, so as not to injure the lower edges, a wooden base or lead block is used as shown at *C* and *D*, Fig. 42.

To protect the upper edges of light material, a mallet is used, and with heavier sorts a short length of round bar or a top fuller and sledge handled by one's helper.

The gripped ends of twisted bars become quite hard, especially if twisted cold and, if they are badly bent while the twisted process is being carried on, it is customary to anneal these ends or to straighten them hot lest they break.

Twisted bars of heavy stock are straightened in the same manner, except that *a lead block support must not be used* for the lead melts at a low temperature, and molten lead may be spattered by the blows; it is, therefore, advisable to use hard wood blocks while straightening hot iron.

PROBLEMS

(See §36, page 56.)

Compute the length of stock required for meat hooks having the following dimensions (see Fig. 37 for the sections referred to by letter): . .

> **1.** *A*. $2\frac{1}{4}$ inches inside diameter.
> *B*. $2\frac{3}{4}$ inches inside diameter.
> *C*. 3 inches.
> *D*. $1\frac{1}{8}$ inches.
> *E*. $1\frac{1}{8}$ inches.

Stock $\frac{5}{8}$ inch square.

> **2.** *A*. 2 inches *outside* diameter.
> *B*. $2\frac{1}{4}$ inches *outside* diameter.

 C. $1\frac{1}{4}$ inches.

 D. $\frac{3}{4}$ inch.

 E. $\frac{3}{4}$ inch.

Stock $\frac{3}{8}$ inch square.

 3. *A.* $1\frac{3}{4}$ inches inside diameter.

 B. $2\frac{3}{8}$ inches *outside* diameter.

 C. 2 inches.

 D. $\frac{7}{8}$ inch.

 E. $\frac{7}{8}$ inch.

Stock $\frac{1}{2}$ inch square.

Compute the length of stock for S hooks of the following sizes referring to Fig. 38:

 4. Large side of hook $1\frac{3}{4}$ inches inside diameter.

 Small side of hook $1\frac{1}{2}$ inches inside diameter.

Stock $\frac{1}{2}$ inch round.

 5. Large side of hook $1\frac{1}{2}$ inches inside diameter.

 Small side of hook 1 inch inside diameter.

Stock $\frac{3}{8}$ inch round.

 6. Large side of hook $3\frac{1}{4}$ inches *outside* diameter

 Small side of hook $2\frac{1}{4}$ inches inside diameter.

Stock $\frac{5}{8}$ inch round.

CHAPTER V

UPSETTING, OFFSETTING, SHOULDERING, DRAWING, FORMING AND BENDING

34. Hammer Blows. The correct use of the hammer is of the greatest importance to the smith, for, while work at the anvil and forge embraces many operations, the use of the hammer is almost always involved. By the various ways of using the hammer and the edges and horn

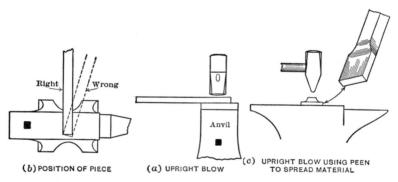

(b) POSITION OF PIECE **(a) UPRIGHT BLOW** **(c) UPRIGHT BLOW USING PEEN TO SPREAD MATERIAL**

FIG. 43.—The Upright Blow.

of the anvil, a great variety of results may be achieved. Among the more common hammer blows employed are the following:

(a) *Upright Blow.* In this blow the hammer meets the metal vertically above the middle of the anvil. The effect is to work the metal toward all sides and away from the spot where the blow is applied; that is, the thickness of the metal is reduced, but the length and breadth are

increased. The upright blow is used *to draw, to spread,* and *to finish* the work smooth.

To reduce the thickness of narrow pieces, the strokes are worked more toward the length of the material, for the hammer face covers more of the length than of the breadth. With very few exceptions, it is better to work with the metal extending at right angles to the face of the anvil, as shown in Fig. 43 at (*b*).

The cross-peen hammer is used to spread the metal in width, as shown at (*c*), Fig. 43. In this manner the metal is spread without appreciable change in length, in other

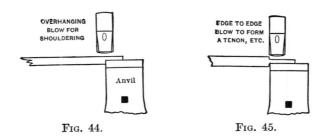

FIG. 44. FIG. 45.

words, one may produce greater breadths without sensibly weakening the stock.

(*b*) *Overhanging Blow.* The overhanging blow is used to form a shoulder on one side, as in Fig. 44. The hammer meets the metal so that the middle of the hammer face is vertically over the edge of the anvil; thus, the upper surface of the metal remains straight and the lower forms a depression or shoulder.

(*c*) *Edge to Edge Blow.* To form a tenon or a double shoulder the edge to edge blow is used. This blow is delivered with the left side edge of the hammer perpendicular with the edge of anvil, as in Fig. 45. The edge of the anvil will form a depression or shoulder on the bottom side of the metal, while the edge of the hammer will form

a depression on the top. Round, square or flat stock may be shouldered from two or four sides in this manner.

The blow is still more effective if the metal is held slightly down at the beginning of this operation.

(*d*) *Shearing Blow.* The shearing blow on the hardie is used for cutting iron hot. The first blows are delivered directly above the hardie, the metal being cut into from all sides. The last blow requires skill and must be well directed and measured according to the size of the stock and the weight of the hammer. The left edge of the hammer should

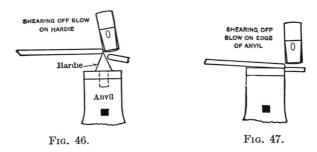

FIG. 46. FIG. 47.

pass close to the cutting edge of the hardie, as shown in Fig. 46.

(*e*) *Shearing off Blow.* The shearing off blow on the edge of the anvil is sometimes used by blacksmiths to cut thin stock hot and cold. This operation, illustrated in Fig. 47, requires more or less skill and the beginner must refrain from using this blow until experience is gained, in order not to destroy the edges of the anvil or disfigure the face of the hammer. The left side edge of the hammer should pass the edge of anvil close but should never strike the edge. The blow is more effective if the metal is slightly raised.

(*f*) *Angle Blow.* The angle blow is used for drawing a point or taper. The point should be drawn on the outside edge of the anvil, as shown in Fig. 48.

Hold up the work for drawing a point or taper in such a way that the portion on the anvil will be in line or on the same level with the point hit by the hammer.

(g) *Leverage Blow*. The leverage blow is used for bending material, such as scrolls, rings, washers, links of chain,

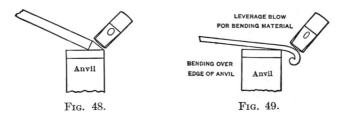

Fig. 48. Fig. 49.

etc. In order to start the curve of a scroll strike beyond the edge of the anvil, as illustrated in Fig. 49, and not directly upon the edge, as the blow will reduce and disfigure the stock. A uniform heat is essential while bending work of this type. If the piece is not heated uniformly it will bend irregularly, making the forming of true circles and lines more difficult.

If a scroll starter is used for bending scrolls, use the hammer in the same manner, striking over the scroll starter.

Rings, washers and curves are bent over the horn of the anvil, as in Fig. 50. Exceptionally wide stock is bent over

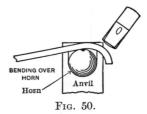

Fig. 50.

the edge of the anvil, the taper of the horn being a disadvantage.

35. Forging Operations. The term **upsetting** means to increase the cross-sectional area, to make heavier, and to thicken stock, as in Fig. 51. It consists of shortening the bar with backing up blows over or upon the anvil

or in the vise, and in the case of heavier, longer bars, by ramming them upon and against the anvil.

Offsetting means to change the lines of the piece off center, as in Fig. 52.

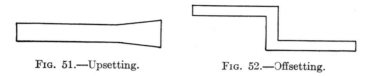

FIG. 51.—Upsetting. FIG. 52.—Offsetting.

Shouldering means to reduce the stock at a given point. A bar may be shouldered from one, two or four sides, as in Figs. 53 and 54.

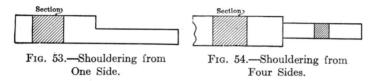

FIG. 53.—Shouldering from FIG. 54.—Shouldering from
 One Side. Four Sides.

Drawing consists in making a bar of iron longer and smaller by hammering or pressure.

Spreading means to increase the width of stock.

36. Calculating the Required Length of Stock. The amount of material needed for short, thick jobs is determined by calculating the weight and adding allowances for losses. These depend upon how complicated the job is, and the material of which it is to be made; allowances for waste in forging and welding are therefore variable.

The simplest method of determining the length needed for pieces, successive parts of which are straight or portions of circles, as, for example, angles, rings, links, eyebolts, etc., is to calculate separately the length required for each part and then to take the sum of these with necessary allowances. In this calculation the basis should be the length of the *center line of the part,* not the outside or

the inside length. For example, in finding the length of stock needed to make a **right-angled bend**, as in Fig. 55, the length of the center line is $4\frac{1}{2}$ inches plus 4 inches, or $8\frac{1}{2}$ inches.

The length of stock for a circle, such as Fig. 56, may be found from the formula,

$$\text{Circumference} = \text{diameter} \times \pi.$$

π is a constant having the value 3.1416, or approximately $\frac{22}{7}$. The diameter to be used is always the *mean diameter*, i.e., measured from center line to center line of stock.

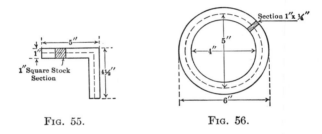

FIG. 55. FIG. 56.

Thus for Fig. 56, 4″ (inside diameter) $+\frac{1}{2}'' + \frac{1}{2}'' = 5''$, mean or working diameter. Mean circumference, and therefore required length of stock, is thus

$$5'' \times \tfrac{22}{7} = 15.71''.$$

If this ring is to be welded an allowance must be made for the weld equal to the thickness of stock. Hence for a welded ring, $15.71'' + \frac{1}{4}''$, or practically 16 inches, would be required.

The computation for length of stock for various shapes of forgings will be given later in connection with the directions for forging. Usually, the computation for the circumference of a circle involves the use of fractions. The

mechanic may avoid these by the following graphical method:

Lay out a circle having the desired diameter; place the corner of a square in the center and draw the lines *A–B*, *B–C* and *A–C* as in Fig. 57. Draw the line *D–E* from the center of the line *A–C* and at right angle to it, to the periphery of the circle. Multiply the diameter of the circle by three and add the length of the line *D-E*; the result will give the desired circumference as nearly as needed for practical purposes.

FIG. 57.

Exercise 7. Gate Hook

Stock: $\frac{5}{16}$ inch square. *Operations:* Shouldering, drawing, forming, bending and twisting.

The length of stock required is $6\frac{1}{8}$ inches. Lay off measurements as noted in Fig. 58(*a*), and mark with a center punch. Note

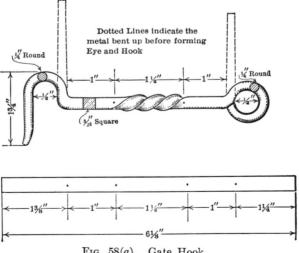

FIG. 58(*a*). Gate Hook.

that $1\frac{1}{4}$ inches of stock are required for making the eye, and $1\frac{3}{8}$ inches for the hook.

Apply a good forging heat to the short ($1\frac{1}{4}$ inches) end first, shoulder in from three sides on the center punch mark for the eye and draw the end as in Fig. 58(b) to one-quarter square. Then form the piece until first octagonal and finally round in section.

SHOULDERING AND DRAWING

Anvil

Fig. 58(b).

Great care should be exercised in forming the shoulder not to reduce the stock at the center punch mark more than $\frac{1}{4}$ inch. While rounding up the metal, do not strike too heavy a blow or the metal may split. The stock will now have been increased considerably in length.

To find the length of stock required for the eye, add one thickness of stock ($\frac{1}{4}$ inch) to the inside diameter and multiply by $\frac{22}{7}$.

Inside diameter $\frac{1}{2}'' + \frac{1}{4}'' = \frac{3}{4}''$, the calculating diameter.

$$\frac{3}{4}'' \times \frac{22}{7} = 2.35''.$$

$2\frac{1}{4}$ inches will give this, therefore, lay off $2\frac{1}{4}$ inches from the shoulder and cut off the extra stock on the hardie.

BENDING

Wrong

Right

Anvil

Fig. 58(c).

Apply a good red heat, place the work with the shoulder at the outside edge of the anvil, the shoulder up, and bend the end down at an angle of about 90°, as shown in Fig. 58(c)

Strike over the edge of the anvil, taking great care not to reduce or flatten the stock at the corner.

Hold the work up vertically with the bent end across the end of the horn as illustrated in Fig. 58(d). Commence bending at the *extreme end* first, then work backward, striking *over* the horn as the piece is fed forward to prevent flattening or reducing the stock. Continue bending until the shape of the full curve is obtained.

Turn the work, hold it slightly up, as in Fig. 58(e), and close the eye on the outside edge of the anvil.

Draw the other end for the hook in a similar manner, slightly tapering the stock toward the end.

To obtain the amount of stock for the hook, add one thick-

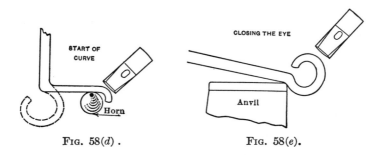

Fig. 58(d). Fig. 58(e).

ness of stock ($\frac{1}{4}$ inch) to the inside diameter and multiply by $\frac{1}{7}^{\frac{1}{7}}$ to find the length of stock for the *semicircular* curve and to this product add the length of the straight sections.

Inside diameter, $\frac{1}{2}'' + \frac{1}{4}'' = \frac{3}{4}''$, the calculating diameter. $\frac{3}{4}'' \times \frac{1}{7}^{\frac{1}{7}} = 1.17''$, the length of stock for the curve. $1.17'' + \frac{5}{16}'' + 1''$ $= 2.48''$, or $2\frac{1}{2}''$, the entire length of stock required.

Lay off $2\frac{1}{2}$ inches from the shoulder and cut off any extra stock on the hardie. Bend the end in a right angle over the outside edge of anvil, as described before. *Bend to the same side as the eye* was bent, so that when finished the point of the hook will be at the bottom at the same side of the joint as the eye.

In making the curve for the hook bend $\frac{1}{2}$ inch from the angle, as illustrated in Fig. 58(f). The curve should be a true semi-

circle and the sides should stand parallel to each other with the end of the hook slightly bent outward.

Apply a uniform red heat to the center section which is to be twisted,* then fasten the piece in the vise horizontally, the one center punch mark even with the edge of the vise, the other even with the right side jaw of the tongs, as shown in Fig. 58(g).

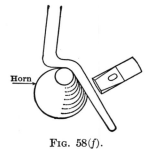

Fig. 58(f).

Work rapidly after the piece has been fastened in the vise, as the vise will absorb the heat quickly and will cool the metal at the end so that the twist will be uneven. Make a complete turn so that after the twist is completed the point of the hook and the joint of the eye will both be on one side. The square parts should stand

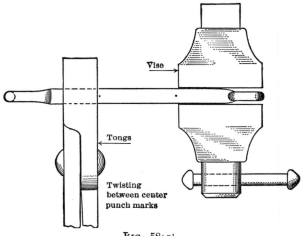

Fig. 58(g).

* A skilled worker will make the twist cold first, then proceed with the other operations, as explained. It would not be wise for the beginner to do so, for the many operations that follow may be of disadvantage to the twisted section, and the edges may be injured.

parallel and the edges even and in one line. If no vise is at hand, use two pairs of tongs.

Reheat the center section to a dark red heat, straighten the hook on a hard wood block, using a mallet as a hammer to prevent the sharp corners from being disfigured or injured.

Examine the finished piece carefully to be sure that it is straight, and that the center of the eye is in the center line of the work.

Exercise 8. Hexagonal Head Bolt

Stock: $\frac{5}{8}$ inch round. *Operations:* Upsetting, forming, chamfering, use of heading tool.

Calculation of Stock. To obtain the amount of stock required for making a hexagonal or square-head bolt from solid stock, multiply the diameter of the stock by 3 and add $\frac{1}{8}$ inch, which is the allowance for upsetting. Thus for $\frac{5}{8}$-inch stock the length would be $(3 \times \frac{5}{8}'') + \frac{1}{8}''$ or 2 inches. $\frac{1}{4}$ inch more is here added, as noted in the drawing, for the beginner, to allow for waste and hammering. The student or apprentice will need more heats, more time, and will do more unnecessary hammering.

To determine the distance across the head of a finished bolt multiply the diameter by $1\frac{1}{2}$ and add $\frac{1}{8}$ inch. Thus for $\frac{5}{8}$-inch stock $(\frac{3}{2} \times \frac{5}{8}) + \frac{1}{8} = 1\frac{1}{16}$ inches, the width across the head.

The thickness of the head is one half that of the distance across the flats. In this case, $1\frac{1}{16}'' \div 2 = \frac{1}{3}\frac{7}{2}''$, the thickness of the head.

Forging. Cut off a piece of $\frac{5}{8}$-inch round stock $6\frac{1}{4}$ inches long. Lay off $2\frac{1}{4}$ inches from one end and mark this length with a center punch; *avoid using a chisel for this purpose,* as it will weaken the metal and the head may break off before it is finished or a crack may be started. While marking round stock, which is more or less difficult, as it may turn on the face of the anvil, place the stock on the neck of the horn and use the center punch at an angle of 45° against the shoulder of the anvil, as illustrated in Fig. 36(*b*). A five-eighth inch bottom swage may also be used for this purpose.

Heat the stock for a short distance on the opposite end, square up and form a $\frac{1}{8}$-inch bevel, which will make the piece fit the heading tool more easily and will prevent a rough edge forming on this end while upsetting the other. If not square on this end,

upsetting will require more skill to keep the stock straight and central.

Apply a good forging heat (light yellow heat) to the end laid

Fig. 59(a).—Hexagonal Head Bolt.

off for the head and heat beyond the center punch mark. Cool all stock below the center punch mark in the water tank, place the beveled end on the face of the anvil, as in Fig. 59(b), and

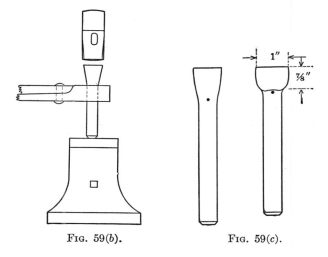

Fig. 59(b). Fig. 59(c).

upset, striking the piece upon the heated end. It requires several heats to upset the head properly. Care must be taken to keep the work straight and central. While upsetting, the head will

spread more at the top, becoming tapered as shown in the figure. To remedy this, cool the head partly from the top; the section below the center punch mark must be cooled after every heat before upsetting. Upset to the size and shape shown in Fig. 59(c).

Reheat the head end to a good forging heat, slip the shank into the heading tool (the narrow side of the bore in the heading tool up), place the heading tool directly upon the tool hole of the anvil so that the tool hole will receive the shank and hammer

Fig. 59(d).

down as illustrated in Fig. 59(d), forming a disk of ⅝ inch thickness. Work the sides of the disk straight on the face of the anvil so that the sides will be parallel to the shank. This operation requires the repeated use of the heading tool and anvil. The disk should be round, straight and central before forming it hexagonal.

To form the head to a hexagonal shape reheat the work, place the disk on the anvil, the shank horizontal to the face of the anvil and work down as shown in Fig. 59(e). One flat side is formed by the hammer, the opposite side by the face of the anvil. Turn

FIG. 59(e).

to the proper angle right and left, as indicated by the dotted line and repeat. This operation also requires the repeated use of the heading tool and the face of the anvil.

Heat to a red heat and chamfer the head by using the cupping tool in connection with a sledge-hammer handled by the helper as in Fig. 59(f).

Where no cupping tools are at hand, use the blacksmith hammer at an angle of 45°, thus breaking the sharp edges on the top of the head and forming a circle at the top which will give the bolt a better finish. All operations should be carried out under a good forging heat, except where stated to avoid a crack on the neck of the bolt, which will make it unsafe to use.

Another more rapid method of making a bolt by welding on a flat iron collar for the head is given in Exercise 11.

FIG. 59(f).

Exercise 9. Bending Circular Curves

Small and medium-size rings made of flat, round or square stock may be bent over the horn, as illustrated in Fig. 60. To do this apply a uniform heat and start bending at the extreme end, striking over the horn. If large quantities of rings are to be made, a form should be made to hasten the work.

In making rings of larger diameter it is a labor-saving devise to bend a section of heavier stock and use it as a form as in Fig. 61. A form of this kind may be used to bend iron hot or cold. If

Fig. 60.—Bending a Ring. Fig. 61.—Form for Bending Rings.

used for bending cold, make the form a trifle smaller in diameter than the ring desired, thus allowing for recoil.

Fasten the form and stock in the vise and start bending at the end; continue bending until the circle is almost completed, then turn and continue the bending from the opposite end. Rings are quickly made in this manner and show no hammer marks.

Exercise 10. Bending a Square-cornered Angle

Various methods may be employed in making a square-cornered angle.

First Method. Lay off the proper length on the bar, heat the section to be bent and cool the end to confine the operation

to the required place. Start bending over the horn first and con-
tinue bending over the outside edge of the anvil, striking over
the anvil, as shown in Fig. 62(*a*).

FIG. 62(*a*).—Bending a Square-cornered Angle.

Square the corner by upsetting the metal at the bend, as in
Fig. 62(*b*). Turn the work until it lies flat over the anvil and
upset as shown in Fig. 62(*c*). Repeat the upsetting in upright
and horizontal positions, thus forming a sharp corner.

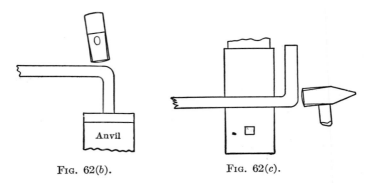

FIG. 62(*b*). FIG. 62(*c*).

While bending and upsetting, care must be taken not to bend
the angle more than 90°, to avoid a crack on the inside edge
of the angle (notice the position of the hammer).

Second Method. Another method more suitable for the beginner is illustrated in Fig. 63.

Heat the section to be bent, upset on the anvil or in a vise, cool the end to confine the operation to the required place, and bend as in the previous exercise. Thicker stock is sometimes used and the ends are drawn out, leaving a ridge, as illustrated.

Third Method. The third (and quickest) method consists in bending square-cornered angles partly in the vise and partly on the anvil, but good judgment must be used in doing this. Mark the place to be bent with a center punch mark, heat to a good forging heat, cool the end quickly and fasten the piece upright in the vise in such a manner that the center punch mark will be

Fɪɢ. 63.—Second Method of Bending an Angle.

one-half of the thickness of the metal above the vise. Then bend down by hand, not using the hammer, to an angle of not quite 90°. Square and upset the metal at the corner, draw the metal, while upsetting, toward the corner, using the hammer in the proper angle, as illustrated in Fig. 64(*a*). Hold the end up to prevent bending the corner more than 90°.

Remove the work quickly from the vise and turn the angle from an upright to a horizontal position, the end pointing toward the bench, and upset as illustrated in Fig. 64(*b*). Take notice of the space between the side of the angle and the vise indicated in the figures. This is of great importance to attain good results. Stop hammering before the inside edge of the corner touches the vise, thus avoiding weakening or reducing the stock. Finish on the anvil, as explained in the previous methods.

A skilled blacksmith should be able to make a square-cornered angle of ⅞-inch square stock under one heat.

Short Z angles, as shown in Fig. 65(a), are often used in connection with scroll-work. They are difficult to make and require skill. If a number of Z angles are to be made, it is of great advan-

(a)

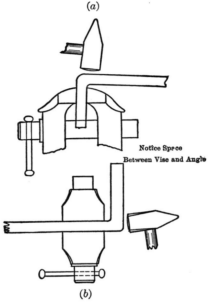

Notice Space
Between Vise and Angle

(b)

Fig. 64.

tage to use a form. For a Z angle made of $\frac{3}{4}''\times\frac{1}{2}''$ flat stock, $\frac{5}{8}$ inches inside measurement, use a piece of $1\frac{1}{2}\times\frac{5}{8}''$ flat iron in making the form. Cut out a section $\frac{3}{4}$ inch in depth and $\frac{1}{2}$ inch

Fig. 65(a).

in width, to receive the stock, as shown in Fig. 65(b). To do this drill a $\frac{1}{2}$-inch hole, saw down right and left, cut the corners out with a cape chisel, and file the sides straight and square.

Heat the section to be bent to a good forging heat, slip the piece into the opening cut in the bar, bend the short end forward, using a pair of tongs, then turn the work and bend the other end

(b)

1½″ x ⅝″

½″

¾″

1½″

(c)

Fig. 65.

in opposite direction. Place the work upon the face of the anvil as shown in Fig. 65(c) and upset, using the hammer at the proper

⅜″ x ⁹⁄₁₆″

1″ A

Closed B

Open

Collar

Section

C

Fig. 66(a).

angle, as illustrated, to increase the thickness of stock at the corner. Finish partly in the vise and partly on the anvil.

Collars or short double angles, Fig. 66(a), are frequently used

in connection with scroll-work as a fastening and for ornamentation. In making a collar of $\frac{3}{4}''\times\frac{5}{16}''$ material to have 1 inch inside measurement, it is of great advantage to use a 1-inch square bar, squared up at the end. For wider and smaller collars use stock accordingly.

Heat the section to be bent, and bend the semicircle or curve over the horn, the short end parallel to the bar, Fig. 66(b). Slip

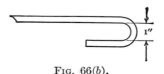

FIG. 66(b).

a 1-inch square bar between the sides and close the angle in upon the bar. Then fasten the work securely in the vise, the square bar even with the side of the vise, and square up the curve, upsetting the corners and forcing the extra stock of the curve toward the corners, as shown in Fig. 66(c).

FIG. 66(c).

Remove the angle from the vise and finish upon the anvil, as illustrated in Fig. 66(d).

Single and double offsets may be made in various ways. By the most common method, the offset is formed on the outside edge of the anvil, using a top fuller or set hammer, as in Fig. 67. Allow a length equal to the thickness of the metal between the fuller and the edge of the anvil to avoid reducing the stock. Finish on the face of the anvil.

Where large quantities of single and double offsets are to be made, it is of great advantage to provide a form such as that illustrated in Fig. 68. The fork *A* is made from flat stock, and the

Fig. 66(*d*).

thickness is determined by the depth of the offset and the size of stock to be used.

The tongue and handle *B* is fastened to the fork by means of

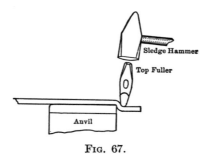

Fig. 67.

rivets. The metal used for the tongue should be well hammered in the center while cold to make it more elastic, prior to riveting it to the fork. The fork and tongue should not be too short. For stock $1\frac{1}{2}''\times\frac{3}{8}''$ they should be about 9 inches in length; for

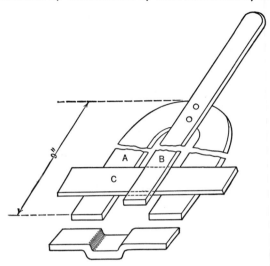

FIG. 68.—Form for Making Offsets. *A*, Fork; *B*, Tongue; *C*, Metal to be Bent.

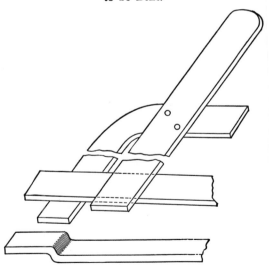

FIG. 69.—Form for Single Offsets.

wider stock increase the length accordingly. The fork must be made wide enough to allow a trifle more than the thickness of the metal to be used, right and left, between A and B.

Heat the metal, slip it in between the tongue and fork near the end, bring the form to an upright position and tighten in the vise quickly, thus offsetting the metal in the center. The whole operation takes a few seconds only. To hasten this kind of work heat a number of bars at once.

Fig. 69 shows a form for single offsets. For semicircular offsets, use half round iron for the tongue.

Where power hammers and power punches are available, special steel dies may be made to offset stock hot and cold. For thinner stock, a hand-power punch will be sufficient.

PROBLEMS

See Fig. 55 for problems 1 and 2.

1. Find the length of stock necessary in making an angle $7''\times5\frac{1}{2}''$ *inside* measurement. Material to be used $1\frac{1}{4}$ inches square.

2. Find the length of stock required in making an angle $6\frac{1}{2}$ inches *outside* by $4\frac{3}{4}$ inches *inside* measurement. Material to be used $\frac{3}{4}$ inches square.

For problems 3, 4, 5 and 6, see Fig. 56.

3. Find the length of stock necessary in making a welded ring washer of 3 inches *inside* diameter. Stock to be used $\frac{3}{4}''\times\frac{1}{4}''$ flat. Allow thickness of stock for welding.

4. Find the length of stock necessary in making a welded ring washer of 5 inches *outside* diameter. Stock to be used $1\frac{1}{4}''\times\frac{1}{2}''$ flat. Allow thickness of stock for welding.

5. Calculate the length of stock required in making a welded *band ring* of 15 inches *inside* diameter. Material to be used $2''\times\frac{3}{8}''$ flat. Allow thickness of stock for welding.

6. Calculate the length of stock required in making three *band rings* of 4 inches *outside* diameter. Material to be used $1''\times\frac{1}{4}''$ flat. Allow thickness of stock for each band for welding.

CHAPTER VI

WELDING

37. Definition. The term *weld* is applied to a thoroughly cohesive union between two pieces of like metal, brought about by steady pressure or hammering while the metals are heated almost to their melting temperatures. This cohesive union requires that the molecules of the two metal surfaces be forced so close together that they are within molecular distances of each other. There must, therefore, be no foreign substances or binders between the welded surfaces; there must be a true cohesion, and not an adhesion. If certain foreign matters, such as slag and scale, are confined between the surfaces, the weld is not complete, and the parts will separate upon repeated bending back and forth.

38. Conditions Necessary. In most cases the materials are first upset, then drawn to a short wedge form in such a way that, after the two pieces are welded, there will be a smooth joint. The forge fire in welding must not be an oxidizing fire, and its sides must be banked up and protected with coal to obtain good results. The most important matter, however, is the heating. The temperature must be sufficiently high to produce plasticity, and both pieces must be equally plastic, that is, *equally hot*. They may then be joined by light hammer blows at first, and later by increasingly heavy blows, or by means of continuous pressure. The welding temperatures for iron and steel are different, for steel becomes plastic at a lower temperature and has a lower melting point, consequently, it may be welded at a lower temperature.

The " weldability " of iron and steel is dependent upon their chemical constituents, particularly upon their carbon content. The greater the percentage of carbon present the more difficult it is to produce a weld, until " weldability " ceases when the percentage of carbon has reached a certain value.

Crucible or tool steel when heated white hot crumbles under the hammer. The metal is then called *burnt*. This same phenomenon, due to overheating, or burning in steel, may also occur in good wrought iron, either as a result of overheating, or by the absorption of carbon in the fire by what is known as a *cementation process*. This absorption of carbon frequently occurs when the smith stops the blast just because the iron is " *almost* hot enough." Cutting off the blast cuts off the oxygen which consumes the carbon, and the iron absorbs some of the carbon, thereby becoming hard and unweldable. It then exhibits the characteristics of steel, such as crumbling under the hammer.

39. Welding Fluxes. Welding compounds are often used for steel, for less weldable kinds of iron, and for delicate artistic or small jobs. They are composed of slag-forming substances (silicates) and fine particles of iron (iron filings). When sprinkled on the iron or steel after it has reached a bright red heat, they lower the melting point of the scale and protect the metal from oxidation. Clean sharp sand is often used for welding. Borax is most frequently used in steel welding, and in the making of leaf and flower work.

Several formulas for common welding compounds are given in the Appendix. In most cases, it will be observed, borax is the basis of the compound. Those compounds containing borax or sand form a thin protective covering of slag upon the white hot metal. The metals then do not oxidize very much, because direct contact with the air is prevented.

40. The Lap Weld. The lap weld is the most common in general practice. For good results with this weld, it is necessary first to *upset* and *shape the ends* of the pieces to be welded. The shaping of the ends should be done in such a manner that after the pieces are welded no sign of the scarf is seen. The ends are upset to allow for waste and hammering. Flat stock should be upset in thickness only, one-third to one-half the thickness of the stock to be used, and the stock should be narrowed in width.

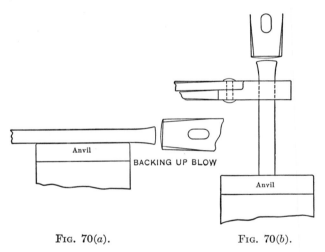

FIG. 70(*a*). FIG. 70(*b*).

In upsetting, the stock should be heated to a good forging temperature at *the end*, to confine the upsetting to the end of the bar, thus avoiding unnecessary bending. The length of upset is determined by the width and thickness of the stock and is usually from one to two times the thickness of the stock. Fig. 70(*a*) shows the method of upsetting a bar in a horizontal position, extending over the anvil. This is the most common way to upset long bars. The metal should be thrust forward while delivering the blow in such a manner that the face of the hammer will hit the metal

squarely, rendering the blow more effective and keeping the bar straight.

Short pieces of stock may be upset in an upright position on the face of the anvil, as in Fig. 70(b), or on the neck of the horn, resting the stock on the neck at an angle of about 45° against the shoulder of the anvil, to prevent the metal from slipping.

To upset thin and medium sizes of stock more rapidly, use the vise. It is more advantageous to fasten the metal horizontally in the vise. In the upright position, care must be taken not to fasten the stock too near the heated end, in order to prevent the sharp edges of the vise from

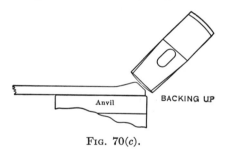

FIG. 70(c).

being worked into the metal, which will partly reduce and disfigure the stock and leave a sharp-angled shoulder on two sides.

In *backing up* the upset end when forming the heel of the scarf, the bar should be brought close to the edge of the anvil, and the blows should be directed at an angle of about 45° against the metal, as shown in Fig. 70(c), so that they will have an upsetting effect in forming the short bevel.

The *scarf* should be formed on the inside edge of the anvil, the metal being held down meanwhile and the hammer used against the anvil, as in Fig. 70(d), to prevent the metal from slipping. The length of the scarf should be about 1½ times the thickness of the stock. To form the

scarf on heavy stock, a top fuller and a sledge-hammer
are used to draw the end upon the surface of the anvil.

In Fig. 70(e) are shown two views of the correct shape
of a scarf on flat stock. The surface of the scarf should
be convex and the end slightly raised, especially while
welding thin stock. Shaped in this manner the end will

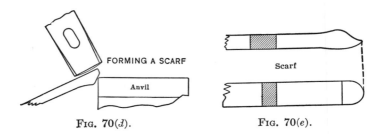

FIG. 70(d). FIG. 70(e).

not touch the cold anvil in welding, which would cool the
stock rapidly and tend to prevent a thorough weld.

Fig. 70(f) shows two pieces of stock properly shaped
and in a correct position for welding. The dotted line
indicates where the metal comes first in contact, leaving
the sides open to force out
the scale.

In Fig. 70(g) are shown
two pieces of stock in the
correct position upon the
face of the anvil. The
first blow delivered at a
proper angle and in the

FIG. 70(f).

center, as illustrated, forces the two pieces of metal against
each other and not apart. The first few blows must be
delivered lightly and in rapid succession, the blows then
gradually becoming heavier.

No time should be wasted in removing the metal from
the fire. The scarfs should be lapped so that the point
of one scarf will meet the heel of the other. Overlapping

will increase the surface to be welded, making welding
more difficult. If lapped too short, the stock will be too
thin at the welded sections. The lap should be made
before the two pieces are brought into close contact, as
otherwise they will adhere, causing trouble and delay. It
is somewhat difficult to lap the pieces quickly and properly;
if desired, the metal may be rested on the inside edge of
the anvil and moved forward into the proper place. Another
method consists in using the hammer to bear against the

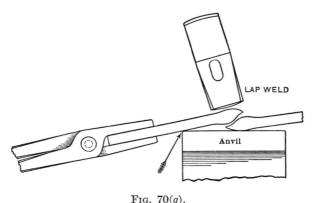

Fig. 70(*g*).

stock in the left hand several inches from the end. Both
methods work well and give full control of the stock.

In all welding great care must be observed to have a
clean fire with the sides well surrounded with green coal
to protect the iron from oxidation and to heat the pieces
properly and thoroughly. To apply a welding heat, place
both pieces squarely in the fire, scarfs down. Maintain a
reduced blast to allow the metal to heat thoroughly, and
see that plenty of burning coke is underneath the metal,
as well as on top of it. Wrought iron when brought to a
welding heat is almost white, much like a pasty mass, with
sparks appearing upon the surface of the iron, which are

nothing but little particles of the iron itself that become separated from the bar and take fire in the air. When a thorough welding heat has been obtained, quickly remove the pieces from the fire by raising them slightly, avoiding as much as possible dragging the heated ends through coal or coke, and strike them quickly upon the outside edge of the anvil, with the heated ends projecting over the anvil, scarf down, to remove all impurities that may adhere.

While applying the welding heat do not bring the two pieces to be welded into close contact in the fire, as they may stick or adhere to each other and thus cause delay and trouble. In welding round stock, draw the scarf to a short nail point to prevent the corners from projecting beyond the edge of the bar.

41. Angle and " T "-Weld. In Fig. 71(a) is shown a flat, *right-angled weld.* The dotted lines indicate the proper lap of the scarfs before welding. There are two ways of making a flat angle weld. In the first method the stock

Fig. 71(a).—Right-angled Weld.　　Fig. 71(b).

is sheared or cut to an angle of about 45°, as shown in Fig. 71(b). A good forging heat is then applied to the end and the stock is placed upon the anvil, with the end even with the outside edge of the anvil, and with the narrow edge up. The metal is then upset and hammered down with backing up blows, to the dotted line. In forming the scarf, rest the metal flat upon the anvil and draw the section with a ball-peen hammer until as shown in

Fig. 71(c). Both ends should be scarfed from the same side, so that when one is reversed they will be right and left.

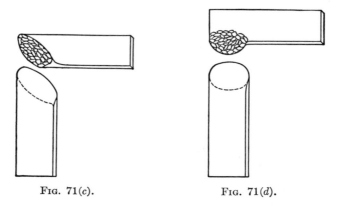

<div align="center">

Fᴵɢ. 71(c). Fᴵɢ. 71(d).

</div>

A second method of making a flat angle weld is illustrated in Fig. 71(d). The ends are upset and scarfs then formed with a ball-peen hammer. The pieces should be lapped as indicated by the dotted line.

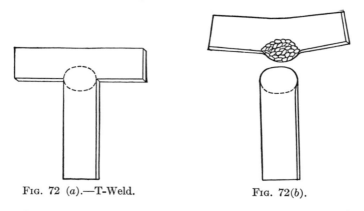

<div align="center">

Fᴵɢ. 72 (a).—T-Weld. Fᴵɢ. 72(b).

</div>

In Fig. 72(a) is shown a *T-weld*, the dotted lines indicating the proper lap before welding. The center section

of one piece is heated, the ends being cooled to confine the operation to the middle of the stock, and the piece is then placed on end upon the anvil and upset. The scarf is formed with the ball peen of the hammer, allowing the metal to bend edgewise, as shown in Fig. 72(b). This will make it more easy to confine the welding heat to the center of the stock. When welded, the T should be examined to see that the pieces are perfectly straight and at right angles to each other, and the surface should be smoothed at a dark red heat, using the flatter and sledge-hammer. In doing this the surface of the anvil must be free from scale.

42. The Cleft or Fork Weld. The fork weld is used in welding iron and steel and heavy short pieces of iron. In making this weld the iron is upset, split and drawn to

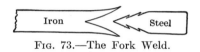

FIG. 73.—The Fork Weld.

chisel points, as shown in Fig. 73. The steel is drawn to a short chisel point and the edges of the chisel point are roughened and carved to imbed it more firmly in the iron. A red heat is applied to the iron (*do not heat the steel*) and the steel is slipped between the forks of the iron, which are then closed together before heating for welding. The joint is then heated and welded. A flux is advisable to use while welding steel to insure good results.

43. The Split Weld. The split weld is used in welding thin and wide iron, spring and tool steel, etc. The ends of the stock are first upset and then drawn to a short, sharp, flat wedge. The stock should not be spread while drawing the point, but should be slightly narrowed. The ends are then split into three or more sections, according to the width of stock, and the sections are bent up and down so that the two ends will fit into each other. Both pieces are then heated to a good red heat and the split parts are

driven together and closed down upon each other. No open space should be left between the split sections, and if any occur the joint should be placed upon its narrow edge and hammered until all spaces are closed. In heating for the welding, a reduced blast should be maintained to insure a more uniform and thorough heat, and it is wise also to turn the metal once or twice. For welding wide stock

Fig. 74.—The Split Weld.

a large fire is necessary with plenty of coke for filling in, as turning the metal will disturb the fire considerably.

44. The Fagot, Lump or Pile Weld. The *Fagot, lump* or *pile weld* consists in welding pieces on top of each other in order to form a lump or *slap*. Two or more pieces may be welded at one time and the pieces may be heated

Fig. 75.—Fagot Weld.

together. The weld should be started from the end to allow the scale to be forced out.

The fagot weld is the most simple weld, as shaping the ends is not necessary, and in most cases no upsetting is required. For these reasons it is often adopted as the first exercise in welding to familiarize the student with the operations in handling a weld. For this purpose any kind of scrap stock may be welded and finally drawn out square or flat. The weld should be tested by twisting several inches of the center section while hot. If the joints open,

the weld is not thorough, and if the corners crack the metal has been overheated. Heavy machine forgings are quite often welded and made by this method.

45. The Jump Weld. The *jump weld* is illustrated in Fig. 76. It may be made with flat and round stock, as shown, of flat and square stock, or of stock of various sections.

In making a jump weld, the flat piece is upset, as shown in section *A–A*, Fig. 76, the ends being cooled to confine the upsetting to the center. The round stock is upset

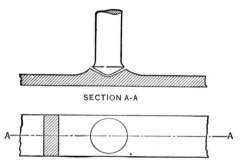

SECTION A-A

FIG. 76.—The Jump Weld.

for a short distance at the end only. The end is made convex, so that *the center of the round stock will touch the flat bar at the point for union first,* before the sides are in contact. The weld is then started and carried out from the center, forcing the scale out. This is of great importance in attaining good results, as welds of this kind are liable to be weak. If the sides of the round stock first come in contact with the sides of the marked or lowered section, the scale will be imprisoned and the weld will be weak.

While applying the welding heat, the marked side of the flat stock should be down, facing the tuyeres. A pair of tongs should be applied crosswise to the round

stock while applying the welding heat so that when the welding heat is completed, no time will be wasted in shifting the tongs to clear the top of the round stock for the hammer. When a thorough welding heat has been attained, both pieces must be removed quickly from the fire and given a jar upon the outside edge of the anvil with the scarfs projecting over the anvil, to dislodge any dirt or foreign matter that may adhere. The flat stock is then turned quickly, scarf up, and placed upon the face of the anvil, the round piece is placed and a few light, quick blows, followed by heavier, applied to the end. To complete the weld the round piece is inserted in a heading tool and placed over the tool hole of the anvil and the hammer blows applied to the opposite side of the flat piece.

The welding heat of the round stock should be confined to the end only, otherwise the stock will bend and upset, thus making welding more difficult. A skilled worker should be able to finish a weld of this type under one welding heat. If another welding heat is necessary, insert the round stock again into the heading tool after removing from the fire. The weld should finally be worked down and finished on the face of the anvil. When finished the flat stock which forms a flange and the round stock should be perfectly straight and at right angles to each other.

As stated above, jump welds are liable to be weak; therefore, where great strength is required, the round stock should be upset short at the end and then shouldered in and formed to furnish a tenon. The flat stock should be upset in the center and a hole then punched through it to receive the tenon. The tenon may then be riveted to the flat stock, thus increasing the strength of the weld.

Fig. 77 shows a type of jump weld, making a T weld of round stock. In this weld the piece marked A is first upset at the end. It is then fastened in a vise and, by the use of a fuller, the center section is lowered, thus making the end concave. The piece marked B is upset,

the ends being cooled to confine the upsetting to the center
section and form a ridge, as illustrated. Piece *A* must be
shaped in such a manner *that it will touch the top of the
ridge first,* the sides being free, in order to carry the weld
from the center outward, forcing out the scale.

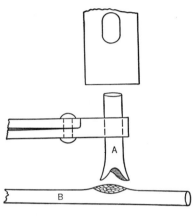

FIG. 77.

After the welding heat has been applied, the piece *B* is
placed.upon the anvil, the ridge standing up, and piece *A* is
held upright and placed in position. A few light, quick
blows upon *A* will start the weld, which may be completed
by welding the sides of the lap with a cross peen hammer.

46. The Butt Weld. The *butt weld*, Fig. 78, is somewhat

FIG. 78.—The Butt Weld.

similar to the jump weld. The ends are slightly rounded
to carry the weld from the center toward the edges, thus
forcing out the scale. After the welding heat has been
applied, the pieces are placed upon the anvil, but if round

stock is to be welded, they should be placed in a bottom swage of suitable size. The ends are driven together and the weld worked down with the bars in a horizontal position. A butt weld does not insure a strong and safe weld, consequently it should not be used if avoidable. Heavier and longer bars may be placed with the ends opposite each other in the fire and after the welding heat has been applied, the ends may be driven together, thus welding them partly in the fire. The weld is finished upon the anvil.

47. Welding Steel Plates to Iron. In preparation for welding steel plates to iron, the face of the iron that is to receive the steel should be carefully squared up. The steel plate

Steel Steel

Fig. 79.

should be made a trifle smaller than the face of the iron; this is more advantageous than if the sides of the steel plate project. The edges of the steel plate should then be cut in hot, using a sharp, hot chisel, so that the points split from the edges will stand up as shown in Fig. 79. The iron is then to be heated to a good red heat and the face to receive the steel plate cleaned with a steel brush or old file in order to remove all scale. The steel plate is placed upon the anvil with the points standing up (*the steel must not be heated* for this purpose) and the iron set vertically upon the steel. One or two well-directed blows upon the iron will now work the sharp points of the steel into the hot iron.

No time should be wasted after the iron has been properly placed upon the steel else the points will become hot and bend instead of entering the iron. To insure a well-directed blow on short stock, the flatter or set hammer should be placed on the iron and the sledge-hammer used to drive the pieces together. A few blows only should be struck or the plate will become loose, but no open space

should be left at the joint. Fig. 79 shows a steel plate properly attached and ready for the welding heat.

Steel, on account of its greater fusibility, will melt at a relatively lower temperature than iron. Since, in attaching the plate, the iron was heated, and the steel was not, if the welding heat is applied immediately they will reach their respective fusing points at about the same time. In welding steel to iron it is advisable to use a flux, such as borax or clean, sharp sand. When the welding heat has been applied, the work should be placed in an upright position upon the anvil, the steel plate up, and hammer blows applied to the

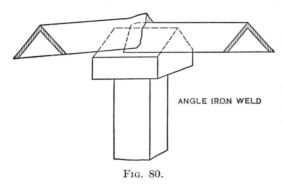

ANGLE IRON WELD

FIG. 80.

plate. The steel plate must be welded against the iron first, before any hammering on the sides is done, as this would force the steel and iron apart. *A medium carbon steel should be used for welding.*

48. Welding Angle Iron. A tool as shown in Fig. 80, made of soft steel and fitted into the anvil, will be found of great assistance in welding angle iron. When such a tool is not at hand, the weld is to be made upon the edge of the anvil.

To prepare for the weld, upset the angle iron and scarf the ends by drawing them to a short, sharp bevel. Then apply a welding heat, lap the pieces properly, and strike

first close to the ridge or center, right and left of the angle, thus welding the angle iron from the center and forcing out the scale.

49. Welding with Gas Flames. Much use is made nowadays of newer scientific discoveries and applications of new inventions in welding. Compressed gases, burning at ex-

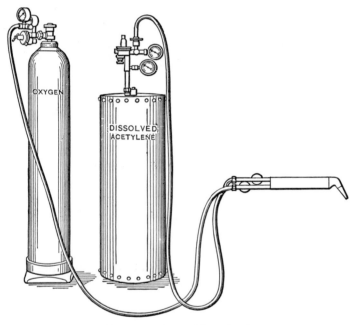

Fig. 81.—Gas-welding Outfit.

tremely high temperatures, electric currents, and chemical actions producing much heat in exothermic reactions, such as the alumino-thermic reactions, are much used.

Welding with gas flames, or so-called *autogenous welding*, is not usually performed with any pressure applied. The metal is heated by means of the flame produced by burning

a mixture of acetylene or hydrogen with oxygen, or of illuminating gas and oxygen under high pressures. The cost of equipment for the various gas-welding outfits is not very high and is soon repaid in a busy plant. The later forms are constructed with particular reference to their portability, thus increasing their usefulness both inside and outside the workshop.

The simple apparatus shown in Fig. 81 consists of two steel cylinders containing the gases under pressure. The gases are delivered by reducing valves and rubber hose to a burner or nozzle and the proper tip. Burners are made interchangeable on the same handling device, and burners and tips are provided for various kinds of work. This kind of flame is used not only for welding metals, as iron, steel, aluminum, etc., but to cut up difficult work, to cut out holes and to braze various metals together. A steel plate 1 inch thick and 30 inches long can be severed lengthwise easily in about $2\frac{1}{2}$ minutes. (*For directions, see page* 255.)

So successful has been the work done with this new cutting tool that an improvement made by a German inventor in 1915 allows its use under water. The great difficulty to be overcome was the quenching of the flame. To prevent this the ordinary burner was surrounded by a bell-shaped head and kept water-free by compressed air. Astounding results were achieved by a diver who used the apparatus in the harbor of Kiel.

50. Electric Welding. Iron is also welded by means of an electric current. The apparatus for electro-welding is so much more expensive to install than the oxyhydrogen or oxyacetylene apparatus, that only a comparatively few large establishments make use of it. But electric welding of certain forms for certain purposes is the only practicable method, and this process has opened up new lines of work.

The electric welding machine grips the two pieces of iron or steel to be joined in two clamps that are insulated from each other. The electric current of high amperage and low

voltage passes from one piece of iron to the other. At their contact point the resistance is high. This produces in a few seconds an intense heat and the softening metals are pressed toward each other until they thoroughly weld together. Electric welding is better than forge welding, for

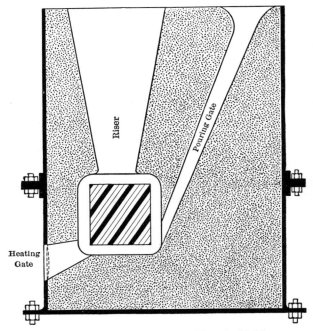

Fig. 82.—Cross-section of a Thermit Mold.

the heat is developed without any chemical action; thus *perfectly clean iron* only is left at the junction.

51. Welding by the Thermit Process. The Thermit process is the result of deep research work by Dr. Hans Goldschmidt, of Essen, Germany. *Thermit* is a mixture of finely divided aluminum and oxide of iron, which, when ignited, produces a chemical reaction, with much heat that

continues throughout the entire mass without any external supply of heat.

Regardless of the quantity of thermit in the crucible, the reaction produces a very high temperature in less than 30 seconds, thus forming a superheated liquid steel and

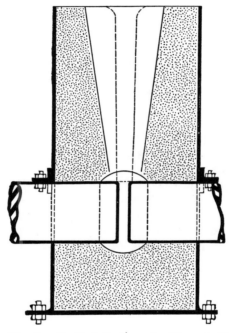

Fig. 83.—Longitudinal Section of a Thermit Mold.

slag, the molten mass attaining a temperature of about 5400° F. in the crucible. The high temperature reached in the reaction is twice as high as the melting temperature of steel, and it is evident that when the metal is poured into the mold, the two pieces of steel are welded and joined by the melted added metal, the whole forming a homogeneous mass.

Figs. 82 and 83 illustrate a typical thermit mold, showing the space left for the collar, gates and riser. When a shaft is to be welded, a wax collar is formed around the broken section, and a sheet-iron mold is placed around it. The mold is packed with highly refractory molding sand, space being left for a preheating gate, a pouring gate and a riser. Space must be left between the two pieces to be welded sufficient not only to allow the metal to enter, but also to melt the metal thoroughly between as well as outside of the joint. The wax collar is then melted out by the flame of a compressed-air gasoline or gas torch applied through the heating gate.

After the mold has thoroughly dried, a thermit crucible is erected over the mold and the charge is ignited. The crucible is tapped at the bottom to insure having the pure metal run first, as the slag will rise to the surface of the molten metal.

The thermit process is, for the metal worker, one of the most interesting accomplishments of modern times. It is used very much in welding railroad tracks, for repairs on ocean steamships, for breaks in complicated machinery, and for repairing or joining shafting. Cast iron, wrought iron and steel all weld by this process without injuring the stock at the point of juncture.

CHAPTER VII

FORGING EXERCISES

THE method of forging a bolt from solid stock is given in Exercise 8. A method more generally followed is to form the head by welding a collar about round stock as given in Exercise 11.

Exercise 11. Forged Bolt with Welded Head

Stock: $\frac{5}{8}$ inch round for the shank; $\frac{5}{8}'' \times \frac{1}{4}''$ flat for the collar.
Operations: Upsetting, bending, welding and forming.

Length of Stock. The length of round stock required is the over-all length of the bolt. To find the length of stock necessary for the collar, add to the diameter of the stock for the shank one thickness of the stock used for 'the collar ($\frac{1}{4}$ inch) and multiply by $\frac{22}{7}$.

$$\tfrac{5}{8}'' + \tfrac{1}{4}'' = \tfrac{7}{8}''.$$

$$\tfrac{7}{8}'' \times \tfrac{22}{7} = 2.75''.$$

The length of stock for the collar is therefore $2\frac{3}{4}$ inches.

The collar should always be made a trifle smaller, but after the round stock is slightly upset, $2\frac{3}{4}$ inches will be the correct length.

Forging. Heat the piece of round stock, square up one end and form a $\frac{1}{8}$-inch bevel. Heat the other end and upset slightly for 1 inch of length, as shown in Fig. 84.

Lay off $2\frac{3}{4}$ inches on the stock for the collar, cut in on the hardie and bend the piece to fit around the upsetted end of the shank. Break the piece off from the bar, slip it over the upsetted end of the shank and close in by hammering the straight sides down

on top of the anvil across the tool hole, or at the neck of the
horn, using the hammer at an angle of 45° against the shoulder
of the anvil, so that the collar will not slip while being closed up.
A bottom swage of suitable size also may be used for this purpose.

In hammering the collar down see that the ends come fairly
close together, as shown in Fig. 84. Avoid hammering too much,
as the collar will stretch and become loose. Have the round stock
project a trifle beyond the collar, as illustrated in the figure, to
provide for a smooth finish on the head.

Apply a welding heat to the end with the collar, heating slowly
and thoroughly; avoid overheating the collar while the round
stock is not at the fusing point. It is more advantageous to

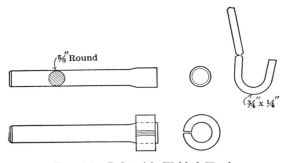

Fig. 84.—Bolt with Welded Head.

heat the round stock to a good red heat, and the collar to a black
heat only, for bending the collar around. The round stock being
thus heated to a higher temperature than the collar before the
welding heat, will reach the fusing point at about the same time, if
the heat is applied immediately after the collar has been closed up.

Weld upon the face of the anvil, taking care while delivering
the first few blows to have the joint of the collar to the right or
left and turning the work while welding. In this manner the scale
between the collar and round stock is forced out and the weld will
be more complete. If the first few blows are delivered upon the
joint, the collar will be forced open, thus making welding more
difficult and the finished head off center. The first few blows
should be light and rapid, the succeeding blows heavier.

Insert the shank into a heading tool and continue welding on top of the tool hole, which will receive the section of shank projecting through the heading tool.

To form and finish the head it will be necessary to reheat several times. If the shank is rough, smooth in a $\frac{5}{8}$-inch top and bottom swage.

A blank $\frac{5}{8}$-inch nut may be used for the collar if desired. Split the nut open on one side, slip it over the upsetted end of the shank and weld as just explained. In making square-headed bolts use the same method for welding and upsetting.

In factories bolts are headed by special machinery. The bars of stock are heated in a furnace and headed by two or three operations which follow in rapid succession.

Exercise 12. Beam Anchor

Operations: Drawing, bending, welding and twisting.

Cut off a 9-inch piece of $\frac{3}{4}$-inch round stock and a 22-inch piece from $1\frac{1}{2}'' \times \frac{3}{8}''$ stock. Lay off $5\frac{1}{2}$ inches from one end on the

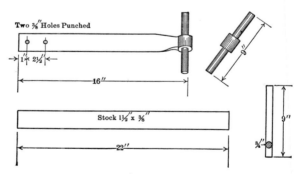

Fig. 85(*a*).—Beam Anchor.

flat stock, apply a good forging heat from the end to the center punch mark, and draw the end to a short, flat point. Bend the end down at the center punch mark over the outside edge of the anvil, striking over the edge of the anvil, as shown in Fig. 85(*b*).

Reverse the work and bend the eye over the horn, close it in on the outside edge of the anvil, and slip a $\frac{3}{4}$-inch drift pin through the hole. The right side of the hammer should be vertical with the outside edge of the anvil in striking, as shown in Fig. 85(c), and the eye should be closed until there is no open

Fig. 85(b).

space between the end and the stock before applying the welding heat.

Remove the drift pin, apply a welding heat and weld the eye joint upon the face of the anvil. Drive the piece of $\frac{3}{4}$-inch round stock 9 inches in length, which was previously cut off, into the eye.

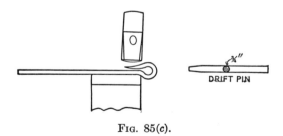

Fig. 85(c).

This must be done while the eye is hot, in order that on cooling it may shrink until tight around the pin.

Fasten the work in a vise, allowing 2 or 3 inches between the eye and the vise, and twist right or left to an angle of about 45° as illustrated in Fig. 85(d). Punch or drill two $\frac{3}{8}$-inch holes for $\frac{5}{16}$-inch anchor nails, as indicated.

Hook anchors, Fig. 86, are made in the same manner. They are nailed on top of the timber beams, the end being hooked over the last beam. The measurements for these anchors should be taken at the building.

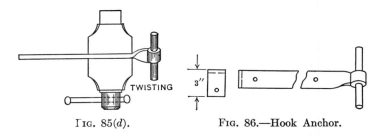

FIG. 85(*d*).　　　　　　　FIG. 86.—Hook Anchor.

Exercise 13.　Dogs

Stock: Flat iron 12 inches long, $1\frac{1}{8}''\times\frac{3}{8}''$ section. *Operations:* Pointing, shouldering and bending. Draw the extreme point

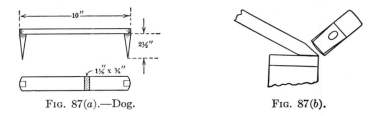

FIG. 87(*a*).—Dog.　　　　　　　FIG. 87(*b*).

at each end of the piece on the outside edge of the anvil, as shown in Fig. 87(*b*).

Make a proper allowance for the point and shoulder in on the inside edge of the anvil, as in Fig. 87(*c*). The left side of the hammer must be directly above the inside edge of the anvil.

Bend the point in a right angle over the outside edge of the anvil,

FIG. 87(*c*).

striking over the anvil. Use a square shank heading tool which fits into the anvil and work the angle down, as illustrated in Fig. 87(d).

A skilled worker will finish one side under one heat.

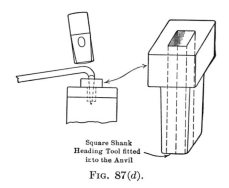

Square Shank
Heading Tool fitted
into the Anvil

Fig. 87(d).

Exercise 14. Welded Flat Ring or Washer

Stock: To make a ring washer of 3 inches inside diameter $1'' \times \frac{1}{4}''$ flat stock $12\frac{3}{4}$ inches is required. *Operations:* Upsetting, scarfing, bending and welding.

Length of Stock. The method of computing the stock for a ring is given in section 36, page 57.

Forging. Heat the ends short for upsetting, to confine the operations to the end. If the metal is heated too long, it will bend, and this will make upsetting more difficult. Place the work, heated end up, upon the neck of the horn at an angle of about 45°, against the shoulder of the anvil, as in Fig. 88(b), and hammer down to upset the metal. Shorten the metal $\frac{3}{4}$ inch on each end. While upsetting apply your tongs about 2 inches from the top, as shown. The reins or handles of the tongs should stand up slightly, as this will protect the hand from the falling scale.

After both sides have been upset, heat and scarf the ends, as in Figs. 88(c) and (d). In making the scarf, upset in *thickness only, do not widen,* but narrow the stock in width a trifle. This is because welding the metal will tend to spread it.

Heat one end for a third of the length, applying a uniform heat. Commence bending at the *extreme* end, striking *over*

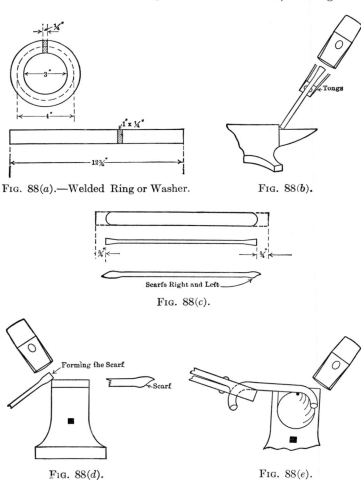

FIG. 88(a).—Welded Ring or Washer.

FIG. 88(b).

FIG. 88(c).

FIG. 88(d).

FIG. 88(e).

the horn, as shown in Fig. 88(e), in order to obtain a true curve.

While bending, apply the tongs in such a manner that the joint of the tongs will prevent the work from being struck out. The tip or *outside corner* may be cooled quickly before any bending is done, in order to avoid disfigurement of the scarf. Repeat the same operation on the other end. Heat the center section and finish bending partly over the horn and partly on the face of the anvil, as shown in Fig. 88(*f*).

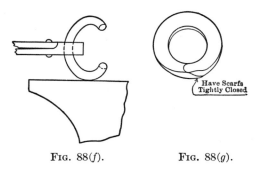

Fig. 88(*f*). Fig. 88(*g*).

Fig. 88(*g*) shows the ring washer properly closed. There should be no open space in the joint before applying the welding heat. Weld upon the face of the anvil and upon the horn, after which the washer must be drawn to size.

Apply a uniform heat and true up the curve on the horn. Use a flatter and sledge to smooth the surface at a black heat. When finished, the washer must be uniform in thickness and in width.

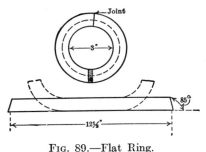

Fig. 89.—Flat Ring.

Exercise 15. Flat Ring

Stock: $1'' \times \frac{1}{4}''$, $12\frac{1}{2}$ inches in length. No allowance for waste or hammering. *Operations:* Bending.

Fig. 89 shows a flatring properly jointed. Cut the ends at an angle of 85°. Heat one of the ends for one-third the length of

the piece, and cool the tip or outside corner. Follow the instructions given for the previous exercise.

Exercise 16. Flat Band

The same principles will apply to this exercise as given for Exercise 14. There is only one exception in this exercise and that is that the stock is bent flat instead of with the narrow edge up.

Fig. 90 shows the band properly jointed and ready for welding. Weld upon the horn first and finish welding upon the face of the anvil.

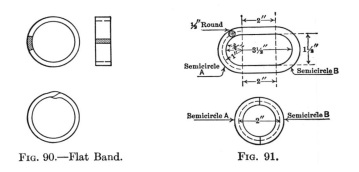

FIG. 90.—Flat Band. FIG. 91.

Exercise 17. Links of Chain

Stock: $\frac{3}{8}$ inch round. Size of the links $3\frac{1}{4}''\times1\frac{5}{8}''$ outside measurement. *Operations:* Bending and welding.

Length of Stock. A chain link may be divided into sections of two straight and two semicircular parts, as in Fig. 91, for ease in calculating the length of stock required. Assuming the dimensions given in the figure, we then have,

$1\frac{1}{2}''$ (inside diameter)$+\frac{1}{2}''=2''$, the calculating diameter.

$2''\times\frac{22}{7}=6.28$ inches, length of stock required for both semicircles.

Total length of stock required $=2''+2''$ (for the straight sections)$+6.28''$ (for the semicircles) $=10.28''$.

With a small allowance for welding, the correct length may be assumed as $10\frac{1}{2}$ inches.

Forging. For the size of link in this exercise, cut off three pieces of stock $7\frac{1}{4}$ inches long. Use a pair of link tongs in handling

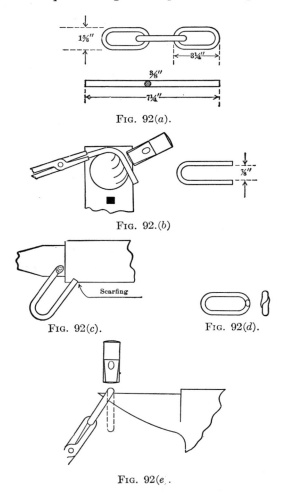

Fig. 92(*a*).

Fig. 92.(*b*)

Scarfing

Fig. 92(*c*). Fig. 92(*d*).

Fig. 92(*e*).

the work, apply a uniform heat to the center section of each piece and bend it over the horn, striking over the horn to avoid reducing

or flattening the stock, as illustrated in Fig. 92(b). Scarf on the edge of the anvil: one side must be scarfed to the right, and the other side must be scarfed to the left as shown in Fig. 92(c).

In Fig. 92(d) is shown a link properly jointed ready for welding. The joint should be closed. This can be accomplished by a few light blows without flattening the stock much at the joint. In welding, build a high, narrow fire, and follow the instructions for welding given in Chapter VI. Weld upon the face of the anvil, striking a few quick, light blows. Finish up the work on the horn, as shown in Fig. 92(e).

To round off the weld, raise the link from an upright position to an angle of about 45°. Working in this position, the horn will round the inside edges of the link, while the hammer will round the outside edges.

The entire link must be heated uniformly. True up the curves on the horn and see that center sections are straight and parallel to each other. Weld two links in this manner, and bend and scarf the third one. Then slip the two finished links into the third one, close in the third link and weld it as previously explained.

All cables and other heavy chains are hand made, but the smaller sizes are made by machines. A long bar is bent cold around a mandrel which is oval in shape. After bending, the bar resembles a spiral spring with its coils elliptical and not round. A special cutting machine cuts the spirals into parts equal in number to the number of coils. The machine spreads each of these sections a little at the opening, at the same time, and then cuts a bevel or a scarf on the ends. The ends are then lapped, and all that is now required is the welding together of the scarfed ends. The chainmaker uses a small power hammer, and heats the links in a forge at his side. When a hot link is taken from the fire, a cold link is put in. With a few quick blows, he welds the links together. He then opens the ends of a new link, and hooks it into the finished one. This he continues until the required length is obtained.

Exercise 18. Soldering Iron

Stock: 15 inches of $\frac{5}{16}$-inch square iron, and $2\frac{1}{2}$ inches of $1\frac{1}{4}$-inch square copper. *Operations:* Drawing, bending, welding, pointing and shouldering.

Lay off 4 inches from one end of the iron stock and draw the

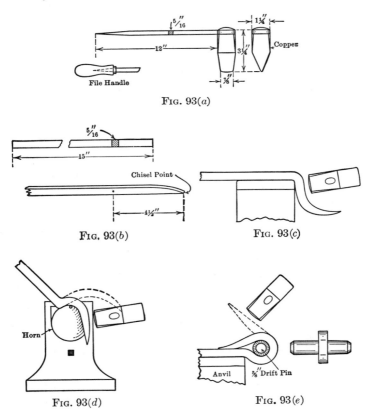

FIG. 93(*a*)

FIG. 93(*b*)

FIG. 93(*c*)

FIG. 93(*d*)

FIG. 93(*e*)

end to a chisel point, as illustrated in Fig. 93(*b*). Heat the piece and bend it at the center punch mark, over the outside edge of the anvil; strike over the anvil, as in Fig. 93(*c*).

Reverse the work, place it on top of the horn and bend the end

down over the horn, as shown in Fig. 93(d), in order to form
the eye. Close the eye on the edge of the anvil, and slip a ⅝-inch

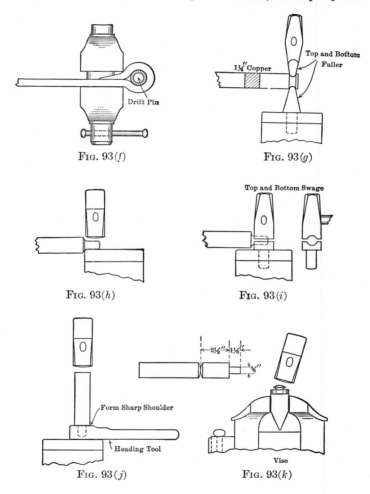

Fig. 93(f)

Fig. 93(g)

Fig. 93(h)

Fig. 93(i)

Fig. 93(j)

Fig. 93(k)

drift pin through the hole, thus truing up the eye, Fig. 93(e).
Fasten the work in the vise in such a manner that the corner

of the vise will force the metal around the pin, as illustrated in Fig. 93(f).

Remove the pin and see that the joint is tightly closed before applying the welding heat. Weld the joint and use the drift pin once more to true up the eye. Heat the other end of the piece and draw it to a nail point ready to receive the wooden handle.

In shaping the copper, great care must be taken not to overheat it, as the melting point for copper is much lower than for iron. Apply a dark red heat to the end of the copper bar. Use a top and bottom fuller, and fuller in the piece short at the end to a $\frac{5}{8}$-inch round, as shown in Fig. 93(g). Form a tenon upon the inside edge of the anvil, as illustrated in Fig. 93(h). Notice the proper position of the hammer in this operation. Finish the tenon in a $\frac{5}{8}$-inch top and bottom swage, as in Fig. 93(i). Heat the end, slip the tenon into a $\frac{5}{8}$-inch heading tool, and hammer down to form a sharp shoulder, as shown in 93(j).

Allow $1\frac{1}{8}$ inch for the tenon, and cut off the extra stock. Cut off $2\frac{1}{2}$ inches from the shoulder of tenon (see dimensions in Fig. 93(k)), heat the piece and draw the end to a chisel point $\frac{7}{8}$ inch wide. Heat the tenon of the finished soldering iron, fasten the piece in the vise, and slip the eye of the handle over it. Rivet on the handle. While riveting, hammer down with straight blows and finish by hammering down the edges, thus forming a round head, as shown in Fig. 93(k).

See that the work is straight and central.

Exercise 19. Straight, Square-point Soldering Iron

Stock: $\frac{3}{8}$-inch round iron; $1\frac{1}{4}$-inch square copper. *Operations:* Welding, bending and drawing.

Use two short pieces of $\frac{3}{8}$-inch round stock. Weld them at the end and scarf. Upset and scarf another piece of $\frac{3}{8}$-inch round stock 11 inches long and weld it to the two pieces already welded together, as shown in Fig. 94(b).

Heat the piece and open up the ends, fasten the work in the vise, bending one end to the right and the other to the left near the weld, as in Fig. 94(c). Bend the ends parallel, and forklike, over the horn, as i ι Fig. 94(d), making proper allowance between. Use $\frac{5}{8}$-inch flat or square stock and slip between the fork, ham-

mering down carefully in order to prevent disfigurement of the stock.

Cut off the extra stock. Then using a $\frac{5}{8}$-inch square pin, bend the ends over, as shown in Fig. 94(e). Draw the opposite end of the piece to a nail point ready to receive the handle.

Apply a *dark red heat* to the end of the copper bar, and draw the metal to a short nail point. Measure off $3\frac{1}{4}$ inches of stock from the point and cut it from the bar. In cutting off the piece from the bar use sharp, hot chisel. Square up the end and fuller in lengthwise 1 inch from th square end, using a $\frac{3}{8}$-inch top and bottom fuller. The depressions thus formed are to receive the fork. Drill a $\frac{3}{8}$-inch hole $\frac{13}{16}$ inch from the end in the groove so as to meet the opposite side of the groove which is to receive the prongs. Heat the fork and open the prongs as much as is necessary to slip the copper between, then ham er down or use the vise to force the prongs of the fork tightly into the hole and grooves of

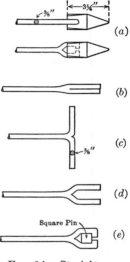

FIG. 94.—Straight Soldering Iron.

the soldering iron. Apply another dark red heat to finish the sides, as in Fig. 94(a), making a bevel on the corners.

See that the work is straight and central.

Exercise 20. Spanner Wrench

Stock: 7 inches of $1'' \times \frac{1}{4}''$ open hearth or soft steel. *Operations:* Bending, drawing and formi g.

Lay off $2\frac{1}{2}$ inches from one end of the piece and mark with a center punch on the wide side of the stock.

For this exercise use a pair of clips or box tongs. If these tongs are not available, use a pair of common blacksmith tongs, but slip the end of the piece through so that it may rest against

the joint of the tongs to give a firmer hold. Care should be taken in bending flat stock the narrow edge up, to prevent the metal from being struck out of the tongs.

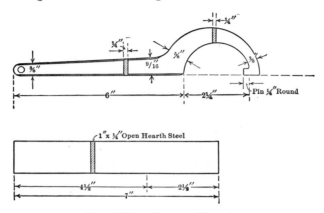

FIG. 95(*a*).—Spanner Wrench.

Apply a good forging heat to the piece and bend it over the outside edge of the anvil or over the horn to an angle of about 90°, as in Fig. 95(*b*). Strike the metal over the anvil or horn

FIG. 95(*b*).

while bending in order to avoid reducing the stock at the corner.

Reverse the stock, placing it upon the horn in such a manner that the corner will stay inside of the horn, as in Fig. 95(*c*), and *not directly upon it.* Draw and form one-half of the curve and keep the remainder of stock parallel with the handle, until drawn to proper dimensions, Fig. 95(*d*). Bend the entire curve over the horn, cutting off the extra stock, as in Fig. 95(*e*).

Form the pin on the inside edge of the anvil, shouldering in from the *outside* end of the spanner wrench, as illustrated in Fig.

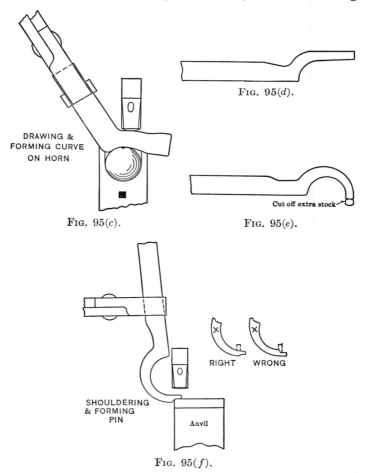

DRAWING & FORMING CURVE ON HORN

FIG. 95(c).

FIG. 95(d).

Cut off extra stock

FIG. 95(e).

RIGHT WRONG

SHOULDERING & FORMING PIN

Anvil

FIG. 95(f).

95(f). The figures marked *xx* explain this fully. If the wrench is shouldered in from the inside, a joint will be left which will weaken the pin. Form the pin $\frac{1}{4}$ inch round and $\frac{1}{4}$ inch long,

heat it and bend around the edge of the hardie, as shown in Fig.
95(g). This is more convenient than bending over the edge of
the anvil or horn. The bending may be confined to the end by
cooling the remainder of the curve, leaving the point hot. In

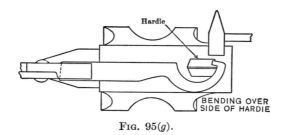

Fig. 95(g).

this manner it can be worked upon the face of the anvil without
the use of the hardie, the horn, or edge of the anvil. The curve
will not be changed by this method.

Use a piece of pipe or round stock of the size and diameter

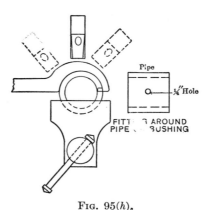

Fig. 95(h).

that the spanner wrench is to fit, and drill a $\frac{1}{4}$-inch hole in the
metal or pipe. This hole is to be used for the pin entrance. The
circular part of the pipe or round stock is to be used as a form
for the spanner wrench curve. Fasten the form in a vise, apply

a red heat to the wrench and fit the curve about the pipe, striking a few light blows, as shown in Fig. 95(h).

Draw the handle to the dimensions given, partly on the horn as illustrated in Fig. 95(i), as it is more effective to do so. While drawing lengthwise, commence at the curve. Cut off the extra

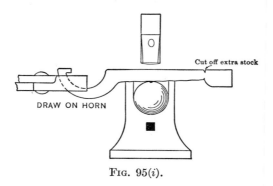

Cut off extra stock

DRAW ON HORN

FIG. 95(i).

stock on the hardie and smooth up the sides upon the face of the anvil. Round off the edges of the handle in a top and bottom swage, as in Fig. 95(j).

Examine the work carefully, being sure that all measurements are correct, that the work is straight and that the bottom side of

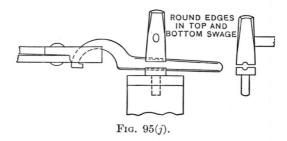

ROUND EDGES
IN TOP AND
BOTTOM SWAGE

FIG. 95(j).

the handle is in line with the bottom side of the pin. There are many varieties of spanner wrenches, and many different designs. They are used on lathes and drill presses to fasten drills or cutters into chucks and to remove the same.

Spanner wrenches are usually case-hardened (see page 144) and are often made by drop forging in factories where large quantities are turned out.

Exercise 21. Chain Hook

Stock: 5 inches of $1'' \times \frac{1}{2}''$ open-hearth or Bessemer steel. *Operations:* Fullering, forming, punching, drawing, bending and chamfering.

Lay off $1\frac{1}{4}$ inches from one end of the piece for the eye and mark with a center punch. Heat the piece and fuller in the metal, the narrow edge up, $\frac{1}{4}$ inch on the top and bottom, using a $\frac{5}{8}$-inch top and bottom fuller, as illustrated in Fig. 96(b).

Round up on the outside edge of the anvil or on the horn, holding the metal up and using the hammer horizontally, as illustrated in Fig. 96(c), while forming the eye, thus preventing the bending back or forth of the section fullered in and avoiding a crack or the breaking of the metal. The eye is formed partly on the edge and partly upon the face of the anvil. Draw the metal in back of the eye at first square, then form it octagonally and finally round, as shown in 96(d).

Heat the end and punch the hole in the center of the eye, using a $\frac{3}{8}$-inch blacksmith's punch. Care must be taken to start the punch in the center of the eye; punch marks which result from not placing the punch properly, and holes that have been punched out of center are very difficult even for highly skilled workers to obliterate. The punch should be slightly tapered toward the end to prevent it from sticking. (For directions for punching heavy stock, see page 185.) Drive the punch more than half way through, as in Fig. 96(e), then remove the punch and cool it in water. Turn the work over and repeat the operation from the other side. After the punch has been started from the other side, place the work over the pritchel hole of the anvil and drive out the burr. Drive the punch far enough through to make the hole $\frac{1}{2}$ inch in diameter.

The method of rounding the edges of the eye is illustrated in Fig. 96(f). Slip the eye over the end of the horn and hold the work at an angle of about 45° with the top line of the horn; turn the work and hammer down.

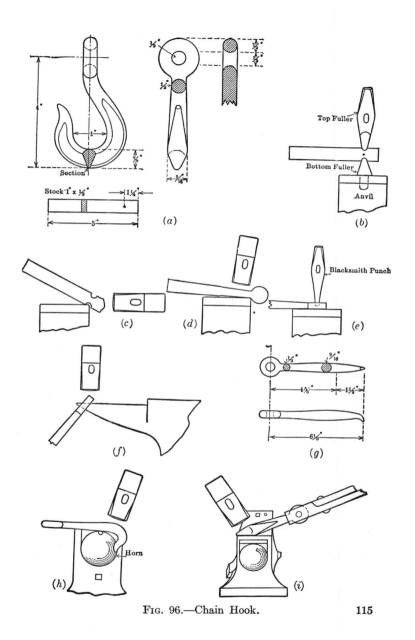

Fig. 96.—Chain Hook.

115

NOTE. Chain hooks used in connection with cables or chains should have round edges to prevent shearing. On the other hand, if the chain hook is connected by means of bolts or rivets, the hole through the eye should be left straight and with the edges sharp.

Draw the body of the hook to the dimensions given in Fig. 96(g) and cut off any extra stock on the hardie. Bend the end short over the horn to form the lip, turn the work and commence bending, striking over the horn, as illustrated in Fig. 96(h). Heat and bend in the opposite direction near the eye, as shown in (a).

Note that while bending the curve of the hook it should be bent to an inside diameter of $1\frac{1}{2}$ inches.

The forming of the bevel, which is known as chamfering, is illustrated in Fig. 96(i). This is accomplished by placing the work near the edge of the anvil and holding it up while striking from the proper angle. Caution should be exercised not to flatten the center section, but to form the bevel on the edge only. In forming the bevel, the outside edge of the curve of the hook will become longer, due to the hammer blows, hence the curve will be partly closed. When the chamfer is finished the inside diameter of the hook should be 1 inch.

Examine the work carefully and make sure that the measure· ments are correct and that the work is straight and central. A straight line drawn from the center of the eye should meet the center of the curve, as illustrated in Fig. 96(a). The eye of the hook should be at a right angle to the curve; if not the curve is twisted. To remedy this, heat the round section near the eye, and using two pairs of tongs or fastening the eye in·a vise, twist either to the right or to the left as required. If corrected at the round section, the twist cannot be seen, while correction by twisting at the chamfered section would show and would more or less affect the lines or appearance of the hook.

Exercise 22. Chain Hook with Swivel

Stock: $5\frac{3}{4}$ inches of $\frac{5}{8}$ inch round for the hook, 4 inches of $\frac{7}{8}''\times\frac{3}{8}''$ for the swivel. *Operations:* As in Exercise 21.

Upset the end of round stock in the vise, as illustrated in Fig. 97(b) to dimensions given in Fig. 97(c).

Fuller in, using a top and bottom fuller, in the center of the

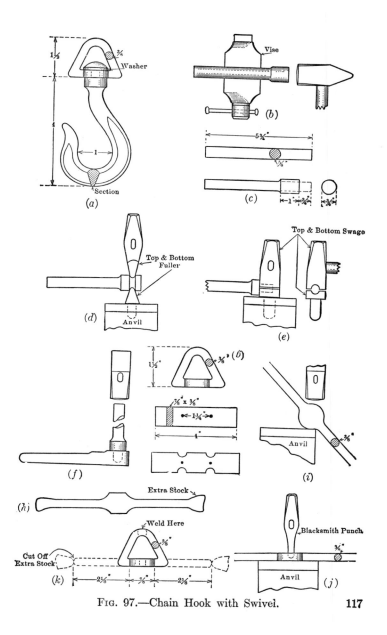

FIG. 97.—Chain Hook with Swivel.

117

upsetted end, as in Fig. 97(d). Draw the tenon on the edge of the anvil and finish rounding up the tenon in a $\frac{9}{16}$-inch top and bottom swage, as shown in Fig. 97(e). Form a sharp shoulder on the tenon in a heading tool, as shown in Fig. 97(f).

In drawing, bending and chamfering the hook, follow the directions for Exercise 21.

In making the swivel, Fig. 97(g), lay off $1\frac{1}{4}$ inches in the center of the piece and mark with center punch, as shown in the figure. Fuller in, using a $\frac{5}{8}$-inch top and bottom fuller, draw the ends of the piece upon the horn and upon the face of the anvil, as in Fig. 97(h), and finish rounding up the ends in a $\frac{3}{8}$-inch top and bottom swage.

Form the eye on the inside and the outside edges of the anvil, as illustrated in Fig. 97(i). Punch the hole in the center of the eye more than half way through from one side, turn the work over and repeat the same process on the other side, using a blacksmith's punch, as in Fig. 97(j). Place the work over the round or tool hole and drive out the burr. Cut off any extra stock and bend, scarf and lap the ends of the piece, as shown in Fig. 97(k).

There should be no open space between the faces in the joint before applying the welding heat. Weld the swivel partly upon the face of the anvil and partly upon the end of the horn.

Cut off any extra stock on the tenon of the hook, making proper allowance for the washer and head, and grind the end of the tenon square, thus making it more easy to draw the rivet straight. Heat *the tenon only,* fasten the hook in a vise, slip the swivel and washer over the tenon and rivet, rounding up the head. While riveting, turn the swivel and follow around with the hammer. The swivel should turn easily on the tenon when finished.

Exercise 23. Engineer's Wrench

Stock: $2'' \times \frac{1}{2}''$ open hearth or Bessemer steel. *Operations:* Fullering, forming, drawing, punching and shouldering.

Lay off $2\frac{1}{4}$ inches from the end of the stock and mark with a center punch. Heat the end and fuller in $\frac{1}{4}$ inch as illustrated in Fig. 98(b). Form the end round partly on the outside edge and partly upon the face of the anvil, as in Fig. 98(c).

Draw in the stock back of the eye, as shown in Fig. 98 (d), then punch a hole through the eye, using a $\frac{5}{8}$-inch blacksmith's punch, as explained in the previous exercise.

Clamp the piece in the vise and cut out the opening, hot, at an angle of 15° with the handle, using a long, sharp chisel, as shown in Fig. 98(f).

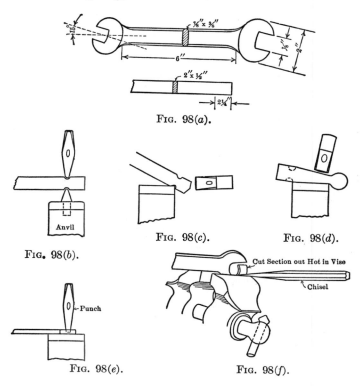

FIG. 98(a).

FIG. 98(b).

FIG. 98(c).

FIG. 98(d).

FIG. 98(e).

FIG. 98(f).

Form the shoulder back of the head on the sharp outside edge of the anvil, using the set hammer, as in Fig. 98(g). Care must be taken to place the work properly upon the anvil and the set hammer upon the work, to form a true curve. The right side of the set hammer must be perpendicular with the outside edge of the anvil.

Draw the stock back of the head to $\frac{7}{8}''\times\frac{3}{8}''\times5\frac{1}{2}''$ long and allow $2\frac{1}{4}$ inches more of the stock for the head on the opposite end. Cut off the stock and form and finish the other end in the manner just described. Finish the handle in the $\frac{1}{2}$-inch top and bottom swage, as shown in Fig. 98(h), and smooth off the sides with the flatter.

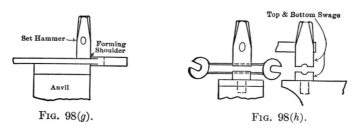

FIG. 98(g). FIG. 98(h).

NOTE. The handle is drawn $\frac{1}{2}$ inch less in length than required for the finished wrench, as rounding off the handle in the top and bottom swage and smoothing the sides by using the flatter will further lengthen the metal, so that when the handle is finished, it should be 6 inches in length.

Case-harden the head by using cyanide of potassium. (See page 144). In factories wrenches are made by drop forging and case-hardened in special furnaces.

Exercise 24. Blacksmith's Tongs

Stock: $\frac{7}{8}$ inch square. *Operations:* Shouldering, drawing, forming, grooving, punching and riveting.

Lay off $1\frac{1}{4}$ inches from one end of the stock and mark with the center punch. Apply a good forging heat to the end, shoulder in on the edge of the anvil, striking overhanging blows, as illustrated in Fig. 99(b), and taper to $\frac{1}{2}''\times\frac{3}{8}''\times1''$ at the end.

Turn the work to the left, place it upon the outside edge of the anvil in such a manner that the shoulder will project $\frac{1}{8}$ inch over the edge of the anvil, as in Fig. 99(c), and work the 'piece down with overhanging blows by holding the work horizontally and at an angle of about 45° to the left. Spread the metal to $1\frac{1}{4}''\times\frac{1}{2}''$.

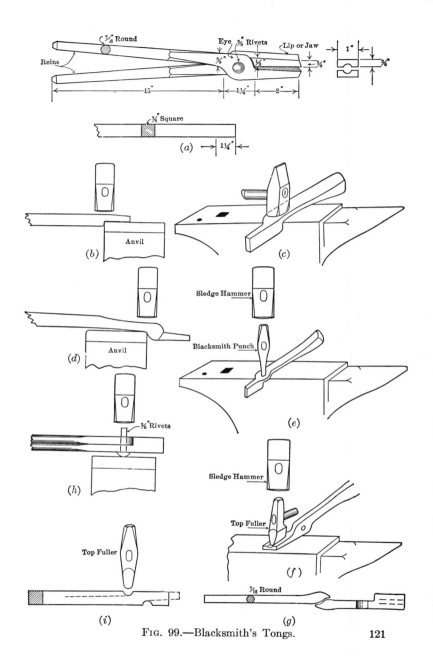

FIG. 99.—Blacksmith's Tongs.

121

Allow $1\frac{1}{4}$ inches from the first shoulder, turn the piece again to the left and form a third shoulder, on the opposite side to the first, on the outside, round edge of the anvil. Do this with overhanging blows, which will keep the top straight, thus forming a depression on the bottom only, as in Fig. 99(d).

The thickness of the metal on the third shoulder when finished should be $\frac{5}{8}''\times\frac{1}{2}''$. Form the section where the eye will be punched round partly upon the round edge of the anvil and on the horn, and partly upon the face of the anvil. Notice the dimensions given on each side of the eye, as these are the weakest places in a pair of blacksmith's tongs. At these places the metal should be heavier (reinforced as illustrated) and tapered toward the ends.

Punch the hole through the center of the eye, using a $\frac{5}{16}$-inch blacksmith punch and sledge-hammer. Place the work upon the anvil as illustrated in Fig. 99(e) with the shoulder *pointing down.* If the hole is started from the opposite side, it is necessary to block up the work by using a nut or bushing in order to keep the work straight while driving out the burr, as the shoulder will interfere. Drive the punch half way through, turn the work over and repeat the process from the other side. Place the work over the pritchel or round hole in the anvil and drive the punch through to force the burr out. In making a $\frac{3}{8}$-inch hole, use a $\frac{5}{16}$-inch blacksmith's punch. To remove the punch raise the work a few inches and strike upon the face of the anvil in such a manner that the punch projecting through the work will hit the anvil squarely. The punch being tapered toward the end is removed in this manner without any difficulty.

Cool the punch in water, but *do not cool it too quickly* or it will harden and, therefore, crack when used.

In making the grooves in the lips or jaws, use a $\frac{3}{8}$-inch top fuller, as in Fig. 99(f). These grooves insure a good hold for round and square, as well as flat stock.

The opposite side of the tongs is forged in the same way. The pieces must be alike, so that when one side is reversed they will be right and left. The stock is usually cut off long enough to make both pieces of the tongs from the same bar, as it is more convenient to handle a longer piece.

After each side has been finished, cut off in the center, using

a hot chisel and sledge, and draw out the heavy ends for the reins roughly with a power hammer.

Continue forming the reins upon the anvil and finish in a $\frac{1}{2}$-inch top and bottom swage. Care must be taken that all dimensions correspond. In shops where no power hammers are at hand, make less allowance for the reins. Draw the section for the reins to $\frac{5}{8}'' \times \frac{1}{2}''$ and 4 inches long and form the scarf on the *wide* side, as shown in Fig. 99(g). This will make a stronger weld because the strain upon the reins or handles is on the narrow side.

Cut off two pieces of $\frac{7}{16}$-inch round stock, upset one end, scarf and weld to the finished parts. Four to 5 inches from the eye should remain flat and slightly tapered toward the round end. Chamfer the edges, increasing the chamfer more toward the round end. Straighten the reins and place the parts together to see if they fit.

In riveting, put the parts together, slip the rivet through cold and hammer down, as shown in Fig. 99(h), thus upsetting the end of the rivet to keep the parts together temporarily. Heat the tongs, applying a uniform heat for the final riveting, and be careful to keep the rivet straight. Finish the riveting by chamfering or beveling the end of the rivet, thus forming a round head. Adjust the tongs while hot to hold $\frac{1}{4}$-inch flat stock. They should fit firmly and be parallel the entire length of the jaws. Move the handles forward and backward in order to have them work freely. When finished, the tongs should be straight and central, with about 1 inch space between the reins.

In Fig. 99(i) is illustrated another method of forming the shoulders with the help of a top fuller. This method is usually adopted by the skilled worker. Students have a tendency to use the fuller too much, thus weakening the tongs. Since time will not be saved by the use of the fuller the first method is recommended as more practicable with beginning classes. A skilled worker will finish one side of the tongs illustrated, except drawing the handle, under one heat, including punching and grooving.

A variety of tongs are used in blacksmith shops, but they are made in a manner similar to that just described.

Small tongs are usually made of flat stock. If no square stock for heavier tongs can be obtained, round iron will serve the purpose.

PROBLEMS

1. Compute (see Fig. 84) the necessary length of stock for the collar of a welded bolt head. Stock for the shank 1 inch round, for the collar use $1'' \times \frac{3}{8}''$ flat.

2. Compute (see section 36 page 57, and Fig. 56) the length of stock required to make a welded ring washer of $6\frac{1}{2}$ inches *inside* diameter. Stock to be used $1\frac{3}{4}'' \times \frac{1}{2}''$ flat. Allow one thickness for welding.

3. Compute (see section 36, page 57, Figs. 56 and 90) the length of stock required to make one band ring of $8\frac{3}{8}$ inches *inside* diameter. Stock to be used $1\frac{1}{4}'' \times \frac{3}{16}''$ flat.

4. Compute (see page 103 and Fig. 91) the length of stock required to make one link of chain $3\frac{1}{2}'' \times 2''$ *outside* dimensions. Stock to be used $\frac{3}{8}$ inch round.

5. Compute (see page 103 and Fig. 91) the length of stock required to make one link of chain $4'' \times 2''$ *inside* dimensions. Stock to be used $\frac{5}{8}$ inch round.

6. Compute (see page 103 and Fig. 91) the necessary length of stock to make one link of chain, the link to be of $5\frac{1}{2}$ inches *outside* by $2\frac{1}{4}$ inches *inside* dimensions. Stock to be used $\frac{3}{4}$ inch round.

7. Compute (see page 103 and Fig. 91) the necessary length of stock to make one link of chain, the link to be of 5-inch *inside* by $4\frac{1}{2}$-inch *outside* dimensions. Stock to be used 1 inch round.

8. Compute (see page 103 and Fig. 91) the length of stock required to make three links of chain $2'' \times 1''$ *outside* dimensions. Stock to be used $\frac{1}{4}$ inch round.

9. Compute (see page 103 and Fig. 91) the length of stock required to make three links of chain $1\frac{3}{4}'' \times \frac{3}{4}''$ *inside* dimensions. Stock to be used $\frac{5}{16}$ inch round.

10. Compute (see page 103 and Fig. 91) the length of stock required to make five links of chain, the links to be of 5-inch *outside* by $2\frac{1}{4}$-inch *inside* dimensions. Stock to be used $\frac{5}{8}$ inch round.

CHAPTER VIII

THE PROPERTIES OF STEEL

As has already been pointed out (Chapter I) steel differs from wrought iron mainly in the percentage of carbon present. Wrought iron contains about 0.04 per cent of carbon, steel from 0.20 to 2.00 per cent. Small quantities of other metals are sometimes added to steel to give it special properties.

Steel may be produced by the *Bessemer* or the *open-hearth process*.

52. The Bessemer Process. The Bessemer process for producing steel consists in blowing air through molten pig iron. It was first introduced in 1856 in England and is named after its inventor, Sir Henry Bessemer.

The manufacture is divided into two principal steps: First, the reduction of the iron ore in the blast furnace; second, the conversion of the molten iron into steel in a vessel called a **converter.** The raw materials of manufacture consist of iron ore, coke and limestone. Fig. 100 illustrates diagrammatically the raw materials used and the successive steps in the manufacture of steel.

The materials are used in the proportion of about ten pounds of iron ore to five pounds of coke and three pounds of limestone. The limestone is used as a flux to aid in the purification of the iron ore.

Blast furnaces are huge steel shells whose height varies from 60 to 90 feet. The furnaces are lined with refractory material and are called blast furnaces because a blast of air is forced into them from the bottom. The blast before

being forced through is always preheated to a temperature of 1000° F. or higher.

Blast furnaces when once started are maintained in continuous operation day and night often for years. They are always charged from the top. A skip hoist carries the material in bins to the top and discharges the contents into a cone-shaped hopper. Special air locks are provided

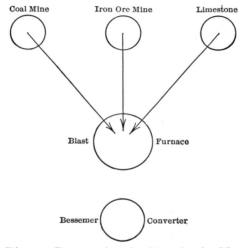

Fig. 100.—Diagram Representing the Steps in the Manufacture of Steel.

between the hopper and the furnace, which prevent the gases from escaping from the furnace. The furnace is charged with a layer of coke and a layer of iron ore, and to these is added the proper proportion of limestone.

The liquid or molten metal and *slag* collects at the bottom of the furnace. This is tapped into a large ladle mounted upon trucks and then charged into the Bessemer converter.

Up to this point the product is a simple, molten cast

iron, which, if run into molds, would form the common, commercial cast or pig iron used in the foundry. From this point on the process is one of converting the cast iron into steel by decarbonizing the molten metal in the converter, and finally by reintroducing the necessary amount of carbon and manganese for the required composition and quality.

53. The Bessemer Converter. The Bessemer converter is a pear or barrel-shaped vessel made of boiler plates, holding ten to fifteen tons of metal, lined with refractory material and carried on trunnions. Through one of the trunnions, which is hollow, an air blast is conveyed to the bottom of the converter. Through the openings in the tuyere or bottom plate of the converter the blast of air is forced through the molten pig iron.

The air passing through the molten mass produces great heat; the oxygen combines with the carbon and silicon, and the heat caused by their combustion is sufficient, not only to keep the metal in the liquid state, but to increase the temperature about 700 to 800° higher than at the beginning of the " blow." The flames and resulting gases escape from the mouth of the converter, and after eight or ten minutes the impurities are practically burned out. This is recognized by the color of the flame. The almost pure iron which is left after the impurities are exhausted is comparatively soft, and to obtain the required degree of hardness and toughness a rich alloy, such as *spiegeleisen* or *ferromanganese*, is added, which reintroduces the necessary amount of carbon and manganese.

Spiegeleisen is a pig iron containing about 12 per cent of manganese, the proportion being such as to introduce into the metal in the converter the proper amount of carbon and manganese, the former being present in Bessemer steel from 0.20 to 0.50 per cent. This gives the steel the necessary hardness. The manganese (about 1 per cent) is added to make it roll well. About one ton of spiegeleisen is added for every ten tons of steel.

As soon as the molten iron in the converter is sufficiently purified (which is recognized by the flame as before explained) the converter is swung over on its trunnions, the charge is emptied into a ladle and at the same time the spiegeleisen is poured into the ladle.

The steel is tapped out at the bottom of the ladle and poured into a series of cast-iron ingot molds. The *slag*, being lighter, floats on the top, thus insuring its separation from the metal. The entire process takes about twenty minutes. After the metal has been cooled sufficiently to become solid, the cast-iron molds are removed by the ingot stripper (hoisting machine) and they are reheated in the " soaking pit," usually a regenerative type of furnace.

Taken from the furnace, the ingots are rolled to the required thickness into *blooms, slabs* or *billets.*

The Bessemer process is the cheapest and quickest process. Bessemer steel is used for steel rails, structural material, hardware, etc.

54. The Open-hearth Process. Open-hearth steel is produced in a regenerative furnace known as **open-hearth furnace.** By a regenerative furnace is meant one in which the heat is carried away into the stack and wherein the gases are used to heat a mixture of air and gas before they unite and enter the furnace. This is accomplished by allowing air and gas to pass through a chamber of loosely laid bricks which have been heated previously by the waste gases. Pig iron and scrap steel are charged and subjected to the extreme heat of burning gases which enter from one end of the furnace and pass over the charge and leave through the flues at the other end. These furnaces are of various types and hold from 10 to 90 tons of metal. They are built chiefly of brick, the hearth being supported by iron beams and plates, while the interior of the furnace, which comes in contact with the intense heat, is lined with silica, brick and other refractory material.

The open-hearth process is preferable to the Bessemer

process, as from time to time samples can be taken from the furnace and tested while the impurities are burning out. Through this facility the exact percentage of the necessary alloy and carbon may be determined and added to the molten metal in order to obtain that particular grade of steel which is desired. This is not possible with the Bessemer process.

When the metal is finally ready, it is tapped in a large ladle and thence poured into ingot molds, after which it is treated in the manner explained for the Bessemer process.

The open-hearth process consumes much more time than the Bessemer process, as it requires 8 to 11 hours for one heat or operation, but it is advantageous, inasmuch as certain grades of metals not suitable for making Bessemer steel can be utilized. In the open-hearth furnace various kinds of steel are manufactured, such as structural steel, rail steel, spring steel, nickel steel, etc.

55. Tool Steel. The steel used for general purposes would not make satisfactory tools. Good tools are those that are made of proper material and are properly tempered for the purpose intended, not merely those that have the correct shape and appearance. Therefore, it is necessary that the smith be familiar with the underlying principles of tool making so that the material he uses may be properly selected and may have proper physical treatment. Not infrequently we find that the tool makers forge many kinds of tools out of the same bar of steel stock, but it is noticeable that these tools when finished have very different properties. Tools which have been properly worked and treated may last many months without damage to their faces or edges, while other tools exhibit the results of unskilled labor and uninformed minds. They do not possess the desired properties and break or crack or bend at their first use. Tool steel is often condemned for these faults when the true cause of the failure of the tools is the ignorance of the workman who forged them.

Tool steel contains a definite percentage of carbon, varying between $\frac{2}{3}$ of 1 per cent and 2 per cent in the various sorts. With its other properties, this places it between wrought iron and pig iron. Its melting point also lies between those of wrought and pig irons, and varies with the carbon content. Steel has a crystalline structure. If a piece of tool steel be heated to a red heat and plunged into cold water, it will acquire a definite hardness, which may be destroyed by annealing. This property also depends on its carbon.

But it is not only carbon that gives tool steel its characteristic properties. These may be modified in many ways by the addition of small quantities of such substances as chromium, manganese, tungsten, phosphorus, vanadium, etc. Chromium gives steel great hardness, and makes chrome steel especially useful for tools that must endure hammer blows or pounding. Chromium is also used in conjunction with nickel in the chrome-nickel-steel of trade. Nickel makes steel very tough and elastic. Nickel steel is not suitable for tools. Manganese produces a dense cast metal, free from bubbles or blisters or blowholes if used to the extent of 2 per cent. If used in greater quantity, it produces rigidity and tenacity. Tungsten steel, containing 3 to 10 per cent of tungsten, is extremely hard and is highly valued for cutting tools. It must be heated slowly and not too often reheated, for this causes it to become brittle and crumbly. Phosphorus is a substance difficult to add to metals. In the cold state, the metal containing it is brittle, but in the hot state its presence has little effect.

Tool steel is expensive and difficult to work. One ought to avoid " upsetting " it as much as possible, for this causes changes in the texture or structure which is followed by cracks. Steel must be worked at a good red heat and heated frequently if necessary, but never worked cold. Forging steel at a dark red heat will make it brittle

and cause cracks. Steel should be heated slowly and uniformly and thoroughly, using just as little wind blast as possible. If the heating is forced along too rapidly, displacements in the crystalline structure of the steel will be produced by forging. The outer surfaces, being hotter and softer, are moved under the hammer and an irregular structure is produced, as a result of which cracks usually develop after tempering. Tool steel should never be overheated, for this also makes it brittle and weakens the structure.

A good quality of tool steel is of a bluish-gray color and of uniform grain or structure. If overheated, it assumes a much whiter or lighter color, and the crystalline structure becomes coarser. If heated to a glowing white heat, it crumbles and is said to be " burnt." In forging, it changes its original crystalline structure, its grain becomes finer, its fiber denser, and its specific gravity greater. In tempering, it becomes shorter and thicker.

56. The Manufacture of Crucible Steel. The process of manufacturing crucible or tool steel is one of the oldest methods employed. The production is rather costly, but it is still used for making high-grade tool steels. A high grade of wrought iron or Swedish charcoal iron is used. The iron bars are cut into short pieces and then placed in a crucible made either of clay or of graphite and clay in about equal parts. Into the crucibles, which are capable of receiving from 70 to 90 pounds of metal, the required amount of carbon (charcoal powder) is also placed. The crucible is then tightly sealed with its cover so that the metal will be protected from the air and oxidizing gases of the furnace.

Fig. 101 illustrates a crucible charged, ready for the cover to be put on and to be placed in the furnace.

The process consists, therefore, of melting a high grade of wrought iron which contains very little phosphorus and sulphur and adding the necessary amount of carbon in order to convert it into steel. When the metal is completely

fused, it is poured into molds, forming a short, stout bar known as an *ingot*. For larger ingots or steel castings, the contents of two, three or more crucibles are mixed in one pot and then poured into the mold through a preheated clay pouring funnel.

Ingot molds for small castings are made in two parts and are held together by means of rings and wedges, while the larger sized ones are usually made of one piece, slightly tapered and with an open bottom. These are known as the open bottom type. After the ingots are cooled, the

Fig. 101.—Crucible Charged, Ready for the Cover.

molds are stripped off, and the ingots are heated again in a furnace and finally rolled or hammered into bars by steam hammers. Steel produced in this manner is often called *cast steel*.

The furnaces of to-day in which steel is melted are heated by either gas or oil with a forced draft of air. They are very economical if used continually day and night. The old type of coke or anthracite furnace has been more or less abandoned because they are more expensive. A larger crew is required to wheel coal and ashes and the melting of the metal is less rapid. The most common size steel-melting furnaces are built to receive from 30 to 36 crucibles.

57. High-speed Steel. High-speed tool steels have had added to them special alloys of iron, such as chromium, tungsten, titanium, vanadium, etc. Chromium and tungsten are principally used. There is but little difference in the melting of high-speed steels and carbon tool steel.

There are many brands of high-speed tool steels on the market, such as " Mushet," " Blue Chip," " Peerless," etc. Tools made from high-speed steel are generally submitted to greater strain, greater speed, and invariably cut and feed much faster than any other tools; therefore, they should be made as strong as possible so as to give the tool a good backing.

For forging, heat the stock very slowly and thoroughly to a yellow color. It is extremely detrimental to hammer high-speed steel below a dark red heat, as cracks are produced.

In order to anneal high-speed steel, it should be heated to a salmon color, packed in charcoal or dry lime, and allowed to remain there until entirely cold. For hardening, it should be heated slowly to a bright red heat and then rapidly to a white heat and cooled in oil or by a blast of air. Lathe tools for heavy, rough cutting are left untempered. As there are so many kinds of high-speed steels manufactured to-day, it is advisable to ask for working instructions from the maker in order to obtain good results.

CHAPTER IX

ANNEALING, HARDENING AND TEMPERING

58. Annealing. Annealing is a process of softening steel. It is accomplished by heating the steel to a full red heat and then cooling it slowly. The slower the process of cooling, the more thoroughly will any strains set up in the steel through rolling or hammering be eliminated.

Most tool steel is annealed by the manufacturers before it is sent out to the trade. Often, however, in forging tools, strains or inequalities of hardness are set up, and a better tool is usually produced if it is annealed before the final hardening and tempering. To prolong the cooling, the tool may be packed in charcoal powder or dry lime. Where no charcoal or dry lime is available, thrust the steel into dry ashes, allowing the steel to remain there until it is entirely cold. This method is the most common and practicable of all.

Water annealing—a method less known—is employed if time does not permit the prolonged cooling. If properly performed, very good results may be obtained. In this method the steel is heated to a full red heat and left to cool without packing until no heat colors are visible in a dim light, after which it is plunged into water to cool entirely.

59. Hardening. Tool steel is hardened by heating it to a full red heat and then quickly plunging it into a bath of clean, cold water. Other liquids or additions affect the hardness. Salt or saltpeter intensify the effect, in that they produce greater hardness. Oil or lime or soda, on the contrary, lessen the intensity of the effect. Steel heated to a full red and cooled by plunging it into mer-

134

cury becomes glass hard, and, therefore, too hard to be worked under a file. It will break easily when an attempt is made to bend it.

In steel mills crucible or tool steel is classified, according to its carbon content, as *very high temper; high temper; medium: mild.* The more carbon present and the more rapid the cooling from the hardening heat the harder the steel becomes.

Tools which are part iron and part steel become, in the hardening process, convex on the steel side and concave on the iron side, because iron shrinks more than steel. This may be remedied by a preliminary bending in the opposite direction before hardening.

Steel articles which do not need to be very hard may be cooled in oil, and in the case of very small articles in a blast of air. Cooling in oil increases the elasticity of the steel and makes it tougher. Other small articles which have openings through them may be strung on a wire, heated together and cooled by swinging in the air.

Steel articles which need a high degree of hardness are cooled in water containing salt or saltpeter. In case many articles are to be hardened, more cold water must be added from time to time. The best temperature for the water is between 50 and 70° F.

The greatest hardness of all is produced by cooling steel in mercury.

60. Tempering. By heating steel, which has been hardened, to certain temperatures, it is possible to release various percentages of the combined carbon and in this way to reduce the hardness as desired. This operation is called tempering. In other words, every tool is first given a certain high grade of hardness. It is then *tempered* down to that grade of hardness which is most suitable for the uses for which it is intended.

In order to make entirely clear the process of tempering, we shall consider some one tool and explain the procedure

step by step. Let us consider a chisel, which is very much used by every worker. The chisel is forged and then ground, as explained in Exercise 26, page 149. To temper it, heat the forged or sharpened end slowly and carefully in the hardening furnace or in a charcoal or coke fire to a full red heat. Cool it immediately in water, plunging the cutting end about one inch under the surface and moving it slowly back and forth, and slightly up and down. The backward and forward motion cools the end more quickly by continually bringing the steel in contact with new cold water, thus preventing the formation of a heat insulating layer of steam surrounding the tool. The up and down motion prevents the fracturing of the steel at any definite water line, a result frequently observed in the tempering of tools. This fracture is due to the contraction of one portion away from the other at the water line.

As soon as the hardening process is completed, the tempering process should be begun. In this operation use is made of a piece of emery cloth fastened to a stick or of a small emery block, to rub the surface of the end of the chisel; or the tool may be rubbed on the cement floor or any hard abrasive to polish its surface. The tempering is accomplished by the heat which still remains in the uncooled portion of the tool being conducted to the cooled or cutting end. In this way, by gradual conduction of heat, the cutting end of the tool is raised through a succession of temperatures and the polished surface becomes oxidized. The oxidized surface takes on various colors, depending upon the temperature. The first color observed is light or pale straw, followed in order by dark straw, brownish-red, and purple, then dark blue and light blue. These colors definitely indicate important changes in character and hardness which take place in the steel at the different temperatures, and they serve, therefore, as a valuable criterion for judgment in tempering steels to desired hardnesses.

The glassy hardness first produced is by this plan modified down to the degree of hardness desired. In order to fix permanently the hardness which is obtained, the edge or cutting end *must be cooled immediately the proper color is evident.* In tempering a chisel, wait till the edge reaches the *dark blue* stage, then plunge the tool again into

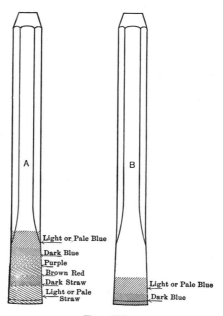

A
B

Light or Pale Blue
Dark Blue
Purple
Brown Red
Dark Straw
Light or Pale Straw

Light or Pale Blue
Dark Blue

FIG. 102.

cold water. In order that the colors may form it is essential that the surface be polished and clean and that it be free from all grease. Fig. 102 (*A*) illustrates the colors which appear immediately upon polishing a portion of the chisel. As the heat approaches the cutting edge, the colors follow, the play of the tempering colors extending to the end. Fig. 102 (*B*) shows the proper temper color for a cold chisel.

If the tempering has been unsuccessful or unsatisfactory the tool may be retempered. Before doing so, however, it should be annealed or softened by heating to a red heat and allowing it to cool slowly, after which the original procedure for tempering is followed. In tempering, steel loses a very small portion of its carbon, and by repeated tempering the tool is spoiled.

Table of Tempering Colors

1. Light or pale straw, 425–430° F. Lathe and planer tools to be used with hard metals, such as steel and cast iron.
2. Dark straw, 465° F. Lathe and planer tools for wrought iron and the softer metals, reamers, milling cutters, etc.
3. Red brown, 510° F. Taps, drills and tools used for bone and leather.
4. Purple, 530° F. Center punches, machine punches, dies and stone drills.
5. Dark blue, 565° F. Cold and cape chisels, hand punches, hatchets, table and hunting knives, etc.
6. Light or pale blue, 605° F. Screwdrivers; certain surgical instruments.

This series shows that light or pale straw color tempering produces the greatest hardness, and pale or light blue the softest temper or degree of hardness.

61. Tempering Furnaces. For the purpose of tempering steel it is best, if possible, to use a tempering or annealing oven. If one of these is not available, it becomes necessary to use the forge fire. Tempering ovens are heated with gas or charcoal, and forges for tempering are heated with charcoal and, where that is not available, with coke, but under no circumstances with green coal. The tool is laid in the fire in such a way as to have every surface of it

covered with charcoal or coke. Very little blast is applied in order that the tool may be heated slowly and uniformly.

Other sources of heat are sometimes used. For small objects a sand bath of fine sifted sand may be used. Oil furnaces especially suited to this work are on the market and are very desirable for tempering many pieces at a time, such as a large number of small tools. All tools must first be hardened by heating their cutting edges to a red heat, and then cooled in clean, cold water. Small cutters which are to be tempered throughout must naturally be wholly heated and then suddenly cooled. For this sort of work, also, hardening furnaces are used to harden many pieces at a time. If no such furnace is available, one may be made from an iron pipe, packing the tools in with powdered charcoal.

Where it is desired to have tools exhibit the tempering colors to make them more attractive, it is necessary to clean the surfaces after hardening. They may then be tempered in sand which has been heated to the proper temperature in an iron box. Where no temper colors are desired, the oil furnace may be used. In this case it is not necessary to polish the surfaces after hardening and before tempering, as is done with small tools at the cost of much time. The tools are put into the oil in the tempering furnace, which is heated by a gas and air blast. The heating is continued until the proper temperature is reached, as indicated by a thermometer in the oil basin. As an example, small lathe tools are put into the oil bath, the temperature is raised to 430° F., the gas and blast are shut off and the tools are removed from the oil and buried in sawdust (not plunged in water). A further cooling is unnecessary in this case, because when the gas flame is shut off a further increase in temperature is impossible. If these tools are cooled in water, there is formed on the surface a thick, clinging layer of grease which is difficult to remove. Sawdust quickly and easily absorbs all the oil and cleans the tools.

62. Tempering a Punch and Die. Fig. 103(*A*) and
(*B*) illustrate the tempering of a punch and die. Short
thick tools, such as dies, are most easily tempered in the
following manner:

The die is heated (slowly) to a bright red heat, hardened
in water, and the upper and a side surface polished by
rubbing with emery cloth or sandpaper. A piece of iron
of about the shape and size to fit the die is prepared and
the iron is heated to a red heat. Upon it is laid the die so

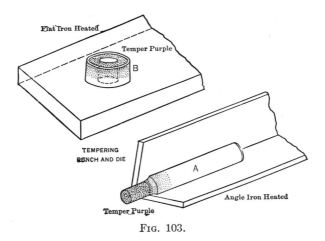

Fig. 103.

that its lower surface is flat upon the iron. The heat of
the iron is imparted to the lower surface, and gradually
carried by conduction to the upper surface. The temper-
ing colors are to be observed as they proceed up the polished
side, and when the purple color reaches the upper surface
the die is quickly cooled in water. In this way the lower
surface of the die remains softer and tougher. By moving
the die away from and then back upon the hot iron, the
heating may be made more uniform and one may readily
control the temper.

The punch is hardened and tempered in the same way as above described for the die, but with this difference, that it is advisable to use a section of angle iron for tempering. The punch projects from the angle, as shown in Fig. 103(*A*), and the tempering takes place slowly, until a uniform purple color extends from the shoulder, when the punch is suddenly cooled.

Molten lead may frequently be used to advantage in tempering. The lead is melted and tools such as the dies of the previous section, having been hardened and polished, are partly immersed in the lead. The heat is very evenly distributed by this plan.

FIG. 104.—Tempering a Reamer.

63. Tempering a Reamer. The reamer is heated slowly and evenly to protect the edges from overheating. At a good red heat it is cooled vertically (not horizontally in order that it may not bend) up to the round shoulder and moved slightly up and down and back and forth as explained in section 60, so that no water cracks develop. After polishing the hardened surfaces, it is best to make use of a heavy cast-iron ring or bushing for tempering, as shown in Fig. 104. The bushing is heated to a dark red and the reamer is inserted horizontally into the middle of the bushing, without having its edges touch the bushing. The reamer is then turned slowly to heat it uniformly. Temper the reamer dark straw and then cool it in water. The round

shoulder and square shank are not hardened. If tempered in oil, the temperature should be 465° F. Other tools resembling reamers, such as taps, may be tempered in the same way.

64. Tempering Large or Long Tools. The tempering of large, stocky tools may be done directly by using a charcoal or coke fire, but this requires skill, because the heating is likely to be irregular, whereby the structure of the steel may be changed injuriously.

The hardening and tempering of long, bar-shaped tools and flat or thin work is somewhat more difficult, because of the necessity for keeping the articles straight. These articles are hardened by vertical cooling, putting the point first in oil or water. Such articles as carving and hunting knives must not be plunged flat into the hardening bath or they will bend toward the side first cooled. Even with care and vertical cooling, it not infrequently happens that articles warp. If this change is not too great, it may largely be remedied while tempering by the greater or lesser application of heat at proper places. In certain tools, in which the formation of bends may be predicted, the piece may be prepared beforehand by an equivalent opposite bend before hardening.

65. Choosing Steel for Tools. Besides the temper grades given in section 59, steel is classified by " points." A point is $\frac{1}{100}$ of 1 per cent of carbon. Therefore, 100 point steel contains 1 per cent of carbon; 150 point steel contains $1\frac{1}{2}$ per cent of carbon, and this is very high temper steel. Seventy to 80 point steel is medium, and 60 point steel is mild temper steel.

In selecting steel, it is highly advisable to choose that which is most nearly in the form of the tools to be made, to avoid unnecessary manipulation, for much manipulation is an evil, as steel does not improve by working. Moreover, one should choose steel containing the suitable amount of carbon for the particular tools to be made.

In ordering or purchasing steel it is advisable to specify the use to be made of it.

The following lists are of assistance:

Cold chisel Cape chisel Center punch Hand punch Blacksmith punch	Carbon per cent 0.80 to 0.90
Ball-peen hammer Hardie Blacksmith hammer (cross-peen) Riveting hammer	0.70 to 0.80
Flat drills (for steel and iron) Countersink	1.00 to 1.10
Flat drills for brass Countersinks for brass	1.10 to 1.20
Flatters Top and bottom fuller Top and bottom swage Set hammer Heading tool	0.60 to 0.70
Lathe tools	1.10 to 1.20
Milling cutters Reamers	1.20 to 1.25
Planing tools	1.10 to 1.15
Screwdrivers	0.90 to 1.00
Stone drills Stone cutting tools	0.95 to 1.05
Pliers	0.90 to 1.00
Steel engraving tools	1.15 to 1.25
Punches and washers	0.80 to 0.90

Scrapers	1.20 to 1.25
Taps	1.15 to 1.20
Saws for Steel	1.60

66. Tempering Springs. The most common method of hardening a spring is known as *blazing off*. The spring is heated slowly and uniformly to a good red heat and cooled all over in oil. Hold the spring over the fire until the oil that adheres commences to blaze, then cool again in oil. Repeat this process three times. This completes the tempering. The blazing of the oil upon the surface of the steel is termed *flashing*.

In tempering spiral springs, do not apply a pair of tongs, as the spring will bend while hot and will not heat uniformly. Slip a rod through the spring, and heat it slowly in the flame. To temper, follow the instructions given above.

Another way to harden a spring is to heat the spring, cool it in oil, then heat the spring again in oil in an oil tempering furnace to 545° F. Remove it from the furnace and place it in sawdust to absorb the oil.

Steel manufacturing plants where large quantities of tools, cutters, springs, etc. are to be annealed, hardened and tempered, use a more modern, scientific apparatus called a *pyrometer*, to register the exact temperature. Prior to the use of pyrometers, the temperatures were regulated by such skill and judgment as the operator was able to apply, unaided by any mechanical or scientific device accurate enough to determine the temperature of the articles or pieces to be treated.

67. Case-hardening. Case-hardening is used for surfaces of wrought iron and machine or soft steel which cannot be hardened by the methods already given. In this process, carbon is added or rather *burned into* the low carbon iron. This method of hardening is valuable for certain articles and for certain parts of machines where

hard surfaces are needed to resist wear, and where toughness is required to withstand shock.

Cast-iron boxes are especially made for use in case-hardening. The articles to be case-hardened are packed in the cast-iron boxes with ground bone, charred leather or charcoal. The articles should be placed in such a manner that they do not come into contact with each other and there should be always a layer of ground bone or charcoal between the articles to insure a more even or uniform carbonizing. The box is provided with a cover, and is closed and placed in a furnace and heated.

Ground bone, burnt leather or charcoal contain a high percentage of carbon which is burned into or absorbed by the iron. The articles are kept hot from 4 to 12 hours, the depth of the hardening depending upon the length of time the pieces are left in the furnace. When the box is removed from the furnace, the contents are quickly thrust into a tank of cold or running water.

Cam shafts, gears, S wrenches, spanner wrenches, set screws, etc. are hardened by this process. Where no case-hardening box is available, a short piece of pipe of large diameter may be used instead. Close one end with clay, pack the pipe as explained previously, close the opposite end with clay and proceed as in the box method.

In shops or schools where no case-hardening furnaces are at hand or where single pieces made of iron require a thin coat of hard material, the article is heated to a light red heat, thrust into or covered with pulverized cyanide of potassium long enough to permit this material to penetrate the surface as deeply as possible, reheated quickly and plunged into cold water or brine. Yellow prussiate of potassium may be used instead of cyanide of potassium, the latter being more effective. *Cyanide of potassium is a powerful poison, the fumes especially being extremely poisonous, therefore it should be handled with the greatest care and kept in places out of reach of persons not aware of its properties.*

CHAPTER X

TOOL MAKING

68. Cutting Off Tool Steel. Tool steel may be cut either hot or cold. In cutting small stock hot, heat to a red heat and use the hardie, but for heavier stock use the hot chisel. In cutting round stock, turn the metal after each blow to avoid flattening or disfiguring it.

In cutting steel cold, use a sharp hand or blacksmith cold chisel. Cut in from all sides, then after placing the stock with one end blocked up by means. of a wedge or piece of iron laid across the face of the anvil, strike sharply upon the cut with a hammer. Small stock may be placed across the tool hole of the anvil after it has been cut in, and broken off with one or two well-directed blows, provided the chisel used was sharp. The breaking off of short pieces cold, by the method just described, should be demonstrated to the beginner, as it requires more or less skill. Too heavy a blow will cause the short piece to fly off and cause accidents.

Steel bars may be nicked in on the edge of an emery wheel and then broken off as described above. For *very short pieces*, cut in while hot and cool the section quickly in water to make the steel very hard. Then place the cut-in section upon the edge of the anvil, strike over the edge, and the piece will break without difficulty.

Exercise 25. Center Punch

Stock: $3\frac{1}{2}$ inches of $\frac{3}{8}$-inch octagonal tool steel. Use 80 or 90 point carbon steel. *Operations:* Forming, drawing, grinding and tempering.

146

Heat one end short to a bright red heat, forge the bevel on the outside edge of the anvil and square up the end as indicated in Fig. 105(*b*), to form the head.

Heat the stock slowly about $1\frac{1}{2}$ inches from the opposite end, draw it square first at the end, then draw backward to the desired

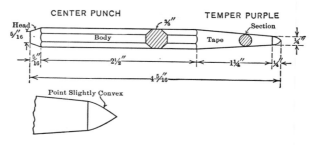

FIG. 105(*a*).

length and proceed to shape it octagonally and finally round. *Do not hammer the stock after it has cooled to a dark red heat,* and while rounding off do not strike too heavily or the steel will split.

Before grinding the center punch make sure that it is perfectly straight and symmetrical. Grind it on the emery wheel to a sharp but slightly convex point, as illustrated in the enlarged view, Fig. 105(*a*). If ground in this manner, the tool will be stronger and in use will work itself free from the metal more easily.

To get a sharp outline of the tool when grinding it, place the back of the hand behind it as a background, while viewing it.

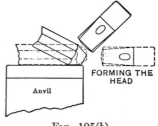

FIG. 105(*b*).

This practice is particularly useful in shops where the grinding or emery wheels are installed in corners poorly lighted and where the background is too dark to produce a distinct outline of a tool requiring care in grinding.

To harden or temper the punch, heat the stock slowly and thor-

oughly to a full red heat (1380° F.) about as far back from the point as B in Fig. 105(c). Harden the end by dipping it into cold water to the point A, Fig. 105(c), and move the tool back and forth with a slight up and down movement to prevent a water crack.

Polish the hardened section quickly, using a polishing block

FIG. 105(c).

emery, sandpaper, or by rubbing it on the cement floor, etc.

The section between A and B being still at a red heat will gradually reheat the cooled part of the tool and the temper colors will appear. A light straw color will be noticed first, then a dark straw, then a brown-red and next a purple, etc. When the purple reaches the point, *quickly* cool the point and a part of the tapered section in water, thus completing the tempering. The section between the points A and B, Fig. 105(c), should not be cooled too rapidly, if still at a dark red heat, as this would make the tool unnecessarily brittle where not desired.

Fig. 106 shows a hand punch which may also be used as a nail set. It is forged as described in Exercise 25. The

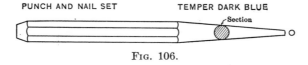

PUNCH AND NAIL SET TEMPER DARK BLUE

Section

FIG. 106.

end should be ground straight and the tool tempered at a dark blue.

Exercise 26. Cold Chisel

Stock: 6 inches of $\frac{5}{8}$ inch octagonal steel. Use 80 to 90 point carbon steel. *Operations:* Forming, drawing, grinding and tempering.

In Fig. 107(a) is illustrated a cold chisel for general use.

Forge the head and shank as described in Exercise 25. Heat the other end slowly and thoroughly, draw it out to $\frac{7}{16}$ inch square,

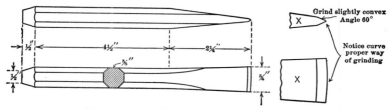

FIG. 107(a).—Cold Chisel for General Use.

as shown in Fig. 107(b). Draw the end first, then draw backward, and finally flatten the square end to $\frac{1}{16}$ inch in thickness and $\frac{3}{4}$ inch in width. Do not hammer the chisel when below a

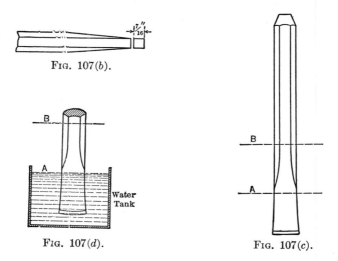

FIG. 107(b).

FIG. 107(d). FIG. 107(c).

dark red heat, and while reheating, great care must be taken *not to overheat the point.*

Straighten the chisel and be sure that the blade is central. Anneal it before grinding. Grind the blade square and slightly

convex at the end first, then grind the bevel also slightly convex to an angle of about 60°. See Sections marked X, Fig. 107(a). The chisel must have a sharp cutting edge to do effective work.

To harden and temper, heat the chisel to a full red heat (dull cherry red) from the cutting edge as far back as the point B, Fig. 107(c). Harden the end by dipping it vertically into water to the point A, Fig. 107(d), and move the tool back and forth with a slight up and down motion to prevent a water crack. Polish the hardened section as explained for Exercise 25. The heat remaining in the body between section A and B will gradually reheat the part just cooled and the temper colors which are a film of oxide, will appear and commence to move slowly toward the end of the chisel. Light straw will be noticed first, then dark straw, then brown-red, purple, and dark blue. When the dark blue color reaches the cutting edge, quickly cool it again in water, thus completing the tempering. If the body of the cold chisel still retains a dark red heat when the dark blue temper color has reached the cutting edge, it is advisable to cool the blade quickly first as just directed and then to cool the body more slowly in order to avoid unnecessary brittleness where not desired.

Some tool makers strike a few *light blows* at a black heat just before finishing such tools as cape and cold chisels so as to produce a stronger and tougher tool. This process is termed *packing*. Beginners must be cautioned about " packing " steel, as there is a strong tendency to overdo it and thus bring about the ill effects which follow improper treatment and forging at too low a temperature.

When sharpening a chisel which has become dull from use, the grinding should be done on a grindstone or wet grinder, where such tools are on hand, and not on the emery wheel. A good mechanic will not sharpen tools of this kind on a coarse emery wheel, and the beginner is liable to draw the temper of the tool.

Exercise 27. Cape Chisel

Stock: $7\frac{1}{2}$ inches of $\frac{5}{8}$ inch octagonal tool steel.

One of the most common kinds of cape chisels is illustrated in Fig. 108(*a*).

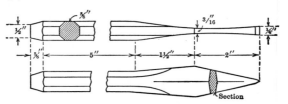

FIG. 108(*a*).—Cape Chisel.

Follow the working directions of Exercise 26. Draw the end for the blade to $\frac{3}{16}$ inch square, as shown in Fig. 108(*b*). Spread the blade upon the horn, leaving a ridge in the center to strengthen the tool. Spread the end to $\frac{1}{4}$ inch, thus giving the tool sufficient clearance. Cape chisels are used for cutting key

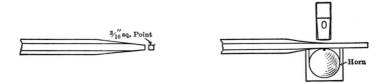

FIG. 108(*b*).

seats, grooves, etc. They must be wider at the end than elsewhere along the blade, in order that they may not become wedged into the metal.

Grind the chisel slightly convex to a sharp cutting edge and temper it dark blue.

Exercise 28. Lathe Tools. (a) **Round-nose Tool**

Stock: $5\frac{1}{2}$ inches of $\frac{3}{4}''\times\frac{3}{8}''$. 110 to 120 point carbon steel. *Operations:* Forming, drawing, grinding and tempering.

Heat one end short and form the bevel with backing up blows on the outside edge of the anvil, as shown at (b), Fig. 109. Heat the opposite end slowly and thoroughly to a bright red heat, then draw and narrow the stock to the dimensions given in Fig. 109, beginning at the end, as shown at (c).

As all lathe tools must have proper clearance, they must be forged and ground properly in order to have the cutting edge project. The lower edge is forged thinner and is worked on a slant to give the proper clearance, right and left, as is shown in the front

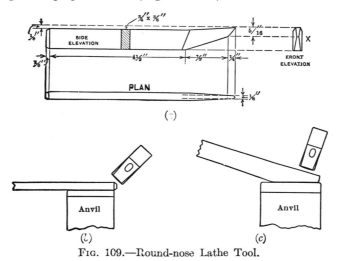

Fig. 109.—Round-nose Lathe Tool.

elevation, X, Fig. 109. The undercut backwards from the cutting edge will give the necessary clearance from the front. Forge the tool with a slight rake, so that the cutting edge is raised a trifle above the top line of the stock.

Cut off the extra stock on a bevel, using a sharp hardie or hot chisel. In doing this, cut half way through and cool the cut-in section quickly in water, thus making the steel hard, then with a light blow over the outside edge of the anvil break the waste end. Cutting in this manner will save time in grinding.

Anneal the tool and grind it round at the end to a sharp cutting edge, giving proper clearance.

For hardening and tempering, heat the tool slowly to a full red heat (dull cherry red); *great care must be taken not to overheat the point.* Cool the end in the water tank, with the cutting edge down and almost horizontal, as illustrated in Fig. 110, moving the tool back and forth to avoid a water crack. Polish quickly on one side down to the point and temper a light or pale straw-color. Lathe tools should not be tempered too short, in other words the temper colors should be drawn slowly in wide bands, thus tempering larger sections to the same degree cf hardness and permitting resharpening of the tool

WATER TANK

Fig. 110.

without reaching soft metal. The reason for cooling the tool almost horizontally when hardening is to draw the heat more from the bottom side of the tool, making the tool softer at the bottom; this will toughen the tool.

The stock most commonly used for lathe tools is from $\frac{3}{4}'' \times \frac{3}{8}''$ to $1'' \times \frac{1}{2}''$, and practically all types are tempered a light straw-color. Smaller lathe tools, such as gravers, cutting off tools, etc., used on speed lathes, are hardened and tempered in oil-hardening furnaces when such furnaces are available. (See section 61, page 138.) The ends with the cutting edge are heated to a full red heat and plunged into cold water, after which the tools are placed in the oil-hardening furnace and the temperature is raised to 430° F. The temperature is usually indicated by a thermometer that reaches down into the oil tank. At this temperature the gas and air are turned off and the tools are put into sawdust (not into water). This method is labor saving, for hundreds of tools may be tempered at one time.

Threading tools are forged and tempered practically in the same manner as the round-nose tools, the only differ-

ence being that the cutting edge is ground to an angle of 59 or 60°.

(b) Cutting Off Tool

Stock: 5¼ inches of ¾″×⅜″ tool steel. *Operations:* Forming, fullering, drawing, grinding and tempering.

Form the bevel as in the previous exercise. Heat the opposite end and fuller in ½ inch from the end, using a ⅝-inch or larger top

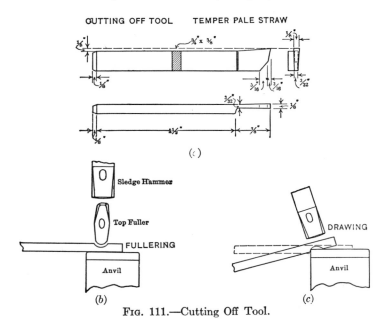

Fig. 111.—Cutting Off Tool.

fuller with the metal resting flat upon the anvil, as shown at (*b*) in Fig. 111. Commence drawing, holding the metal down as illustrated at (*c*) to avoid folding the metal over, which would leave a crack and weaken the tool. The cutting edge must be made wider and the remainder of the blade at the back and toward the bottom should be slightly thinner, to give proper clearance and prevent the tool in use from being wedged into the metal.

Cut the extra stock of the blade to the dimensions given in Fig. 111 and grind. Temper a light or pale straw-color, in the

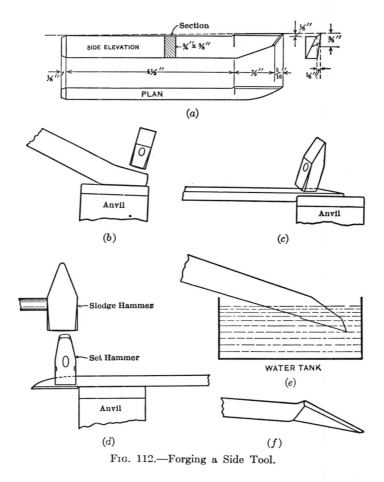

FIG. 112.—Forging a Side Tool.

way directed for round-nose tools. Cutting off tools are also called *parting tools,* and the blade of these tools may be forged either to the right or to the left or to the center.

(c) Side Tool

Stock: 5½ inches of ¾″×⅜″ tool steel. *Operations:* Forming, drawing, offsetting, grinding and tempering.

Side tools are used for finishing and facing ends, flanges, etc. Form the bevel as shown in Fig. 112, and follow the working instructions given for making a round-nose tool. Heat the stock for a distance of two inches from the opposite end slowly and uniformly to a bright red heat and narrow and draw it to a taper, as shown at (*b*). Shoulder in on the inside edge of the anvil about 1¼ inches from the end, striking a few overhanging blows upon the right side of the stock, as shown in Fig. 112 at (*c*), and continue flattening on the same side, thus forming the cutting side of the blade. Cut the extra stock to the dimensions given in the figure, reheat the piece and finish forging by offsetting the top edge of the blade to give the tool the proper clearance.

Fig. 112 illustrates at (*d*) the most common way of offsetting a side tool. Heat the piece and place it upon the anvil so that the blade will extend over the outside edge of the anvil, the shoulder being even with the edge. Place the set hammer upon the blade, leaving a space of about ⅛ inch between the edge of the anvil and the hammer as at (*d*) to prevent shearing. Tip the set hammer slightly over so that the blow will affect or offset the narrow or cutting edge only. Straighten the blade and see that there is a slight rake toward the point. Grind as shown in the figure.

While heating the tool for hardening and tempering, place it in the fire with the cutting edge up to avoid overheating the edge. Heat slowly to a full red heat (dull cherry-red) and cool the entire blade almost horizontally, as shown in Fig. 112 at (*e*). Polish the blade and temper it a light or pale straw-color.

Side tools are made either left or right hand and from light or heavier stock, depending on the work to be done. Fig. 112 shows at (*f*) the plan of a right-hand, *bent* side tool. The blade bent in this manner affords more clearance to the shank.

(d) Diamond Point

Stock: 5½ inches of ¾″×⅜″ tool steel. *Operations:* Fullering, drawing, forming, grinding and tempering.

Form the bevel as in the previous exercises and fuller in $\frac{1}{4}$ inch, $\frac{3}{4}$ inch from the opposite end, as shown in Fig. 113(b).

Rest the section fullered in upon the inside edge of the anvil, as in Fig. 113(c), and draw the end square, as indicated by the

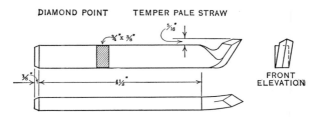

DIAMOND POINT TEMPER PALE STRAW

FRONT ELEVATION

FIG. 113(a). Diamond Point Lathe Tool.

dotted lines. Change the stock from the square form to a diagonal form by placing one corner on the anvil and hammering down on the opposite one, as in Fig. 113(d).

Cut the extra stock to the proper angle with a sharp chisel. As diamond points are made either right- or left-handed, the

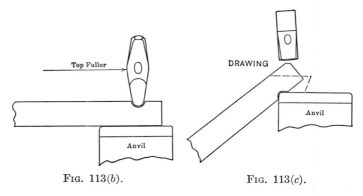

Top Fuller

Anvil

DRAWING

Anvil

FIG. 113(b). FIG. 113(c).

forged section is bent accordingly slightly to the right or left so as to give the tool the proper clearance. Anneal and grind the tool.

When heating for hardening, care must be taken not to overheat the point. Place the tool in the fire with the cutting edge

standing up, heat slowly and uniformly to a full red heat. Cool
the section as shown in Fig. 113(e), moving the tool back and

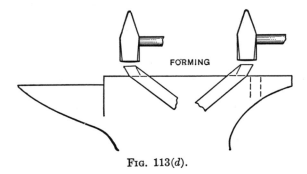

Fig. 113(d).

forth in the bath. Polish the hardened section and temper a
light or pale straw color.

Where no fuller is at hand, the stock is nicked in and shaped
square on the outside edge of the anvil, as illustrated in

SHOULDERING & DRAWING
OVER OUTSIDE EDGE OF ANVIL

Fig. 113(e). Fig. 113(f).

Fig. 113(f). For heavy work diamond points are made of
heavier stock.

Exercise 29. Boring Tool

Stock: The length and the material is determined by the depth
of bore. A medium-sized boring tool is usually made of $1'' \times \frac{1}{2}''$

stock. *Operations:* Shouldering, drawing, forming, bending, grinding and tempering.

Heat the stock and shoulder in on the inside edge of the anvil with overhanging blows, as in (*b*), Fig. 114. Draw the end square

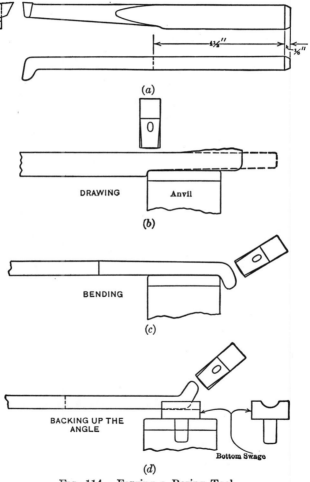

Fig. 114.—Forging a Boring Tool.

first, slightly tapering toward the end, then form it octagonally and finally round. To avoid springing, boring tools should not be drawn out too thin and should not be made any longer than necessary. Bend the end short over the outside edge of the anvil, to an angle of about 70°, the shoulder pointing to the right, as shown at (c).

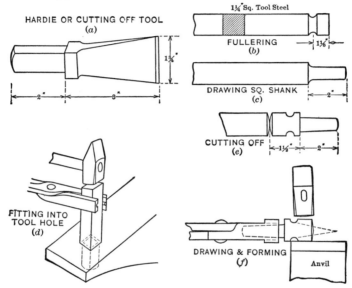

Fig. 115.—Forging a Hardie.

Place the end of the tool in a suitable bottom swage with the nose standing up, and work the stock down with backing-up blows, as illustrated at (d). This will straighten and reenforce the corner. Grind the end slanting and backwards as illustrated to give the tool the proper clearance. Harden and temper the end only at a pale or light straw-color.

Exercise 30. Hardie or Cutting Off Tool

Stock: For a medium-sized anvil use $1\frac{1}{4}$-inch square tool steel. *Operations:* Fullering, drawing, grinding and tempering.

Heat the stock to a bright red heat and fuller in $\frac{1}{4}$ inch on each side, as in (b), Fig. 115, $1\frac{1}{8}$ inches from the end, using a $\frac{5}{8}$-inch top and bottom fuller. Where the size of the fuller does not matter, always use a larger sized fuller, thus making it more convenient to draw the metal. This is of particular value, for it will prevent folding and leaving a crack.

Draw the end square and slightly tapering toward the end to fit the tool hole of the anvil, as shown at (c). Heat the end up to the shoulder, slip the shank into the tool hole, and hammer down, as shown at (d), in order to form a square shoulder. Make proper allowance for the blade, and cut in squarely from all four sides, as at (e), upon the face of the anvil, using a sharp, hot chisel. If the stock is placed over the outside edge of the anvil, the blow has a shearing effect, preventing the cutting edge of the chisel from coming into contact with the hardened face of the anvil.

FIG. 116.—Bottom Fuller.

Fuller in from two sides and draw the stock as illustrated at (f), the dotted lines indicating the drawn blade. Cut off the extra stock and grind the tool to a sharp cutting edge, slightly convex (see Exercise 26), so that it will work itself free from the metal when in use.

The tool described above is used for cutting stock hot, therefore it does not need to be tempered. The blade of a hardie used to cut stock cold should be made heavier and tempered dark blue. A tool such as a bottom fuller, Fig. 116, small mandrels, etc., are forged in practically the same way from flat or round stock with some modification in the design.

Exercise 31. Blacksmith's Punch

Stock: 1-inch square-tool steel. *Operations:* Punching, drawing and forming.

Use a hammer punch and start punching $2\frac{1}{2}$ inches from the end of the piece. Drive the punch about two-thirds through the metal, as in Fig. 117(b), turn the work over, as shown in Fig. 117(c), and repeat the process on the other side, placing the work

over the tool hole in the anvil and driving out the burr. Punch
at a light red heat, and do not try to drive the punch any further
in after the stock has cooled to a dark red heat, because tool steel
is very tough and will cause the punch to bend. Reheat as often

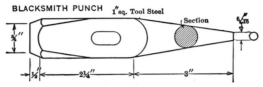

Fig. 117(a).—Blacksmith's Punch.

as necessary to obtain good results, and after more skill has been
acquired no difficulties should arise in punching a hole of the
required size under one heat. The punch and drift pin should
always be in proportion to the size of the stock to be used in making

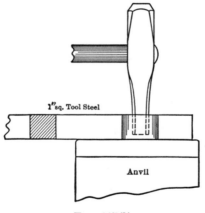

Fig. 117(b).

a tool or a hammer. In Fig. 117(d) is shown a drift pin of suitable
size for punches and smaller sized hammers.

While punching the eye, the stock widens more or less side-
ways, and in order to keep the stock and eye of proper shape,

the drift pin is allowed to remain in the eye, as in Fig. 117(e), while the sides are being flattened down.

To remove the pin, place the work over the tool hole in the anvil, and drive the pin through. Draw the punch to the dimen-

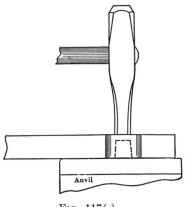

FIG. 117(c).

sions given in Fig. 117(a), square first, then octagonal, and finally round. Cut off the extra stock and grind the punch straight at the end. Make allowance for the head and cut off the tool from the bar, using a sharp, hot chisel. Draw the corners tapered

FIG. 117(d).

toward the ends, form the bevel and square up the end. A variety of punches are used in the forge shop such as round, square, flat, etc., but they are all made in practically the same way. When using heavier stock for making larger tools of this kind, it is advisable to put a small piece of green coal into the

hole after it has been started. This will prevent the punch from sticking provided the punch is slightly tapered toward the end. Blacksmith punches do not need to be hardened or tempered.

Fig. 117(e).

Exercise 32. Set Hammer

Use 1½-inch square-tool steel. Square up the end, punch the eye 2½ inches from the squared end to the center of the hammer, and proceed punching, following the instructions for Exercise 31.

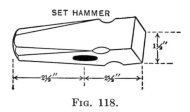

SET HAMMER

1½″

2½″ 2½″

Fig. 118.

To form the depressions across the corners, use ½-inch top and bottom fuller. The face is ground smooth and at right angles to the sides.

Exercse 33. Cold Chisel

A good grade of tool steel $1\frac{1}{2}$ inches square in section should be used for this tool.

Punch the eye $2\frac{1}{2}$ inches from the end to the center of the eye and follow the working instruction for Exercise 31.

COLD CHISEL

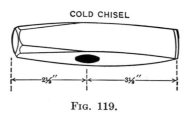

Fig. 119.

Draw to a chisel point, grind slightly convex, as illustrated in Fig. 119, and temper dark blue. (For particulars about grinding see Exercise 26, page 149.)

Exercise 34. Hot Chisel

Use a good grade of $1\frac{1}{2}$-inch square-tool steel. Punch the eye 2 inches from the end, following the working instructions for

HOT CHISEL

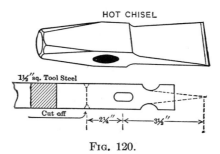

Fig. 120.

Exercise 31. Fuller in $\frac{3}{8}$ inch from the eye, as shown in Fig. 120, using a $\frac{5}{8}$-inch top and bottom fuller to a thickness of $\frac{3}{4}$ inch between the depressions made by the fuller. Draw the end from the shoulders to a chisel point, as indicated by the dotted line

and a trifle wider at the end. Cut off the work from the bar, form the head, and grind the blade to a sharp cutting edge. In grinding the blade the sides should be ground convex and to an angle of about 60°. Do not harden or temper.

Exercise 35. Riveting Hammer

Stock: One-inch square-tool steel. *Operations:* Punching, drawing, grinding and tempering.

Punch the eye 2 inches from the end, following the working instructions for Exercise 31. Draw the end to a chisel point and

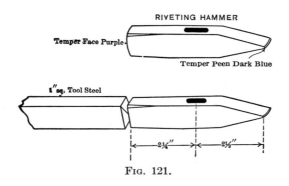

FIG. 121.

cut in (but not off) $2\frac{1}{4}$ inches from the center of the eye. Chamfer the corners, tapering them toward the face of the hammer, as shown in Fig. 121.

After the necessary forging has been done, the work is cut from the bar. Grind the peen semicircular and slightly convex to avoid hammer marks while being used.

Before heating for hardening and tempering, select a pair of suitable tongs that fit into the eye hole or catch firmly across the hammer. Heat the whole hammer slowly and uniformly to a full red heat, for tempering.

Great care must be taken not to overheat the peen. Cool the peen first, holding the hammer vertically and moving it back and forth in cold water. After the peen has been cooled, instantly reverse the hammer and cool the face in the same manner. The

end must be cooled long enough to gain sufficient time to watch the temper colors, but the center section must be hot enough to supply the necessary heat. Cool each end about $\frac{1}{4}$ inch from the eye, polish quickly one side of the hammer and watch the progress of the colors as they approach the ends. While drawing the temper on both sides, the desired color will usually not appear at the two ends simultaneously, therefore it is necessary to watch closely the temper colors as they run toward the ends of the hammer. As soon as the desired color reaches one end, cool that end only immediately by submerging it in water. While doing this the other end must not be neglected; watch it very closely until the desired color reaches that end, then plunge the whole hammer into the water.

The face of a riveting hammer is tempered purple, while the peen is tempered dark blue.

CHAPTER XI

ADVANCED FORGING

A COURSE in elementary forging, requiring four hours per week during one school year, may readily be arranged

FIG. 122.

by selecting the forging operations and exercises given in the preceding chapters. In such classes, there will

doubtless be some boys who have a particular liking for forging and a marked ability in the work; such boys may well be permitted to attempt some of the more advanced work described in this chapter and in Chapter XII. As a suggestion of work that the author has found

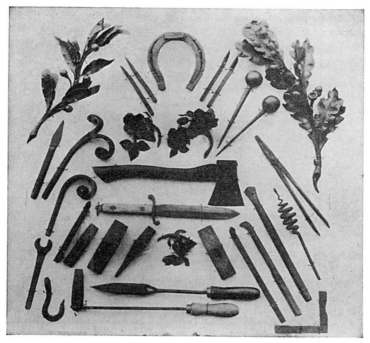

Fig. 123.

feasible with a beginning class, which gives to forging the amount of time just suggested, Figs. 122 and 123 are here given, showing regular exercises and advanced projects executed by boys of the Stuyvesant High School.

The exercises of this and the chapter which follows may also be used in arranging suitable advanced work for even-

ing and trade classes, or for self-instruction. Such work as bending a pipe without filling; making an axe, which involves welding steel to iron; making and tempering a hunter's knife; forging roses or branches of oak leaves, laurel leaves or grape vines, all of which require dies, which can only be made from solid forgings; forging stone drills, connecting rods, levers, S wrenches, chain hooks with swivel, collars for derricks, with loops to the left and right for guide ropes, ice picks, door knockers, etc. will yield much good practice and lead to skill.

Exercise 36. Andirons *

In Fig. 124 a pair of andirons, in front and side elevation, are illustrated. These serve as an example of simplicity in design combined with artistic work. The stock used is $1'' \times 1\frac{1}{2}''$, while the side pieces, ending in a scroll at the top, are $1'' \times \frac{1}{4}''$. The bottoms of the legs of these andirons are first upset on the face of the anvil, and then, after placing each against the neck of the horn or against the side of a bottom swage in the tool hole, with the aid of a top fuller and a few hard blows with the sledge-hammer, each side is reduced to the shape in the drawing. The rings hanging from the scrolls are made of 1-inch square stock, and it may be observed in the side elevation that the ring is slightly tapered as well as gently curved. This adds considerably to the artistic appearance of the entire work. The two collars on each andiron are also placed to enrich the appearance of the pieces.

The short, bill-like projection at the top of each andiron is made either by welding a small piece of iron to the main bar, or by using heavier material and splitting it at that point, while the remainder is drawn out.

69. Heavy Forging. The forgings heretofore described are light and comparatively simple. They are made by hand and by the usual methods, and hence are called hand forgings. Heavier forgings are commonly produced

* It is recommended that a number of boys be permitted to work together, each one making a separate piece or part of the andiron, where this exercise is used with beginning classes.

FIG. 124.—Andirons.

FIG. 125.—Steam Hammer.

by the use of *drop hammers, steam hammers* and *presses.*
This work may be designated as machine forging.

Steam hammers were first used, according to records,
about the year 1840. They were much developed and
improved about the year 1853, and were first used to make
parts of firearms. Since that time they have been greatly
improved. In Fig. 125 is shown a steam hammer of the
ordinary type. The essential parts are the *frame*, the *ram*
or *hammer*, which moves vertically between two uprights
or guides in the frame, the *steam cylinder*, attached on top
of the frame, and the *anvil* on which the hammer strikes.

The bottom of the ram and the top of the anvil are
fitted with steel blocks held in place by means of wedges,

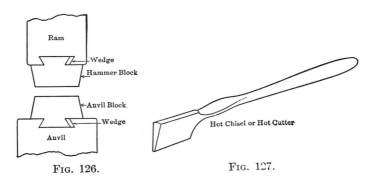

FIG. 126. FIG. 127.

as in Fig. 126. The hammer is started by admitting
steam into the cylinder and by means of the adjusting
levers. The blows may be regulated, becoming light or
heavy as desired.

The tools used with the steam hammer, as well as with
other power or drop hammers, differ widely in design
from those used in common forge-shop practice, although
they serve the same purpose.

70. Tools Used with the Power Hammer. (a) The
hot chisel or cutter is shown in Fig. 127. The handle and

blade are made out of one piece, the blade being tapered
to a flat cutting edge. The section next to the handle is
flattened to allow elasticity and to prevent jarring the
hand while the blows are being delivered. The method of
using the cutter is illustrated in Fig. 128. A flat bar is
cut almost through from one side, then it is turned over
and a piece of steel covering the entire width is placed on
top of the bar, as illustrated in Fig. 128(b). Care must
be taken to place the steel vertically and parallel to the
cut, to produce a smooth and straight end. A quick and
heavy blow upon the steel will separate the piece from the

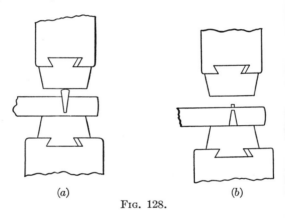

(a) (b)

FIG. 128.

bar. The edges of the cutter and the piece of steel used for
cutting should have sharp corners.

Square stock is first cut equally from all sides. The fin
which sometimes adheres to the work is removed with an
ordinary sharp, hot chisel and sledge. Besides the com-
mon cutter, a variety of circular and rectangular cutters
are used for cutting and trimming.

(b) **The cold chisel or cold cutter** is made very flat
and stout to withstand a heavy blow, as shown in Fig. 129.
The cutting edge is ground sharp, tapered like that of an

ordinary cold chisel, and tempered as such. Stock to be cut cold should be nicked in deep enough to insure the breaking of the metal.

Light stock, after it has been nicked with the cold cutter, may be broken off by lowering the ram or hammer

FIG. 129.

firmly upon the bar, the nick or cut of the bar being even with the edge of the hammer and anvil, and striking a few blows with the sledge upon the projecting end. Tool steel will break more readily and care must be taken not to strike too heavily.

Fig. 130 illustrates the method of breaking heavier stock by using the power hammer after the bar has been nicked. The bar is placed upon the anvil and is blocked up underneath with two pieces of flat stock. (It is better to use one piece of flat stock and bend the narrow edge up to give it a U shape, leaving the center portion hollow.) A short bar of round stock is placed horizontally in the nick of the bar and the bar is broken with one or two blows.

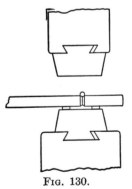

FIG. 130.

Avoid standing near the ends or in line with the bar when employing the above method, and in particular when cutting short pieces of tool steel.

(c) **The fuller,** Fig. 131, is used to form circular depressions from one side. Various sizes of these tools should be on hand, but round bars may be used in their place.

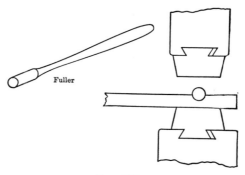

Fuller

Fɪɢ. 131.

For work requiring depressions from both sides, the **combined spring fuller,** Fig. 132(a), is used. The curved section of the handle is made thinner but wider to be more flexible, and permit the tool to be opened to receive the stock. Fig. 132(b) illustrates the tool in use.

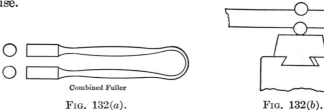

Combined Fuller

Fɪɢ. 132(a). Fɪɢ. 132(b).

(d) **Top and bottom swages,** Fig. 133, are used for finishing and smoothing round material after the work has been drawn out and roughly hammered to the required

dimensions. For use, the bottom swage is placed upon the anvil block with the legs at the bottom projecting over the sides of the anvil.

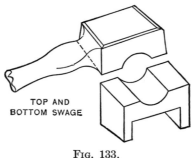

TOP AND
BOTTOM SWAGE

FIG. 133.

Fig. 134 illustrates a combined top and bottom swage.

FIG. 134.—Combined Top and Bottom Swage.

(e) The Side Fuller. The sectional view of this tool is triangular with one sharp and two rounded corners, as shown in Fig. 135. The two sharp corner sides are at

FIG. 135.—Side Fuller.

right angles to each other. The rounded corners are used to form depressions in metal. The forming of right-angled depressions is illustrated in Fig. 136. The depressions

shown are right and left, made with the same tool. Crank shafts are started in this manner, the stock being properly checked to avoid disturbing the center section, while the ends are drawn out.

(f) For tapering pieces of metal, **the combination fuller and flatter** is used as illustrated in Fig. 137. The rounded face of the tool is used first to draw the metal, leaving a rough

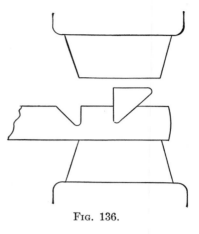

FIG. 136.

surface. To finish, reverse the tool, using the flat side.

The tapering cannot be done successfully between the ordinary anvil block and the hammer, because the working faces of the hammer and the anvil are flat and parallel to each other.

71. Finishing Allowance. For all forgings that require finishing, as where the work is to be machined to the required dimensions to attain smooth surfaces, proper allowance must be made. For small forgings, $\frac{1}{16}$ of an inch may be sufficient; for medium size forgings, $\frac{1}{8}$ of an inch will be enough, while for exceptionally heavy work, $\frac{1}{4}$ of an inch is necessary.

FIG. 137.

On work finished with the file, less allowance is made.

72. Shrinkage. Iron when heated expands, and in order to control the dimensions, particularly the length of large and heavy forgings, caution must be exercised to make the proper allowance when the metal is hot.

A bar heated the entire length to a good forging heat expands about $\frac{1}{8}$ of an inch to the running foot and contracts the same amount on being allowed to cool. The expansion at a dark red heat is less than at a good forging heat, and this also should be taken into account when measuring work that is to be of accurate dimensions when finished.

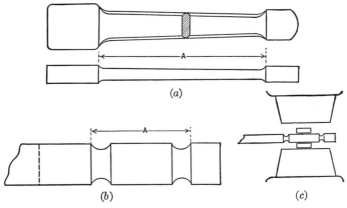

Fig. 138.—Connecting Rod.

Exercise 37. Connecting Rod

This forging, or forgings, of similar type require calculation to ascertain the exact amount of material needed between the given points, so that after the metal has been drawn out, it may have the proper length and dimensions.

For this calculation, estimate the volume in cubic inches of the finished connecting rod between the shoulders A. Lay off the same number of inches on the bar, add for finishing if called for, and also make slight allowance for waste and scaling. Fuller in,

using a combination spring fuller. Draw the section between the shoulders, first using a steel block and set hammer (Fig. 139) until the metal is stretched long enough to clear the edges of the anvil and hammer between the shoulders A. When this is accomplished, remove the block and set hammer, and continue drawing directly upon the anvil. Finish the edges in a top and bottom

FIG. 139.—Set Hammer

swage. Make the proper allowance and cut off the work from the bar.

While drawing the material, hold the stock horizontal on the face of the anvil block to avoid shock or jarring of the hands, and turn the work either to the right or to the left and at the proper angle so that the sides will remain rectangular. If the work should become twisted and out of shape, due to not turning the work to the proper angle, it may be corrected by working the square edges down, as illustrated in Fig. 140.

FIG. 140.

Work to be drawn and finished round should be drawn square first, then octagonal and finally round, to prevent unnecessary shifting of the structure, because the iron is liable to split. The tongs to be used for short pieces of work should be carefully selected to insure a firm grip. A ring or a link is frequently used which is slipped over the reins of the tongs, making the handling of the work more easy.

In making the larger sizes of connecting rods, make proper allowance on one end, then fuller in and draw the section to the required dimensions. It is advisable to make the section a little shorter in length than the finished work. Then make final allowance on the ends, fuller in and finish.

The ends of connecting rods are secured to the crank in various ways, therefore they are of different designs. The center section A, Fig. 138, is usually drawn flat, slightly tapered toward one end, and the narrow edges are rounded off or left square. Sometimes the entire section is drawn out round.

NOTE: To calculate the amount of stock by weight necessary for a forging, find the volume in cubic inches and multiply by .2779, which is the weight for wrought iron per cubic inch.

On steel forgings multiply by .2833, steel being a trifle heavier than wrought iron.

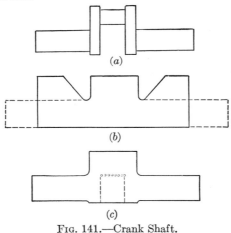

FIG. 141.—Crank Shaft.

Exercise 38. Crank Shaft

Make the necessary allowance for the center section and ends. Form depressions right and left, as shown at (b) in Fig. 141, using a side fuller. Draw the ends as indicated by the dotted lines straight on the lower side to the required dimensions, first square, then octagonal, then finally round. Finish by using the top and bottom swage, and straighten and examine the work. The center section indicated by dotted lines in (c) is usually cut out by the machinist. A number of holes are drilled as shown, two slits

are cut with a cold saw following the dotted lines, and then the block is forced out with the hammer.

Small crank shafts may be bent up out of round material. Another but older method consists in making crank shafts of wrought iron, welding up the pieces of flat and round stock. Of late, crank shafts are made of machine steel by the method described above or by drop forging.

Exercise 39. Solid or Weldless Ring

From suitable flat stock cut out a disc, using a curved or circular cutter. Square and true up the disc and through its center punch a hole large enough to receive a steel mandrel. The mandrel is inserted and placed upon a U-shaped rest, as illustrated in Fig. 142. The lugs of the U rest project at the bottom and fit over the anvil block, to prevent it from being displaced, and two V or semicircular depressions are made on top to keep the mandrel in place. Turn the ring while forging it into shape, thus increasing its width.

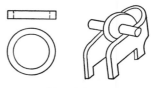

Fig. 142.

Mandrels of larger size are inserted as the diameter of the ring increases, to insure a smooth and more even finish.

73. Drop Forgings. Many complicated forgings are made by drop forging. The process consists in making forgings in dies which are in two parts. The dies are made to conform to a drawing or model. One die is fastened to the ram or hammer, the other is held stationary on the anvil or foundation block. The ram or hammer is raised vertically to any desired height, then released to drop. The blow of the upper die will force the heated metal into the depressions made in the top and bottom die.

In Fig. 143 is illustrated an engineer's wrench, forged by drop forging, with the surplus metal which is to be removed cold with the trimming dies on a special machine made for this purpose.

Plain and small forgings can be made under one operation, while for complicated and curved work more operations are required. Dies are often made for two or three operations, as some work requires drawing or blocking out and bending before completing in the stamping dies, thus enabling the operator to finish a forging under one heat without changing the dies.

For heavy and complicated work a number of dies may be required, which are fitted to a number of hammers, so

FIG. 143.

that the heated metal is passed from one hammer to another until completed under one heat.

A variety of hammers are used for drop forging, the most common type being the *board drop* and the *steam drop*. Steam hammers and power hammers, the latter running by belts, are quite frequently used for drop forgings, for stamping sheet metal and for leaf work. Trip hammers and vertical and horizontal presses are also used.

Crank shafts, wrenches, yoke ends, crane hooks, connecting rods, socket wrenches, bolts, eye bolts, etc., are made by the drop forging process.

74. Bending Angle Iron. Fig. 144 shows how to bend an angle iron in a curve by means of a practical device. To make the form, a piece of square stock is necessary. An angle is riveted to the square bar, as shown in the figure, to hold the angle iron in place. The outer corner of the square stock, which comes in contact with the inner corner of the angle iron, should be rounded off to prevent it from denting the hot metal while the latter is being curved on the form.

Heat the section to be bent uniformly, and with light blows hammer the sides of the iron closely against the sides of the form.

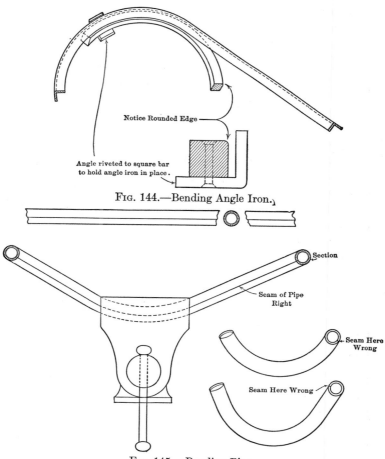

Notice Rounded Edge

Angle riveted to square bar
to hold angle iron in place.

FIG. 144.—Bending Angle Iron.

Section

Seam of Pipe
Right

Seam Here
Wrong

Seam Here Wrong

FIG. 145.—Bending Pipe.

75. Bending Pipes. In Fig. 145 is illustrated the proper way to bend pipes. In order to obtain good results

the pipe should be heated uniformly where it is desired to bend it.

When a full red heat, which is more advantageous than a light red or scaling heat, has been obtained, the heated section is fastened loosely in the vise with the seam or line showing where the pipe was originally welded at one side, and not at the bottom or top, because while bending both the top and bottom of the curve are strained, and if the seam were thus lengthened or shortened, the pipe might open. Thus fastened, the pipe is easily bent by raising or lowering both ends. Do not bend sideways or the corners of the vise will work themselves into the pipe, disfiguring or flattening it.

A very old and prolonged process of bending pipes consisted in plugging one end with a removable cork and filling the pipe with rammed sand, which for this purpose had to be sifted and dried. If the sand is not dried before placing it in the pipe, the result is an explosion or bursting open of the pipe when the latter is heated for bending.

76. Welding Pipes. In Fig. 146 is illustrated the method of welding boiler pipes. Gas pipes are more difficult to weld because the seam is made by the butt weld, therefore it is liable to open. The seam of the boiler pipe, however, is made by the lap weld, which will offer more resistance. A suitable bottom swage to receive the pipe, two hammers and a special made pin are the tools required to carry out a weld of this kind. The pin is made from a short piece of round iron that will fit into the pipe loosely. Both ends are tapered, and to one end a bar of round iron is welded, which is to be used as a handle. The bar should be left several inches longer than the length of the pipe to be welded. Its length should be measured from the center of the pin to insure perfect control.

Before applying the welding heat slip the pin into the pipe so that the heavy end will project half way through, and on the opposite end make a chalk mark on the handle

bar even with the end of the pipe, so that no time may be wasted in placing the pin properly after the welding heat has been applied. Remove the pin from the pipe and heat it to a red heat to avoid chilling the thin walls of the pipes too rapidly. Then slip the pin again into the pipe, but several inches from the end which is to be welded.

Apply the welding heat and remove both pieces quickly from the fire. One piece should be handled by the helper

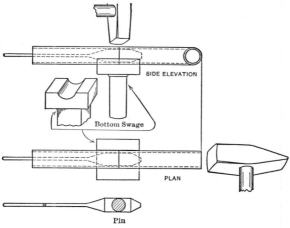

SIDE ELEVATION

Bottom Swage

PLAN

Pin

Fig. 146.—Welding Pipe.

and placed in the bottom swage. Bring both pieces in close contact, slip the pin quickly through, the chalk mark even with the end of the pipe. While one man is forcing the pipes together by hammering from the end, as illustrated, thus upsetting the pipe, the other man hammers down the sides rapidly. If necessary, apply another welding heat. Withdraw the pin several inches from the section to be welded while applying the welding heat, and repeat the same process.

77. Punching Round, Square and Heavy Stock. The punching of round or square stock is quite frequently

necessary on railing work, window guards and in certain designs for ornamental work. In accomplishing this, there is no necessity for upsetting the bar, as is the general belief, except in exceptional cases. The important point consists in punching the bar in such a manner that as little as possible of the metal is wasted and that the sides of the hole are left as heavy as possible. The tools required are made in accordance with the size of the hole to be punched. Fig. 147(a) shows a slit chisel, which is similar to a cold chisel with the exception that the former has three sharp cutting edges, while the latter has one. The three cutting edges are slightly tapered toward the end so that the tool will work itself free and not stick to the metal.

Slit Chisel

Fig. 147(a).

The width of the slit chisel should be about one and one-half times the diameter of the hole. Heat the bar and drive the slit chisel about two-thirds into the center of the bar. Turn the work over and drive the chisel through from the opposite side. To split round stock, place the bar in a large bottom swage, as the bar will spread.

The next step is to use a round drift pin drawn to a tapered flat point with the sides well rounded off, as shown in Fig. 147(b). In driving the pin through the metal will spread sideways, thus forming a round hole. (Note that the bar will become a trifle shorter, which must be taken into consideration when punching a number of holes in one bar.)

Drift Pin

Fig. 147(b).

Fig. 147(c) illustrates a round iron bar punched and finished. Where many holes must be punched, it is advis-

able to make a form to insure more uniformity. A form for this purpose is shown in Fig. 147(d). Two pieces of flat iron of suitable thickness are fitted to the punched bar and fastened by means of rivets to a heavy sheet-metal plate. Drill a hole in the center of the eye through the plate large enough to receive the drift pin and then finish the bar in the form by placing it directly

FIG. 147(c).

FIG. 147(d).

upon the tool hole of the anvil, and driving the pin through. For large size holes, place the form upon the swage block, or use a suitable bushing with a bore large enough to receive the drift pin.

FIG. 148(a).

Fig. 148(a) illustrates the three steps in punching a square hole in a square bar. Split the bar first, then use a round, and finally a square drift pin. The upper bar in

the figure portrays the steps in punching a square hole diagonal to the axis and the middle one the same operation with the hole rectangular to the bar in square stock. Much more difficult is the punching of a square bar through the corner, that is, starting the punch from one corner and meeting the opposite corner on the other side of the bar. The operations are practically the same, but more skill is required. Upset slightly the section to be punched and split the bar in a V-shaped tool, Fig. 148(b), with the center section wider in order to allow the metal to spread.

Fig. 148(b).

SECTION A-A

Fig. 148(c).

Open the slit in a special made die, Fig. 148(c), using a round drift pin first, then use a square pin and finish.

In punching wide, flat stock, and on all work where the width of the material right and left from the hole is not taken into account, an ordinary round or square blacksmith punch should be used, thus punching a round or square hole under one operation. On heavy material place a small piece of green coal in the hole after it has been started, to prevent the punch from sticking. Drive the punch about two-thirds through, turn the work over and repeat the same process from the other side. The burr is driven through into the tool hole of the anvil, but for larger holes use the swage block or a suitable bushing.

The common and simple method of punching iron hot by driving the punch through does not work to advantage if used to punch round or square material. A round or square hole punched in a round or square bar, no matter how small it has been started, will *stretch or draw the sides lengthwise*, making the bar longer and the sides too thin when using the drift pin to widen the hole to the proper size. In other words, it will be noticed that the bar is considerably weakened, disfigured and out of proportion even though the bar has been previously upset, which is not necessary. Round and square stock *should first be split* so that when the drift pin is driven through the split section will spread right and left, making the bar shorter but leaving practically about one-half of the bar on each side, which is sufficient.

Fig. 149 shows a flat, iron connection quite frequently used on heavy railings and window guards. The most

Fig. 149.

common and economical way to make a connection of this kind is to use a piece of flat stock having the full width and thickness called for by the drawing.

Lay off the dimensions and punch out the corners and sides on a punching machine, using a square punch. The ends should be left wider, as shown. This allowance is made for welding. The eye or center section is also punched out on the punching machine. When no flat punches are on hand use a square punch, which will require two operations.

CHAPTER XII

ART FORGING

If the student has completed a reasonable number of the preceding exercises, it is to be assumed that he is familiar with the principles of simple forging and that he has acquired some skill.

The more artistic and difficult work of this chapter may, therefore, be attempted. In outlining these exercises, many details have been omitted, as the student should be able to supply them from his own knowledge, and the more general suggestions and directions only are given.

Exercise 40. Lock Plate

Fig. 150(a) shows a lock plate with a door handle. From ⅛-inch sheet metal cut out the plate in the form desired, and hammer off one side of the plate, using a ball-peen hammer to enrich the appearance of the design. The holes for the nails are next drilled.

In making the keyhole, drill a number of holes and cut and file out the opening to fit the key. Use 1-inch square stock for the handle support and make proper allowance for the spindle. Fuller in and draw the end square first, as shown in Fig. 150(b), then octagonal and finally round, leaving a short section square at the shoulder to prevent the handle support from turning in the plate.

Cut the work from the bar, making the necessary allowance, and square up the shoulder and the top in a ½-inch square heading tool, as illustrated in Fig. 150(c). Finish the head of the handle support by filing the corner down, thus forming a square diagonal to the original square stock. Cut off the extra stock of the

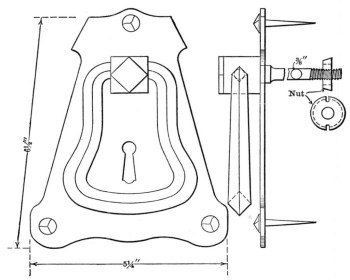

FIG. 150(a).—Lock Plate.

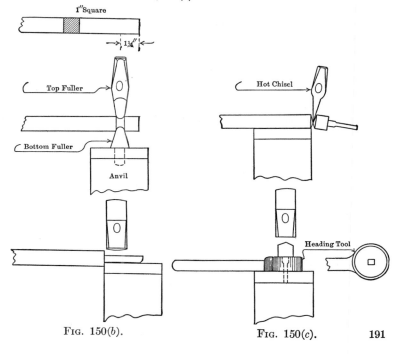

FIG. 150(b).

FIG. 150(c).

191

spindle, thread the end and use a round nut as illustrated, having the sides beveled to insure a smooth finish if used on a wooden door.

The handle is made from $\frac{9}{16}$-inch square stock, tapering the ends

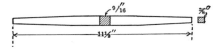

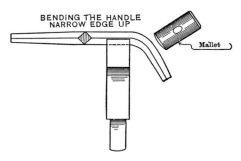

BENDING THE HANDLE
NARROW EDGE UP

Mallet

Fig. 150(d).

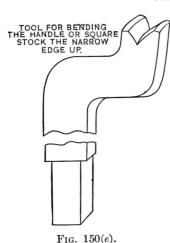

TOOL FOR BENDING
THE HANDLE OR SQUARE
STOCK THE NARROW
EDGE UP.

Fig. 150(e).

to $\frac{3}{8}$ inch, as shown in Fig. 150(d). To bend square stock with the narrow edge up, make a tool as illustrated in Fig. 150(e), to fit into the tool hole of the anvil, or to be fastened in the vise. The top is V-shaped to receive the square stock, and to avoid flattening or disfiguring the edges while being bent. Heat the handle and bend it, as shown in Fig. 150(d), using a mallet. After the bending has been completed, file the ends round, forming a tenon and drill a hole of the proper size through the handle support.

Heat the center section of the handle and open its end just far enough to receive the handle support and then close it by pressure, using the vise.

Forge the nails as described and illustrated on page 44.

Exercise 41. Flame Ornaments

The tops of the upright bars on fences are ornamented in various ways. Plain fences usually have the ends drawn to a

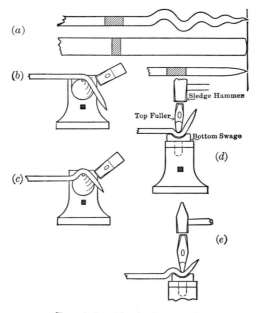

Fig. 151.—Flame Ornament.

point, others are decorated with cast-iron ornaments, still others are highly ornamented by pieces welded to the bar to conform with the design. Frequently a design is used such as is shown in Fig. 151, called a *flame ornament*.

Draw the end of the stock to a short chisel point. Make the proper allowance and bend the end over the horn, as illustrated

at (*b*), to nearly a right angle. Turn the work over and bend in the opposite direction as at (*c*). Continue forming the curves in this manner, each curve to be a trifle smaller than the last, but be sure that the central axis of the work is straight when finished.

Another method employed is to use a bottom swage and a top fuller, as illustrated at (*d*) and (*e*). Use at first a large-sized swage and fuller and change sizes as necessary to conform with the drawing. Finish the end on the edge of the anvil.

While bending over the horn, the bending may be confined to the portion of the bar to be worked by cooling the section finished with water.

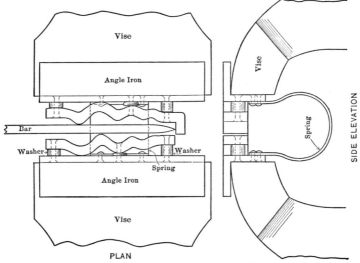

FIG. 152.—Form for Making Flame. Ornaments.

When many bars are to be shaped as above, it is advisable to make a form as illustrated in Fig. 152. The first piece or sample is bent by one of the methods already described. Two pieces of wider flat stock are shaped and fitted, one to the right, the other to the left of the bar. When finished, the pieces are fastened by means of rivets,

each to a short piece of angle iron. To fasten the uneven pieces securely to the angle iron, block the space with washers as shown. A spring of flat stock connects the two angles at the bottom so that it may be opened and closed. The form is placed in a vise, and after the bars have been drawn to a stout chisel point they are heated again, slipped between the form with the point of the bar touching the angle bent on the end to insure uniformity. The vise is quickly tightened and opened, thus completing the process.

A number of bars should be kept in the fire, as the entire operation takes only a few seconds. Hundreds of bars may be shaped by this method in one hour.

In Fig. 153 is shown a flame ornament of square stock

Fig. 153.

bent with the narrow edge up. Use a tool and mallet, as in Exercise 40.

Exercise 42. Spirals

Fig. 154(a) illustrates a spiral made of one wire. Spirals are made in various sizes from light and heavier wire to conform to the design and are used for ornamentation in ornamental iron work.

Many methods are employed in making spirals, one of the most common ones being as follows:

Draw the end of the wire and bend a short section in a right angle. Make the proper allowance for the spiral and bend the wire in the opposite direction, giving the shape illustrated in Fig. 154(b).

Anneal the entire length of the wire between the two bends. Using a piece of pipe or round iron of the proper size, fasten the stem against the iron in a vise and wind the wire around the

form by hand without leaving any space between the coils. As the stock becomes shorter, winding by hand will become more

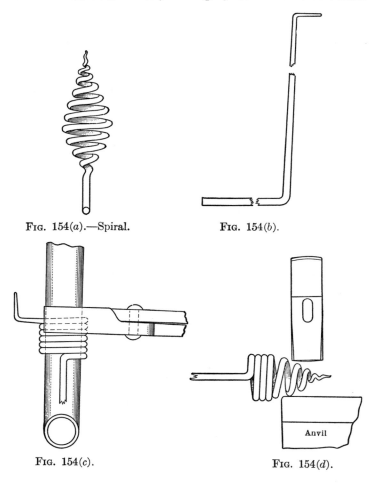

FIG. 154(*a*).—Spiral.

FIG. 154(*b*).

FIG. 154(*c*).

FIG. 154(*d*).

difficult, therefore it is advisable to use a pair of tongs, as illustrated in Fig. 154(*c*). Finish winding by forcing the wire against the pipe by turning the tongs around.

The finished spiral so far is of cylindrical form. It is now removed from the bar, heated and partly opened, using a screw-driver or long thin chisel. Narrow the spiral, beginning at the center and working toward the end, using a light hammer as shown in Fig. 154(d). Turn the spiral while doing this in order that the end may be in the center. Repeat the process for shaping the bottom side of the spiral, using the outside edge of the anvil. To finish, apply a uniform heat, and use a chisel or a small pair of tongs to equalize the spaces of the spiral.

Fig. 154(e).

Another method consists in forming the spiral cold, using a vise, as shown in Fig. 154(e). Start in the same manner as described above, narrow the top and bottom in the vise by pressure.

Spirals of two, four, six or more wires are more difficult to make. Fig. 155 shows a spiral made of four wires. Draw the ends of all four wires uniformly. To weld all four wires at one time at the end, hold them together by twisting a thin wire around them as illustrated at (b). Make the proper allowance and weld the opposite end. Apply a uniform heat, fasten the end horizontally in the vise and twist the section between the welds as at (c).

Water should be kept on hand to control the operation if necessary by cooling a section that has already been twisted sufficiently. The tapered end in particular needs special atten-

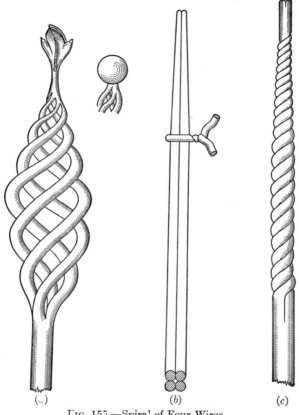

Fig. 155.—Spiral of Four Wires.

tion while twisting, as this section, being thinner, will twist more readily.

The next step is to open the spiral, and to do this heat the entire length of the twist to a uniform red heat, fasten the end or top horizontally in the vise, and open the spiral by twisting in

the opposite direction with a slight pressure against the vise. Use water if necessary to insure uniformity.

Irregular sections may be corrected by using a small pair of tongs or a chisel or a screwdriver, pressing them between the wires. The top of spirals of this kind usually ends in a leaf or ball ornament. To make the leaf ornament, the stock is spread or flattened, cut out and shaped. For a ball ornament, the end is drawn out round and threaded, and the ball is tapped and screwed to the top; if preferred, the ball may be welded to the top.

Exercise 43. Spiral Ornaments Made from the Solid

Split the square bar centrally from all four sides while it is hot, using a sharp chisel. Square up the rough inside edges

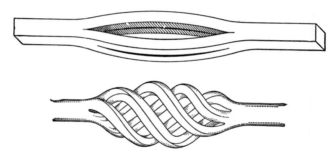

Fig. 156.—Spiral from Solid Stock.

while hot by using an old half-round file. Straighten the split section carefully so that the joints will come in close contact, apply a uniform heat, and twist and open the spiral, as explained for Exercise 42. While opening, the spiral becomes shorter, therefore the necessary allowance should be made and a long enough piece of stock used.

A spiral of this kind may be made also in the following manner: Cut off four short pieces of stock long enough to make the spiral and in addition make the necessary allowance at the ends for welding. The thickness of the stock is determined by the thickness of the bar it is to be welded to. For instance, a 1-inch bar

would require four pieces of $\frac{1}{2}$-inch material. Upset the ends and weld them together on both ends, scarf and weld to the square bar. Proceed with the twisting and opening as already described. The latter method requires less skill.

78. Form for Bending Stock. Fig. 157 explains the operation of a simple device for bending flat, square or round stock. By means of the wheel attached to the lever bar, and through proper adjustment, iron may be bent to any radius. The entire apparatus is simple, easily made

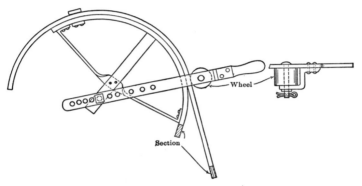

Fig. 157.—Form for Bending Stock.

and very economical. It consists of four pieces of iron, a wheel and a clamp. Two of these pieces are flat iron bars, one longer and the other shorter. Both the longer and shorter bars serve to keep in place the semicircle, which is also made of flat iron, but a little stouter than the other two bars.

The fourth piece is a long bar which serves as a lever, having a wheel riveted or bolted on one end. The lever can be used for larger or smaller forms by drilling another hole in the lever bar for the required radius. If the form is to be used for hot stock, it should be made exactly the required size. On the other hand, if it is to be used to

bend cold stock, it is advisable to make the form slightly smaller to allow for elasticity.

79. Scrolls. Scrolls are used in ornamental iron work for decoration. In order to carry them out, a full-sized drawing is required. A knowledge of design and a trained eye are essential to attain harmonious combinations of curved and straight lines.

A labor-saving device for tracing the drawing from the paper to the sheet iron is to rub chalk on the back of the drawing; then by tracing the latter, a full, clear impression is made upon the sheet iron. Where many scrolls are to be made, it is advisable to make one entirely by hand according to the drawing, and from the sample to make a *scroll form*. This will insure uniformity as well as save time. Scrolls are made singly and combined and vary greatly in design. Fig. 160(*a*) shows a simple scroll made from flat stock, combining one of the simplest methods used for this kind of work. Scrolls may be made from flat, square or round stock.

To determine the length of stock required, a string or a thin wire is carried around the scroll on *the center line* of the drawing, i.e., the dotted line of Fig. 158.

Another but slower method is to use a pair of dividers, *following the center line*, stepping it off in short sections and counting the number of steps. This method is frequently adopted in the drafting room.

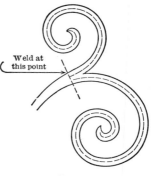

Weld at this point

FIG. 158.

A **measuring wheel** or disk is sometimes used to measure the inner diameter of rings and bands. It consists of a wheel or disk 5 to 8 inches in diameter, mounted through

its center by a rivet or axle to a handle. The measuring wheel is an absolute requisite for the wheelwright, for all wheels have their tires shrunk on, and therefore an accurate measurement is necessary.

In using the measuring wheel, a point is marked on the inner surface of the band and at the same time one is marked on the edge of the wheel with a scriber, soapstone pencil or chalk. Starting with the marks together, as in Fig. 159, the wheel is moved around the curve, following the

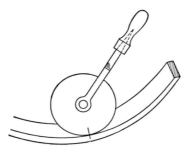

FIG. 159.—Measuring Wheel.

center line, and the revolutions are counted and the part revolution between the marks determined. Measuring wheels may be purchased which make this work easy, as they usually have a scale of inches or centimeters on the circumference.

Exercise 44. Forging a Scroll

The end or *eye* of the scroll should be spread, as illustrated in Fig. 160(*b*), using a cross-peen hammer. Draw and spread in proportion to the thickness of the stock, but exercise care not to make the end too thin. Commence to bend over the scroll starter, Fig. 160(*c*), a tool resembling a hardie and having a curved top. Where no scroll starters are on hand bend the end of the scroll over the edge of the anvil, making a narrow curve,

as shown in Fig. 160(*b*). Feed the stock forward and continue bending partly over the anvil and partly upon its face, as in Fig. 160(*d*). The blow of the hammer, delivered as illustrated, will bend only the section indicated by the arrow.

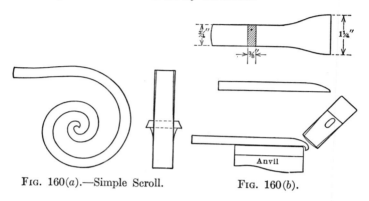

FIG. 160(*a*).—Simple Scroll. FIG. 160(*b*).

Heat the stock uniformly and continue to bend the remainder of the scroll, as already explained, or by using a top and bottom scroll fork, such as illustrated in Fig. 160(*e*). The inner sides of the scroll fork must be parallel to each other and their inside

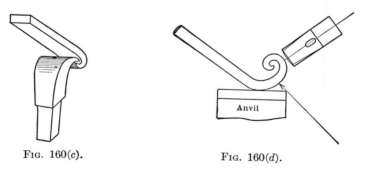

FIG. 160(*c*). FIG. 160(*d*).

faces rounded off in order to avoid marks on the scroll. The top part of the scroll fork is used as a lever, and by gradually feeding the scroll between the top and bottom fork the best results are obtained. The finished scroll should have continued

lines to conform with an approved drawing, as the presence of kinks or irregular bends will depreciate the appearance.

The scroll form, Fig. 160(*f*), is made of wider and a trifle thicker stock than the iron used for the scrolls. The form is started in the same manner as the scroll and is bent and fitted approximately into the sample scroll and then a uniform heat is applied to it. Fasten the sample scroll in the vise, the end in a horizontal position so that the vise will clear the projecting side of the scroll form, and slip the heated scroll form into the scroll. Strike a few blows on the cool end of the form, thus

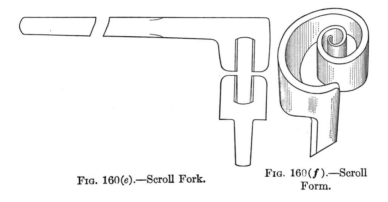

FIG. 160(*e*).—Scroll Fork. FIG. 160(*f*).—Scroll Form.

driving the outside wall of the scroll form against the inside wall of the sample scroll.

The end of the scroll form may be bent and fitted into the tool hole of the anvil and held there by means of a wedge or it may be left straight so that it can be fastened in a vise. The start of the scroll form should be the highest point, while the other sides should gradually sink lower. This will allow the ends of the scrolls to be made from the form, to be carried around the form without twisting or disfiguring the started scroll. For light work the scrolls are bent cold around the form after the end of the scroll has been drawn and started. In this case the form should be made a trifle smaller than the finished scroll to allow for elasticity.

80. Welded Scrolls. In Fig. 161 is shown two welded scrolls fastened by means of a ball-pin rivet and collar to the bar. Scrolls of this kind require more skill and can be made from square, flat or round stock. The scrolls shown are made from several pieces of ¾-inch square mate-

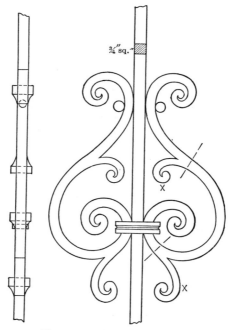

¾″ sq.

FIG. 161.—A Welded Scroll.

rial. For the scrolls marked X in the figure use $\frac{3}{4}'' \times \frac{1}{2}''$ flat iron.

To find the length of material necessary for each part measure as previously directed, starting from the place the welds are to be made.

Another method of making scrolls is to weld a piece of round iron to the end, to form the eye, before starting

the scroll. The eye should be raised, giving the scroll a more artistic appearance, as shown in the side elevation.

Exercise 45. Forging a Welded Scroll

Start the scroll by making the eye of the scroll first. Spread and draw the end to a chisel point, as shown in Fig. 162(a). The extremity of the eye ought to be slightly rounded to a hook-

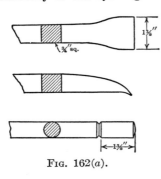

Fig. 162(a).

like form, so as to insure better control when placed upon the piece of round iron to be welded to it, as the latter is liable to roll on the anvil. Use $\frac{5}{8}$-inch round material for the eye and make proper allowances as indicated. Cut in on the hardie (but not off) from all sides, apply a welding heat to it as well as to the end of the flattened scroll bar and weld them together, as shown in Fig. 162(b). Break off the round bar by bending it back and forth and apply another welding heat to insure a more thorough weld.

Commence to form the scroll by bending it as directed in Exercise 44. Bend the *ends only*, while the rest of the stock is left straight. Weld the scrolls by the fagot weld and scarf end. Upset and scarf the other piece to be welded, as shown in Fig. 162(c). Then weld and continue in this manner until the five pieces are assembled, as Fig. 162(d).

Bend the scroll partly over the scroll starter or over the horn and continue to bend in the top and bottom scroll fork.

In Fig. 162(e) is shown a scroll bent around a scroll form. This is accomplished by applying a uniform heat and by placing the eye of the scroll, properly started, so that it will catch in the hooklike eye of the form. By a combined pull and winding motion the scroll is then easily bent. A welded section is more difficult to bend, being thicker at that point and so usually it is bent in a scroll fork or by striking it a few light blows. Care

must be exercised in straightening the scroll to place the eye in the tool hole or allow it to project over the edge of the anvil. Welded scrolls should be made as accurate as possible so that very little time is required for final fitting or setting when cold.

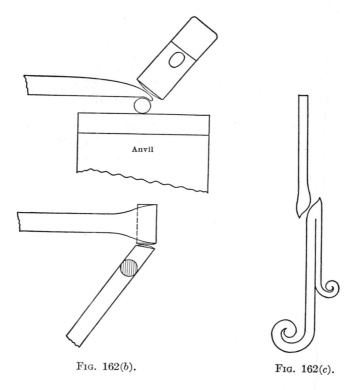

Anvil

FIG. 162(b). FIG. 162(c).

Work of this kind ought to be finished on the anvil so that little filing is necessary.

The eyes of scrolls are quite frequently rolled in at the end of the stock, leaving the eye flat and not raised, that is even with the width or thickness of the material. Such scrolls have not the artistic appearance of those already described and very little time is saved.

81. Other Forms of Scrolls. An inexperienced worker may prefer to join complicated scrolls by rivets. The smaller scrolls are drawn out to a chisel point and riveted to the main scroll as shown in Fig. 162(*f*). Scrolls may

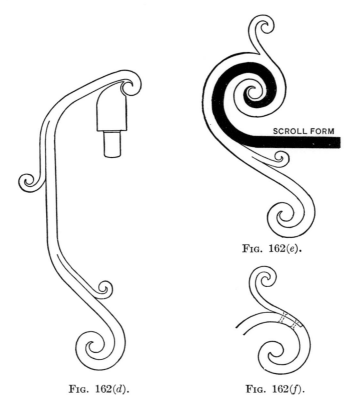

SCROLL FORM

FIG. 162(*e*).

FIG. 162(*d*). FIG. 162(*f*).

be joined by this method where leaf work is used for ornamentation and where the leaves will cover the joints. In this case the fitting and joining need not be done very accurately. There are designs, however, where the scrolls are joined purposely by means of rivets and collars, and the

ends of such scrolls are shaped in a way to serve as additional ornament. The rivet heads and collars furnish added decoration.

Fig. 163 shows still another type of scroll eyes. The end of the stock is upset, spread and then split. The larger groove in the center is drawn with a narrow fuller, while the smaller grooves on the sides are drawn with a hand tool called a *veiner*. This tool is much like a cold chisel, but instead of having a sharp cutting edge, it has a semicircular or round edge like a fuller.

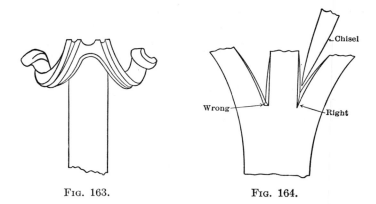

FIG. 163. FIG. 164.

On hinges and work of Gothic design, the smaller scrolls or ornaments are quite frequently split from the solid stock. To obtain good results and not weaken the scrolls at the joint, use a hot chisel and split lengthwise with the metal from the end as shown in Fig. 164. The illustration also shows the right and wrong way of splitting the stock. If the material is split across, the joining section is weakened and liable to break if much bending and shaping is done.

In cases where it is not possible to split lengthwise, use a chisel that has three cutting edges; the narrow sides

of the chisel should be ground to a sharp cutting edge as well as the blade.

Fig. 165 shows an adjustable scroll fork, a very handy tool for bending scrolls.

FIG. 165.—Adjustable Scroll Fork.

82. Leaf Forms. A good problem for the beginner in leaf forging is the laurel leaf. The natural forms of the plants must first be studied, and all minute details in treating the material must be avoided. The artsmith who carries his work to the smallest and finest details will never produce the effect that may be secured by means of free, but sure, strokes. It often happens that in work of this kind the leaves and flowers are perfect, but the grouping is poor. Proper grouping is really an art by itself which must not be neglected if the finished work is to produce the proper effect when viewed from a distance.

Laurel and oak leaves are usually welded in groups of two, three or four and arranged in a free and natural manner. The berries and acorns are welded to the stem singly or in groups of two, as one wishes.

Grouping in wreaths, garlands, or festoons is quite a different problem, as for this work drawings or models are necessary in order to give harmony, and bring out the effect of the whole. In making garlands involving the use of various forms of flowers and leaves, one must especially avoid too much uniformity and similarity. The leaves and flowers must not be grouped too closely but must be arranged in a very free and natural manner. If the artsmith has had the proper training, the enormous sums of money often spent for plaster of Paris, wax, or wood models may be saved.

Exercise 46. Forging Laurel Leaves

Fig. 166 illustrates a group of laurel leaves and berries welded to a rod which forms a branch. Leaves of this kind cannot be made successfully of sheet metal, as the latter cannot produce a rigid stem, therefore the leaves will twist at the stem, as it is the weakest point. They should be forged from square or round stock, thus saving labor, as a laurel leaf of ordinary size can easily be forged under one heat, requiring no trimming, as the

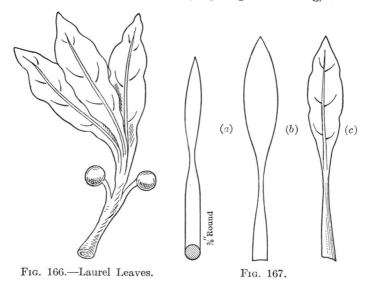

FIG. 166.—Laurel Leaves. FIG. 167.

leaves are never of one size; in fact they should vary a little in width and length.

Draw the end of the stock to a point, make proper allowances and form the stem, as shown in Fig. 167 at (a), upon the horn of the anvil. Flatten the stock to form the leaf upon the face of the anvil. The leaf should be about $\frac{1}{16}$ inch in thickness and become heavier near the stem. In Fig. 167 at (c) is shown the vein raised in the leaf, wider at the stem and gradually becoming thinner toward the end. To form this vein a tool called a *veiner*

is necessary, which is much like a flat punch ground slightly convex and on a slant as illustrated in Fig. 168 at (a). In striking upon the tool, the metal is forced to one side, leaving a ridge called the vein. The side veins are lowered or cut in, using a veiner which looks much like a half-round chisel having the edge ground round, or convex, as at (b). A slight variation should exist between the positions of the side veins.

VEINER

(a) (b)

FIG. 168.

Anneal the leaf and shape it cold upon a lead block, using a riveting or ball-peen hammer and also raising a few sections on the edge of the leaf as indicated in the drawing.

To forge the berries, a top and bottom die as shown in Fig. 169 is necessary. These are made from steel, and a steel model of the berry turned upon a lathe is necessary. After the forging of the dies has been completed, heat the faces to a good red heat, place the bottom die in the tool hole of the anvil, place the model between it and the top die, and drive the dies together with a sledge hammer, thus sinking the cold model into the heated dies. Sometimes more than one heat is required. Finish at a black heat to obtain a smooth surface. The corners of the impression in the dies should be rounded off with a file to keep the metal from sticking while forging the berries.

Round stock is used in forging the berries, and it must be proportional to the size of the dies. Make proper allowances and fuller in as shown in Fig. 169. Then heat the piece to a good forging heat, and place it between the dies. The first few blows should not be too heavy, and it is necessary to turn the metal between the blows. If cotton waste is soaked in oil and gently rubbed over the depressions in the dies, it will make them work more freely. The scale that gathers in the bottom die should be removed.

In Fig. 169 is shown a finished berry cut in on the hardie ready to be broken off and drawn out. Leaves and berries are welded

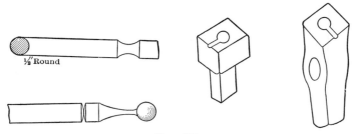

FIG. 169.

together by the fagot weld. Sometimes three or four leaves are welded at one time and afterwards welded to the branch.

The assembling of a branch is accomplished by welding the three or four leaves together which are to be the extremity or tip of the branch and by successively welding other groups of leaves further down, always working toward the bottom of the branch ; never from the stem toward the tip or top.

83. Flower Table. In Fig. 170 is shown a flower table with three legs, ornamented with branches of laurel leaves. The stock used for the legs is $\frac{1}{2}$-inch round iron, while the three rings are made of $\frac{3}{4}'' \times \frac{1}{4}''$ flat stock. The plate at the top is made of copper with the center sunk in, leaving a margin or rim about 2 inches

FIG. 170.—Flower Table.

wide. The branches are fastened to the table by means of rivets. The ends of the stem of each branch are shaped to appear as if they had been torn from the plant.

Exercise 47. Oak Leaves

Oak leaves are of different design but are forged in practically the same manner. For ordinary size oak leaves use ⅝-inch round stock. Make allowance for the leaf and draw the stem upon the horn of the anvil. Spread the stock with the assistance of a striker or with the help of a power hammer if possible, and finish upon the face of the anvil with the blacksmith hammer. Proceed to shape the leaves according to the directions for a laurel leaf, Exercise 46. Cut off the leaf from the bar and finish drawing out the stem.

Sketch out on a heavy piece of paper a few oak leaves. If proper instruction in designing is lacking, it is advisable to make a sketch from a natural branch of oak leaves. Place the paper pattern upon the blank leaf and trace the outline by following the edges with a soap-stone pencil or scriber. It is of advantage to drill holes where deep cuts occur on the leaf to facilitate the cutting and shaping of the leaf.

Use a sharp chisel in cutting out the leaves so that very little or no filing will be necessary. The veins are made in the manner explained in Exercise 46. Anneal the leaf and hammer it into relief with a ball-peen hammer. The center section of the leaf should remain low while the sides are raised or lowered. The round, deep cuts of an oak leaf are raised by using a punch ground convex at the end; for this operation, the leaf is reversed, plcaed upon the lead block, and with the aid of a punch the edge is raised, giving the leaf a more artistic appearance.

The acorns are forged in a proper top and bottom die, as explained in forging laurel berries, Exercise 46, with the exception that heavier material is used. The ornamentation of the shell of the acorn is accomplished by placing it upon a lead block and cutting in with a cold-chisel so as to form small squares. As it is advisable to have some variation in work of this kind, some of the acorns should be cut off even with the shell. The hollow

section is obtained by using a drill that accommodates the thickness of the acorn.

Weld the leaves and acorns as directed in Exercise 46.

Oak branches have a naturally rough finish which may be secured partly with the blacksmith hammer and partly with the aid of a tool, as shown in Fig. 171.

84. The Use of Angle Iron in Making Leaves.

A very convenient and labor-saving scheme in making grape-vine leaves or chestnut leaves is to forge them from a flattened piece of angle iron. As is generally known, the stem of these

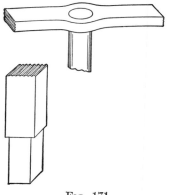

Fig. 171.

leaves should be very rigid, hence they could not be made successfully from sheet iron. In order to secure

Fig. 172.

such rigidness, the leaves are commonly forged from heavy material, but this consumes time, while, if an angle iron is flattened out, the ridge in the center affords the necessary stiffness. A paper form is placed on the flattened angle iron, traced and the extra stock is cut out, leaving a good strong leaf. Fig. 172 fully explains the foregoing statements.

85. Rose Branches.

Rose branches may be forged in various ways. When making the leaves, some artsmiths first form one leaf at the end of an iron rod and then proceed to make single leaves which are afterwards welded to this rod. The method explained in Exercise 48

is recommended, however, as giving more nearly the natural appearance of real branches.

Exercise 48. Forging Rose Branches

In forming the leaves, the thickness of the stock to be used depends upon the size of the finished rose; usually $\frac{3}{8}$- or $\frac{5}{16}$-inch stock is used in making a natural-sized rose branch. Weld two rods of $\frac{3}{8}$- or $\frac{5}{16}$-inch round stock together about $1\frac{1}{4}$ inches from the end so as to form a cross. Cut off one rod, leaving enough material beyond the welded section to equal that on the other side of the weld. This when finished will form a three-leaf stem; rose leaves come in groups of three, five or seven.

If a five- or seven-leaved stem is desired, at a point about $1\frac{1}{2}$ inches down from the first weld, weld another piece in the shape of a cross as previously described, and cut off the extra stock. Before doing this, however, it is necessary to draw out the section between the two welds to about $\frac{3}{16}$-inch round, because if the welding is done before the drawing, it will be much more difficult to draw the stock afterward.

Spread the upper and lower cross pieces as at (A), Fig. 173, with a cross-peen hammer. This spreading of the leaves should be done so that all are finished at about the same time, for, if one finishes one leaf entirely before going on to the others, the finished one may be burned while raising the others to a forging heat, or if not burned, the continued reheating would cause it to scale off so that when all the leaves are finished one or two would be thinner than the others.

At (B), Fig. 173, is shown a rose stem with five spread leaves, each of the five in a different stage of its evolution from rod to leaf. Starting from the right, the upper right leaf is exactly as it appears after spreading and cutting away the rest of the stock. The middle leaf and its mate to the left show the raised vein through the center. The lowest leaf at the left shows the side veins and the leaf opposite it shows the serrated margins that all natural rose leaves have.

The final appearance of such a branch is shown at C; every leaf has been hammered while cold into relief on a lead block; one section is raised, another lowered, but the center section should

always be lower than the rest to produce an artistic, as well as a natural, appearance of the leaves. For further particulars concerning the forming of the veins, see Exercise 46.

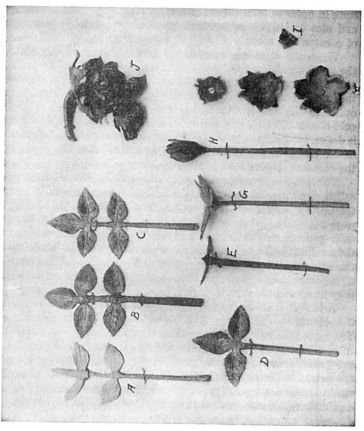

FIG. 173.—Forging a Rose Branch.

At *D* is shown a three-leaved branch, which is less difficult to make than a five- or seven-leaved one.

At *E* is shown the stem and the calyx of a rose which has been forged from heavier stock than the leaves. In order to form

a round disk from which the three calyxes may be cut, a depression of about $\frac{1}{4}$ inch on each side of the stock is made with a top and bottom fuller. From one end of this depression the stock is drawn out to fit a special heading tool which has been countersunk in order to form a heavier section where the calyxes diverge, and also to imitate as much as possible the natural appearance of a calyx and stem.

When the stem has been drawn to fit into the heading tool, the stock should project from the face of the tool about 1 inch, and then should be hammered down until a disk is formed, the thickness of which should not exceed $\frac{1}{16}$ or $\frac{1}{32}$ inch. Then, after outlining the calyxes, the extra stock is cut away with a keen cold-chisel. Finally, they are split a bit at the ends and the stem is drawn to about the thickness of a natural stem. A hole is drilled in the center of the calyx and then tapped so that the petals of the rose may be fastened to it by a screw.

The petals are made of copper and may be colored to a red called *royal copper* by a special chemical process which is more thoroughly explained later under the topic of "Coloring," page 250. The petals are hammered into relief on a lead block; their general outline is shown at *F*. The inner petal, which is the smallest, is divided into four sections, while the middle one and the outer one are cut into five sections somewhat larger than those of the inner one. They should be so shaped that when assembled they fit so well that a close resemblance to nature is obtained.

A bud is made in practically the same manner as a rose. At *G* is shown the bud ready to be raised, and at *H* a finished bud. The leaves, bud and rose are welded together by the fagot weld. After the bud has been welded to the branch, it should be opened, the petals inserted, and the bud closed again. Before putting the petals in the rose or in the bud, the whole branch is *pickled*, which is also a chemical process for freeing the iron from all scale and undesirable substances accumulated while working, and producing a natural appearance. At *J* is shown a finished rose branch, illustrating the natural appearance and imitating as nearly as possible all the details noticeable in such a flower.

In shops where this kind of artistic work is carried out on a very large scale, it is a good plan to make a top and

bottom die which, with one blow from a sledge hammer, will form all the veins on the leaf. The die can be used successfully only on small leaves such as rose, laurel, etc. This will save a considerable amount of time, and although it may produce monotonous uniformity, is preferable to hand veining. In larger leaves, the veins could be produced in the same manner but a power hammer would be necessary.

86. Flowers Forged from Solid. The art of forging flowers from solid material is the highest goal that a smith can reach; in fact it is the final step in advanced art in all forge work. To be successful in this difficult undertaking it is essential for a man to be familiar with all the preliminary work in forging. A substantial knowledge of art and botany is also necessary. There are many men who, although they have not gone through such a course of study, are able to produce successfully one phase of art metal work due to constant repetition and conception by one of superior skill and knowledge. But if these men were to be asked to produce another kind of work new to them, they would be at a loss to do so, without help.

Exercise 49. Forging a Rose from Solid Stock

In this kind of work very few tools are necessary. A long hand chisel plays the most important part.

To forge a rose from the solid, a piece of $1\frac{1}{2}$ or $1\frac{3}{4}$ inches round stock is most convenient. Norway or Swedish iron may be used, although soft steel is to be preferred. At about $1\frac{1}{2}$ inches from one end, fuller in as deep as $\frac{1}{2}$ inch on each side and draw the stock as at (a), Fig. 174, so as to form a square shank that will fit into a square heading tool. The hole of the heading tool should be slightly beveled on one side to afford additional strength at that point. After making the necessary allowance, cut the work from the bar, using a sharp, hot chisel. For an ordinary-sized rose $1\frac{1}{2}$ to $1\frac{3}{4}$ inches of metal, measured from the shoulder of the shank will be sufficient.

The next step is to apply a good forging heat to the thick section, and, after having inserted the shank into the square heading tool, to form a disk $\frac{5}{8}$ or $\frac{3}{4}$ inch in thickness, as shown at (b).

With the aid of a soapstone pencil, divide the side of the disk as accurately as possible into three or more equal sections. These lines cannot be seen when the blank has reached a forging heat, and in order to overcome this, the lines are made permanent

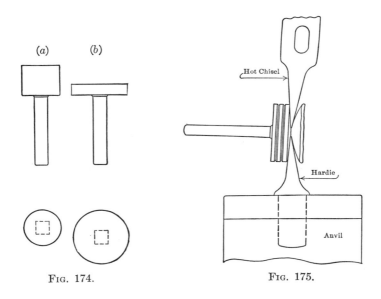

Fig. 174. Fig. 175.

by slightly cutting in with a cold-chisel along the chalk marks before the blank is thrust into the fire. The splitting of the blank into the required sections may be done in two ways: One way, and the hardest and quickest, consists in cutting the individual disks or sections apart by using the hardie and the hot chisel simultaneously as in Fig. 175. The center section of the blank should be left uncut and ought to be at least $\frac{1}{4}$ inch in diameter. This method is employed by the more experienced man.

An easier method consists in placing the side of the blank

in a suitable bottom swage and, with the aid of a long hand chisel, cutting the sections apart as in Fig. 176.

The blank should now have the appearance shown at (*a*), Fig. 177. The next operation is to heat the blank again to a uniform forging heat and, after having inserted the shank into the heading tool, to thin it down until each section is not thicker than $\frac{1}{16}$ inch, as at (*b*). The thinning of the blank is done partly on the face of the heading tool and partly on the face of the anvil.

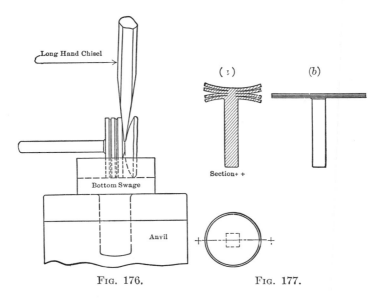

Long Hand Chisel

Bottom Swage

Anvil

(*a*)

(*b*)

Section+ +

Fig. 176. Fig. 177.

Extreme care should be exercised when applying the heat for reducing the thickness of the blank, otherwise the iron will reach the welding heat, with the result that all the sections just cut will adhere to each other, spoiling the entire work.

When each disk has been reduced to the required thickness, they are ready to be cut and shaped into petals. The top disk should be divided into three or four petals as in Fig. 178, while the others should be divided into five. In order to approach nature as much as possible in this kind of work, near the edges

of each petal, lines varying from $\frac{1}{4}$ to $\frac{3}{4}$ inch in length are made with the aid of a top and bottom " veiner."

Before closing the petals, in order to give them a natural as well as an artistic appearance, they are hollowed out in a tool such as is shown in Fig. 179, which can be fastened in the vise.

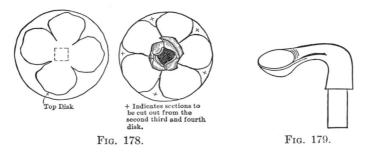

Top Disk

+ Indicates sections to
be cut out from the
second third and fourth
disk.

Fig. 178.

Fig. 179.

Each petal is shaped separately by means of a ball-peen hammer and the hollow tool. The other disks are left untouched during the shaping of the petals. After the top disk has been cut into petals and these in turn shaped and closed in, as illustrated at

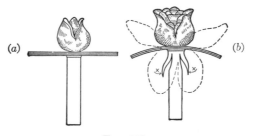

(a)

(b)

Fig. 180.

(a), in Fig. 180, the three remaining disks are cut as stated before into five petals, all following more or less the same outlines.

Before thinning out and shaping the petals of the second, third and fourth disks it is necessary to twist the disks slightly in the center in order to cover the spaces between the petals of the preceding disk. The twisting is accomplished after opening the

disks by bending the petal of the second disk up while the petals of the lower disks are thrown backward to have the necessary clearance. Heat slowly and carefully until the center section is heated to a red heat; fasten two petals of the second disk in the vise and slip the heading tool on the square shank and, by turning the tool, the disks are twisted either to the right or left in such a manner that the spaces of the second disk are covered by the petals of the third. The remaining disks are twisted in the same way.

The step which follows this is to bend the two bottom disks backward in a curve so that they nearly touch the shank, as in the dotted lines at (*b*), Fig. 180, in order to afford more clearance while shaping the petals of the preceding disk.

While shaping a rose it is essential to start with the upper disk forward while the other disks are thrown back for the sake of clearance. The calyxes marked *X*, Fig. 180, are split from the square corners of the shank with the aid of a sharp, hot chisel. A forging heat is then applied to them and they are for-

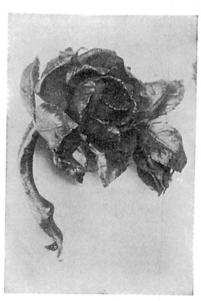

Fig. 181.

ged to the proper thickness and shape.

The shaping of the rose itself is accomplished by first modeling the center sections of petals close together so as to give the appearance of a natural rose and then gradually increasing the spaces. The ends of each petal are twisted to different forms, using a pair of round pinchers and in most cases forming a corner near the center of the petal. The leaves and buds are then welded and shaped as shown in Fig. 181, which illustrates a paper weight.

For particulars about the forging of rose leaves and buds, see Exercise 48.

The forging of other forms is similarly done. In Fig. 182

Sun Flower
Section through
Center

FIG. 182.

is illustrated the cross-section of a sunflower also made from the solid. Besides the section in the center, the two disks from which leaves are cut and shaped show that they have been cut apart by the method described in forging a rose from the solid. In Fig. 183 is shown the finished flower.

Fig. 184 shows a morning glory. The flower itself is forged from the solid, while the leaves are made from sheet metal. The stamens are made from ordinary wire nails welded together and screwed in the center.

FIG. 183.—Sunflower Forged from Solid Stock.

Fig. 185 shows a garland or festoon designed and executed by the author. It is a combination of various flowers, all forged from the solid and arranged to har-

Fig. 184.—Morning Glory.

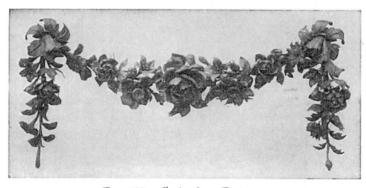

Fig. 185.—Garland or Festoon.

monize. Fig. 186 shows a tulip also made from the solid, while the leaves are made from sheet iron.

In forming a lily branch, as in all kinds of art-metal work which deals with botany, it is necessary to imitate the natural form as much as possible. Care must also be taken not to overdo a piece of work of this sort. In making a lily, the first step is to forge a blank from a piece of round stock in the same way as in forging a rose from the solid. The blank is then inserted into a heading tool and the head is hammered into a single disk which does not exceed $\frac{1}{16}$ inch in thickness, as shown in Fig. 187 at (a). This disk is then cut into petals, as illustrated at (b).

Fig. 186.—Tulip.

The veins are cut into the petals in such a manner as to lower the center section. They are then hammered into relief on a lead block to imitate nature as closely as possible. The petals are raised on the horn and on the face of the anvil. The stamens are made of ordinary wire nails, the heads of which are hammered into the shape of a bean. They are then welded together and fastened to the lily by tapping and screwing the group into the stem.

At (c), Fig. 187, is shown a bud of a lily. It is forged from a piece of round stock which is formed into the proper shape. The effect of a bud about to open may be produced by undercutting the bud by means of a sharp chisel in order to show parts of the petals.

The leaves are cut from sheet metal, heated and placed in a top and bottom die which has grooves cut in it as shown

in Fig. 188. In this way, one blow is sufficient to vein the leaf on both sides. Fig. 189 shows a branch with leaves, flower and buds assembled.

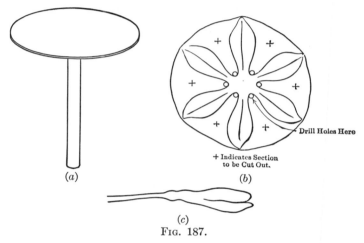

(a)

(b)

Drill Holes Here

+ Indicates Section
to be Cut Out.

(c)

Fig. 187.

Faces, animal figures, as lizard heads, birds, etc., are split from solid stock in a similar way, and only a few special tools are necessary.

Fig. 188.

87. Hammered Metal Work. The art of hammering metal ranks high in metal working. For the beginner,

as well as for the most skillful man in this line, a knowledge of art and a taste for beautiful figures, lines and forms are necessary. Beginning with a simple ash-tray or bowl, and advancing to the stage of hammering life-size figures,

Fig. 189.

the skill needed is comparable with the highly developed skill required of the sculptor.

When executing any piece of work, a drawing is necessary. The making of a piece of art metal work may be divided into two parts or branches—design and construction.

Design includes the mental conception of the idea and involves the making of a sketch and, finally, of the working drawings.

Construction includes getting out the stock and laying out, shaping, assembling, and finishing the parts.

The material for hammered metal work must be pliable as well as malleable. Copper is best suited for the purpose, although brass and bronze are often used. Leaves used for purposes of decoration on ornamental iron are usually hammered from wrought iron.

Fig. 190 shows a wood block which is very commonly used for this kind of work. It is hollowed out in order

FIG. 190. FIG. 191.

to receive the vessel to be shaped. This particular block is best suited for finishing deep vessels such as the one illustrated in the figure. Some art-metal workers prefer a lead block, such as shown in Fig. 191, for this work, while others use either of the two. Of the two, lead is preferable because it can be used for any purpose, and the shape can easily be changed either by melting it or by hammering.

The thickness of the material to be used always depends upon the shape of the object, for if a very deep vessel is to be made, it is not advisable to use thin material, because before the stock has been hammered into the required

shape, it may be torn by the excessive hammering and stretching necessary. In hammering, the vessel should be slightly turned after each blow, and the blows should be uniform and well distributed.

The tool extensively used in hollowing out copper, brass or bronze vessels is a round ball-peen hammer such as shown in Figs. 190 and 191.

As copper is constantly hammered, it becomes more or less hard and must be annealed. Copper may be annealed in two ways, both of which will prove satisfactory. One way consists in heating the copper to a dark-red heat and allowing it to cool slowly, while the other method consists in heating the copper to a dark-red heat and then plunging it into water.

To obtain the dimension or measurement for making a bowl or vessel, follow the outside line of the vessel with a string. This is the most practical means of obtaining as near as possible the required length of the material necessary, but it is not very accurate, because, as stated before, the metal stretches; therefore the stock is usually cut a trifle under measured size. In cases where vessels have an overlapping edge or border on the outside, the proper allowance should be made for material to form that edge.

In making trays or bowls which are rather flat, a bag filled with sand may be used in place of a block, as no deep surfaces are required. Quite frequently light work on trays or bowls is done on a high-speed lathe, using long tools which force the sheet of brass or copper against a wooden pattern. The brass or copper is held by friction between wooden centers. Sometimes, due to the peculiar or irregular shape of a vessel, more than one pattern is necessary.

Exercise 50. Making a Vase

Fig. 191 illustrates the starting of a vase. It is first hammered into a dish form on a hollowed lead block, using a round,

ball-peen hammer. When it has gradually become narrower,
it is placed on the end of a T anvil, as illustrated in Fig. 192,
and by the use of a hammer free from all sharp edges or corners,
is brought to the shape illustrated at (a) in Fig. 193.

FIG. 192.

In Fig. 193 at (b) is illustrated the tool on which the neck of the
vase is shaped. It resembles a T anvil with the end to the right
tapered in order that it may be inserted in the neck of the vase

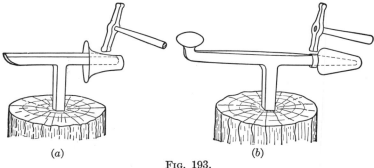

(a) (b)

FIG. 193.

while the opposite end is shaped in a knob-like form to make it
possible to hammer vessels having long necks. This tool is
called a **snarling tool.** Both the T anvil and the snarling tool
have a square shank with a shoulder which fits into a hole made
in the block.

To form the collar on the vase after it has assumed the proper shape, the vase is placed upon the edge of the tapering end of the snarling tool with the end of the vase projecting about 3 inches over the snarling tool, and slowly working down, with a round hammer first, and then with a hammer having square corners in

Fig. 194.

order to make a sharper line between the collar and the body of the vase.

To bring out the effect of sharp lines, in very difficult work and in places hard to get at, fill the vase with lead or pitch after it has assumed nearly the final form, and hammer it down where necessary.

88. Repoussé or Embossed Work. Embossing is the art of bringing certain sections of a piece of work into relief

while others are worked down. This kind of hammered-metal work is closely connected with the art of sculpture, especially when figures are worked out of a soft metal like copper, which is best suited to this purpose. To obtain good results the workman must be highly skilled in using a hammer, as this particular kind of work requires a sure hand.

In Fig. 194 is shown a head of Lincoln made from a piece of sheet copper. To make any figure of this kind, a section is raised in the center of the piece of metal, large enough to envelop the entire finished figure. Then the piece of metal, copper in this case, is placed on a pitch block, and the flame of a torch is played upon it to soften or melt the pitch, thus filling up the hollow or raised section in the piece of copper. With the aid of small punches, some having rounded edges, others flat, the various parts of the head are worked down gradually. While working,

it is sometimes necessary to remove the piece of copper from the pitch block in order to anneal it, or to fasten it in a different position than that in which it was first placed. This may be necessary in forming the undercut of the ear or the eye.

89. The Acanthus Leaf. Among the large number of plants which have served in creating artistic forms, the acanthus leaf ranks first. Although it does not possess a symbolic importance, the highly developed ornamental leaf, Fig. 195, with its beautiful, serrated form, has served as an important, characteristic factor in the

Fig. 195.—Acanthus Leaf.

evolution of decoration. From this leaf have been developed by conventionalization an enormous number of variously shaped leaves used for ornamental purposes in iron work.

90. Leaf Hammering. Fig. 196 shows a finished leaf riveted to a bar of square iron. To make a leaf of this kind a pattern is necessary, and in many cases the workman has to make his own pattern from a finished leaf. This is often done by the rather slow method of stepping off or dividing the outside of the center curve into a number of equal parts, and then duplicating these on a straight line

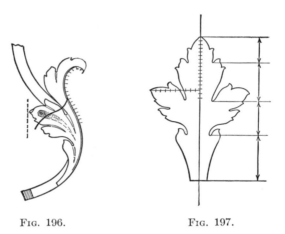

Fig. 196. Fig. 197.

as shown in Fig. 197. The width of the leaf is obtained in the same manner.

An easier method, combining accuracy also, consists in folding a sheet of paper lengthwise, then, starting at one extremity of the leaf, bending the paper to coincide with the outside of the center curve, and placing a pencil mark each time that the paper meets one of the deep cuts which separate the minor leaf from the leaf proper.

In the finished leaf there are two main curves running in opposite directions; the lower one to the left, the upper one to the right. These different curves influence greatly the various cuts, because if the curves are slight, the allow-

ance for the cut is less, due to the smaller opening left after the leaf assumes its permanent shape. The opposite is true in making allowance for the cut if the curves are rather steep.

Many leaf workers, before making the deep or inner cuts, drill a hole of the required size where the cut ends and after bending the leaf to the required shape, they finish the cut. This will prevent the leaf from tearing at that point, which often occurs if proper care is not exercised.

The leaf should be fastened to the bar of iron in such a way as to form a continuous line, thus showing as little as possible where the leaf starts or is joined to the iron bar. Heavy leaves are usually welded, while lighter ones are riveted on. The rivet heads should not show on either side, but should be countersunk. Very often, before riveting a leaf on an iron bar, a shoulder-like depression is formed by means of a file, where the bar meets or receives the leaf.

Fig. 198.

In Fig. 198 is shown another finished leaf, differing from the one previously described, in that this is a single leaf, or a half leaf, while the former one is double. This single leaf is much easier to make. The veins are produced by means of a tool resembling a chisel with a rounded edge, as shown in Fig. 199. This tool has a shoulder and a square shank which holds the tool more firmly in the vise. The section where the vein is desired is placed over the rounded edge of this tool and with a hammer such as shown in the same figure, blows are delivered first to one side, and then to the other side of the tool, thus raising the center section.

As all the operations are carried out with the metal cold, it is necessary to anneal the leaf as often as required.

FIG. 199.

The dotted lines at the right near the outside edges of the finished leaf indicate the width of the leaf as it was before the veins were produced, thus showing that the leaf has become narrower. The allowance near the bottom of the leaf was partly absorbed by the veins, and partly left blank. The blank part is bent at right angles to the face of the leaf in order to make the stem more rigid and stronger.

To shape properly a leaf of this kind, a variety of tools and hammers are necessary. Fig. 200(a) shows a tool ending in a ball-like form with a square shank for fastening in a vise. This tool, together with the corresponding hammer, Fig. 200(b),

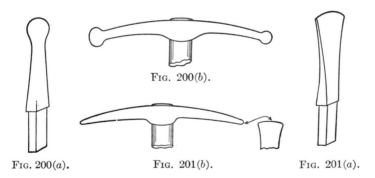

FIG. 200(b).

FIG. 200(a). FIG. 201(b). FIG. 201(a).

is mainly used to hollow out certain sections of the leaf. Fig. 201(a) and (b) and 202 show other tools and hammers also used in leaf hammering.

Some leaves terminate in the shape of a parrot bill, as shown in Fig. 203, front and side elevation. To bring

out such effects, certain special tools are necessary. First
of all, a leaf of this nature roughly assumes its outline by
hammering it hot into a tool resembling a bottom swage,
and illustrated in Fig. 204. The groove shown in the front

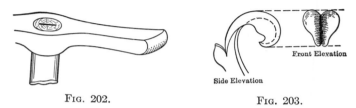

Fig. 202. Fig. 203.

elevation of Fig. 203 is produced by placing the leaf on a
tool such as illustrated in Fig. 205, and delivering a few
blows with a leaf hammer.

The groove or vein is continued after it has been started

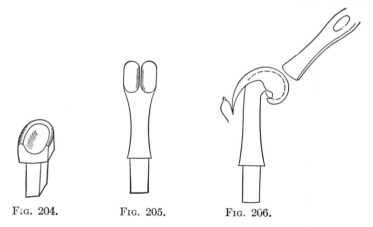

Fig. 204. Fig. 205. Fig. 206.

in the tool illustrated in Fig. 206 in the same manner as
the veins are produced in Fig. 199.

On all double leaves, it is a labor-saving device to keep
the sides of the leaf slightly opened in order to reach the
bottom tool which is fastened in the vise.

Some leaf ornaments, which end as shown in Fig. 207, are hollowed out by using a ball-peen hammer on a lead block. Such leaves have a ridge or groove formed from the opposite side and the section to the right and to the left of the ridge is hollowed out as just explained.

In forming veins on straight work, special tools may be made. The bottom tool may either have a shank to be fastened in the vise or a shank to fit the tool hole of the anvil, and a V-shaped depression is made in it. By heating a tapered piece of steel and driving it into the V

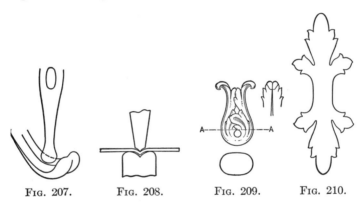

FIG. 207. FIG. 208. FIG. 209. FIG. 210.

depression of the bottom tool, its end takes the shape which corresponds. These tools are illustrated in Fig. 208, which shows the proper way of using them. They may be used either on cold or on hot material.

In Fig. 209 is shown a leaf ornament resembling a tulip with the section $A-A$ resembling an ellipse or oval. The figure to the right shows the side elevation of the top of one side of the leaf ornament.

The pattern for these leaf ornaments is shown in Fig. 210, and the entire pattern or one-half of it may be traced on a piece of sheet iron. Some leaf workers prefer to make such leaf ornaments out of one piece, while others prefer

two pieces. If made from two pieces, a hole should be drilled in each piece on the bottom side near the sections which come in contact, and after a wire has been inserted it is twisted and the two are brazed together. After brazing, each leaf ornament should be *pickled*, otherwise the flux or borax which has been used in brazing turns the leaf ornament white after it has been in place about three or four weeks.

After the leaf ornament has been cut out and filed, the ends are shaped first and then it is hollowed out in an oval hollow tool illustrated in Fig. 211. The ornament is then gradually shaped as previously explained.

Fig. 211. Fig. 212.

All veins on double leaves of this type must be formed immediately after the leaf ornament has reached the shape illustrated in Fig. 212 and then finally closed.

In shops where large quantities of one design of leaves are turned out, a top and bottom die can easily be made, thus saving an immense amount of time. To make these dies, a finished leaf is opened enough to avoid undercuts, and after both surfaces have been shellaced and then oiled, the leaf ornament is filled with plaster of Paris. When the latter has become dry, the leaf ornament is removed, leaving a very good impression on each side of the plaster of Paris pieces. These pieces of plaster bearing the impression formed by the leaf are then cast, and the top die is fastened to a drop hammer, while the bottom one is held in a stationary position. The sheet iron orna-

ments are in turn heated and placed upon the bottom die, while the top one is caused to drop upon it, thus shaping the sheet iron. The final touches are applied to the leaf ornaments after the latter has been removed from the top and bottom die.

The edges of such dies should be rounded off as so not to cause any dents in the leaf ornaments.

APPENDIX

Bending Brass, Bronze and Copper Pipes

An excellent method for bending brass or copper pipes is illustrated in Fig. 213. As a rule these pipes are somewhat hard after they leave the mill, therefore it is neces-

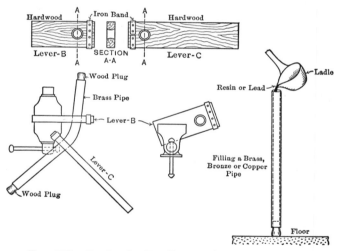

FIG. 213.—Device for Bending Brass and Copper Pipe.

sary to anneal them before attempting to bend them. After having annealed them, insert a removable cork tightly in one end, and fill with resin or lead. The former is preferable, as it is not as heavy as lead, and fully answers the purpose. Then bend with the aid of the device shown. Lever B and lever C are two pieces of hard wood, with a

hole drilled in each one to fit the pipe to be bent. Each one of these pieces of wood has a band of iron screwed on close to the end nearest the drilled hole in order to prevent the wood from splitting. Section A–A shows how the holes should be drilled, that is, the sharp corners should be removed in order to prevent the pipe from being dented.

Lever B is fastened in the vise as also shown in the figure, and the pipe is inserted in the hole. Through the other end of the pipe the other piece of wood is also inserted, and is used as a lever in bending the pipe to the desired shape. The figure also illustrates how the lever B should be fastened in the vise so as to allow sufficient clearance for bending the pipe.

When the pipe has been bent in the desired shape, free it from the resin or lead with which it has been filled by heating it slowly and uniformly, starting from either end, and not in the center, otherwise the pipe will burst.

FIG. 214.

Punching and Marking Pipes

When a number of holes are required in wrought iron pipes or columns, the holes may easily be punched by using the proper tools instead of drilling them with breast-drills.

An illustration of these tools is furnished in Fig. 214. They consist of a center punch and of an ordinary punch. On the ordinary punch, a certain distance from its tapered end, a shoulder is formed. This shoulder serves to insure equal-sized holes. Before applying this tool, a cavity or hollow is made with the center punch to receive the ordinary punch. This method of making holes in pipes is to

be preferred when no power presses are at hand, or when these pipes or columns are already placed in permanent positions.

In marking pipes at an angle, it is quite a difficult task to obtain a good line, due to the convex shape, and in such a case it is a good plan to use water. In doing so, place two chalk marks on the pipe indicating the extremities of the desired line, and dip the pipe in water in such a

Fig. 215.

way that the water line will connect the chalk marks. Fig. 215 illustrates this.

Twisting Band Iron Cold

In Fig. 216 is illustrated a very simple and useful device for iron workers who make a specialty of grill work or work of a similar character. At (a) is shown a U-shaped iron with an additional piece riveted on each arm and shaped as illustrated. The offset in the two pieces of iron riveted to the U-shaped form varies according to the thickness of the iron which is to be inserted. At (b) is shown a

straight piece of iron with a short piece of the same material riveted on and shaped, which may be used as a lever.

Fig. 216(c) illustrates the U-shaped form fastened in a vise with a flat iron bar inserted in the two jaws, while the jaws of the lever are slipped over the bar, leaving equal

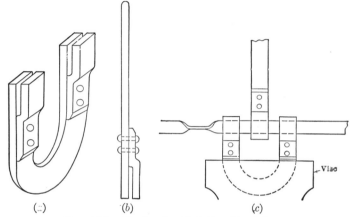

FIG. 216.—Device for Twisting Band Iron.

spaces on each side. By a pull on the lever, the bar is easily twisted uniformly.

Straightening Sheet Metal

One of the most difficult operations in metal work is to straighten a piece of sheet metal. When an area becomes larger than the rim of the other metal inclosing it, a " lump " is formed in the sheet and the metal at the center will go in or out each time a slight pressure is applied to it.

To get rid of these " throw-ups," the sheet is usually passed between rollers, first with one face up, and then with the opposite face up. This is a good method when a sheet is rather thick, but in this sheet the four edges are the ones to suffer most, as they are thinned or stretched

more than the center section. In such cases it is necessary to employ the hammer. The blows should be delivered *around the lump*, starting with light blows, and slightly increasing the force of the blow as the distance from the raised section increases. While hammering, the piece of sheet metal should be slightly raised from the surface on which it rests. This will cause the sheet to assume a concave shape, but this gradually disappears if hammered from each side a few times.

The hammering around the lump will stretch the metal where the blows are directed, and in proportion to the force of the blow, thus equalizing the various sections of the metal. A perfectly smooth surface must be used. This method

Fig. 217.—Hammering a " Lump " out of Sheet Metal. The circles indicate how the blows should be distributed.

of leveling throw-ups is very useful to the men who work in shops which lack rollers and other equipment for the work.

Cutting Holes for Dowels and Expansion Bolts

In cutting holes for dowels and expansion bolts, the outline of the bolt or dowel should be followed. The hole should be widest at the bottom. The most common mistake is to taper the dowel and cut the hole accordingly, and as a result, in the course of time, the dowel will come out, carrying the plaster or lead with it. Fig. 218 shows the proper way to shape a dowel. The stock is upset at the end, and notched as shown to insure a tight joint.

The top or outlet of the hole has a smaller diameter than the ends of the dowel after the notches are filled with lead and it is almost impossible for the dowel to come out.

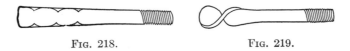

FIG. 218. FIG. 219.

Stone screws are sometimes used instead of dowels. These are formed from either square or round stock, flattened at the end and bent into a sort of propeller shape

Stone Wall

FIG. 220.—Proper Shape for Dowel and Hole.

as in Fig. 219. The most common way of making a dowel is illustrated in Fig. 220.

Drilling a Square Hole

To drill the hole through a soft metal, such as copper, use a three-cornered drill with the sides parallel to each other, and meeting in a point, as shown in Fig. 221. The other end of the drill should be round and centered, so that when placed in a chuck, it will not wobble.

To drill a $\frac{5}{8}$-inch square hole in steel is more difficult, due to the hardness of that metal. In such a case it is advisable first to drill a $\frac{5}{8}$-inch round hole, and then to fasten a template containing a square hole of the exact size

of the required one, to the piece of steel; the square corners can then be formed by using the three-cornered drill. The section around the hole in the template should be tempered so that while the drill revolves it will be kept in place and at the same time will not enlarge the hole.

Fig. 221.—Template.

Hexagonal or octagonal holes may be drilled in the same manner with drills having five sides and seven sides respectively.

Forming a Tenon on Flat Stock

In small shops, where expensive machinery cannot be afforded, the tool illustrated in Fig. 222 will be found very handy. This tool would prove especially useful in shops where grate work is carried on, and hundreds and perhaps thousands of tenons need to be formed on bars. It cannot be bought, but is easily made by hand. After heating the bar it is placed between the bottom die and the punch, and the punch is driven through the bar in to the bot-

tom die, leaving a perfect tenon. One blow is usually sufficient for this operation, and after the tenon has been formed, the bar being at a red heat will also anneal.

In forming the tenon on the other end of the bar, in order to make the bars of equal length, a special form or

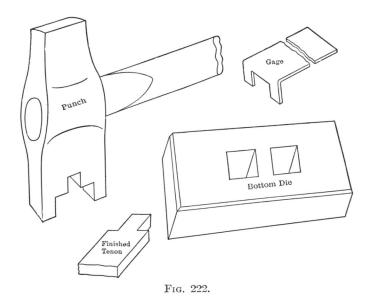

Fig. 222.

gauge is used which hooks on the already formed tenon and shows where the other tenon should be formed.

Finishing

After any piece of iron work has been completed as far as the use of tools is concerned, in order to add to its general appearance as well as to safeguard it from atmospheric changes, one or two coats of paint are usually applied. Quite frequently, on work which has a rough surface, such

as hinges on church doors, door knockers, etc., instead of paint, a process of burning linseed oil into the iron is used for decorative purposes.

To attain this finish, the iron should be first thoroughly scraped, or better, *pickled,* in order to free it from any undesirable substance, and then a heavy coat of linseed oil should be applied. Finally, the iron is heated uniformly and thoroughly on a charcoal fire (which is preferred to a coke fire), care being taken not to overheat the iron and burn the oil out. When applying this process to iron that is of unequal thickness, great care must be exercised to heat the stock uniformly and not have the thinner section hotter than the thicker one, as this will show when the iron has cooled.

Fancy work, such as flower work, is sometimes finished by applying a very light coat of dull black paint. When the paint has dried, the higher sections of leaves or flowers are rubbed with an emery cloth, and finally lacquered. This will produce the silvery color or iron, and immensely add to the artistic appearance.

Coloring Brass and Bronze

Brass and bronze may be colored either dark blue or red by the use of a solution consisting of one part of sugar of lead and four parts of hyposulphite of soda dissolved in water. Before the brass or bronze is lowered into this solution, it is essential that it be thoroughly clean, that is, free from oil or anything that would interfere with the coloring. The best way is to polish the piece before coloring. After the pieces to be colored have been polished, they are attached to a copper or brass wire (never an iron one), lowered into the solution, which should be very hot, almost boiling, and kept there until the reddish or bluish color appears. When the desired color appears they are taken out and quickly thrust into cold water.

After the pieces have been dried, they may be lacquered in order to hold the color.

To produce steel gray on brass, bronze, or copper, the following solution is used:

Water	2 gallons
White arsenic	1 pound
Potassium cyanide	1 pound
Carbonate of copper	2 ounces

This solution should be used hot, *and is extremely dangerous because of the fumes of hydrocyanic acid gas which arise.* It is advisable to use this solution in a room well ventilated, and with windows wide open, or better, in an open place. To produce the color, the solution is placed in a vessel and on one side is attached a piece of iron, while opposite to it is the piece of brass, copper or bronze to be colored. A suitable current of electricity should pass from the iron *anode* to the brass, bronze, or copper, which is the *cathode*.

One of the most beautiful colors that can be produced on copper is known as *royal copper*. The color is a beautiful dark cherry red, and is obtained by first pickling the article, and then lead-plating it in a solution of sugar of lead. The article is then heated uniformly almost to the melting-point, and quickly plunged into a dilute solution of saltpeter. The work may then be slightly polished on a polishing wheel, and lacquered. This will insure the color remaining more firm, although it is a color which lasts longer than any produced by different methods.

To color copper green, the metal is first pickled or cleaned, and then submitted to the fumes of spirits of ammonia.

Cleaning the Surfaces of Metals

The trade name of this operation is *pickling*. When plain surfaces on wrought iron, steel, or cast iron are to

be cleaned, the scale may be removed with a steel brush. But when pieces of fancy work containing many undercuts are to be cleaned, the best method is pickling. In the pickler, a solution of hydrochloric acid is usually employed. If work which needs to be finished in a short time is to be pickled, a strong solution may be used. If large amounts have to be cleaned, and it is not necessary to hasten the work, very weak solutions may be used, so that the work may be left in the pickler for one or two days. In pickling, as in other processes, the expense figures greatly. The stronger the solution, the more expensive pickling will be. Caustic soda may take the place of the acid, and should be used to remove grease.

For metals such as brass, nitric acid is used. For bronze and copper a mixture of nitric and sulphuric acid is employed, sometimes equal parts. When working with any of these acids, great care must be taken, as their action is destructive to the skin and clothes.

In taking fancy work having undercuts, such as flowers, ornamental leaves, etc., out of the pickle, they should immediately be dropped into hot water for a few minutes, so that the work will be freed from acid, and will dry rapidly. After pickling plain work, it should be dropped into cold water, and then dried in sawdust.

Brazing

Brazing is the process of joining metals by means of a melted metal which has a lower melting-point than either of the metals to be joined. An alloy of copper and zinc is sometimes used and sold under the name of *brazing spelter*.

In order that a good joint may be secured, it is essential that the surface to be united be thoroughly clean, bright, and free from oxide. To obtain quicker and better results a flux is commonly used in all brazing operations.

A *flux* is a substance which will prevent oxidation when the hot metals come into contact with the air or the gases escaping from the fuel used in heating. It also cleans the surfaces. Borax, powdered glass or clay may be used successfully as a flux, but borax is commonly used, as it answers most purposes.

For brazing cast iron a special flux is used which contains as its principal ingredients red cuprous oxide. This produces very good results.

Hard soldering is practically the same operation as brazing. It is employed on work of gold and silver by using a soldering spelter of either gold or silver. Borax is the flux used for this kind of soldering.

Ordinarily in brazing iron to iron, copper or brass may be used where no brazing spelter is obtainable.

Brazing a Band Saw

File the broken ends to a bevel-like shape, similar to the bevel on a wood chisel, so that when one bevel is placed upon the other they will not exceed the thickness of the saw.

In order to make one end adhere to the other, silver or brass solder is used. Where neither is available, half of a silver coin the size of a ten-cent piece will be sufficient for one brazing.

Heat the lips of a pair of tongs to a yellow heat, and slip the saw between them until the silver which has been placed between the joint has melted and the ends have united. A flux, such as borax, is needed to aid the operation. A special pair of tongs with flat, heavy jaws and with no groove in the center must be used for this purpose. If any other tongs are used, the saw may *throw up*, thus spoiling the joint.

In order to hold the saw firmly in place, a special device, such as is shown in Fig. 223, is made. It consists of a lock-

shaped iron affording sufficient clearance for slipping on the tongs, and is riveted on both sides to clamps. Between the upper part of the clamp and the saw an iron block may be inserted, so that on tightening the clamp a larger area will press upon the face of the saw.

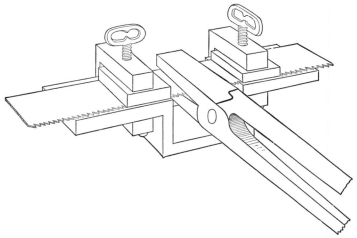

Fig. 223.—Device for Use in Brazing a Band Saw.

Soft Soldering

Soft soldering is the process of uniting metals with alloys of lead and tin. There are different kinds of soft solder, all differing slightly in composition. For example, common *half and half soft solder* contains one part of tin to one part of lead, while *plumbers' solder*, which is also soft, is composed of two parts tin to one part lead. There is still another kind which bears the name of *special soft solder*, containing two parts tin, one part lead, and one part bismuth.

In soldering it is absolutely essential to know the safe working heat of the soldering iron, for if it is overheated,

its usefulness is impaired, and only poor results may be expected afterwards from it. The tin will not adhere, and very often it burns the solder. In this case it is advisable to cool the bit with a wet rag. Overheating causes the surface of the copper to appear rough, and in some places it seems as if the acid had eaten into the copper. The right heat, when obtained, makes the solder flow like water when it is melted by the copper bit. On the other hand, never try to solder when the copper bit is too cold, as the solder will not flow freely, and good results cannot be obtained. When soldering, the same rules in regard to cleanliness apply as in brazing.

The flux used for soft soldering is principally zinc chloride, made by dissolving zinc in a diluted hydrochloric acid solution. Pure hydrochloric acid is especially useful when soldering zinc. Resin or wax are used in soldering lead with very good results. Other fluxes which can be successfully used are olive oil, honey or ordinary candle wax. Mutton tallow is almost the only flux used by plumbers in *wiping* lead-pipe joints.

In soldering aluminum a special flux and solder are necessary. Although there are many compounds on the market for the purpose, the one that has proved the most successful was invented by C. E. Steinweg of Germany. The solder consists either of pure aluminum or any alloy rich in aluminum. The following is the flux: cryolite, 30 parts; common salt, 35 parts; potassium chloride, 35 parts. The solder is a tube-shaped form which is hollow and the flux is placed inside it. These tubes differ in length and thickness. When heated, the flux and solder both drop upon the work after melting. The flux drops first, then the solder, firmly soldering the joint. The great convenience of this solder lies in the use of the flux inside of the tube.

Soldering Cast Iron

One of the most unusual and difficult operations in soft soldering is the soldering of cast iron. To secure good results it is necessary first of all to clean the surfaces to be joined by scraping them with a brass or copper brush until some of the brass or copper adheres to the joints, or by copperplating them, and then soldering them. The same precautions and hints apply in this place as previously described in soldering.

Welding Compounds

Nearly all welding compounds contain more or less borax which has the water of crystallization driven off.

A useful welding compound for use with wrought iron at a light red heat is as follows:

Borax 4 parts.

Sal-ammoniac 2 parts.

Iron filings (rust free) 4 parts.

To weld steel and iron at a light red heat, use the following:

Borax 9 parts.

Ferrocyanide of potassium 1 part.

Sal-ammoniac 1 part.

Welding with the Oxy-acetylene Torch

Welding with the oxy-acetylene torch should not be considered a special trade. Any man with average ability can acquire in a few weeks the necessary knowledge and skill to do ordinary work. In ornamental iron producing shops, torch welding is considered a side line, and practically every skilled metal worker in other lines can do his own welding, brazing and cutting. The blacksmith or the man with forge experience is likely at the start to be more successful with the torch, because he already possesses a train-

ing that enables him to discriminate between the various working heats.

The apparatus is provided with high and low pressure gauges. The low pressure gauge is provided with a valve to regulate the pressure according to the size of head or tip in use, thus insuring a constant and even pressure. The blowpipe or torch is provided with two valves to regulate the pressure as shown in Fig. 224. The acetylene pressure

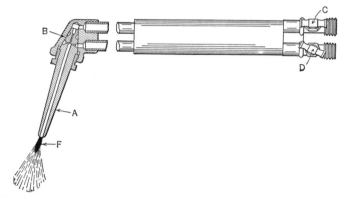

FIG. 224.—Section View of Welding Torch. *A*, tip; *B*, ground conical seat; *C*, oxygen needle valve; *D*, acetylene needle valve; *F*, luminous cone.

for all heads is between $\frac{1}{2}$ and 1 lb. per square inch. The oxygen pressure range is between 6 and 30 lbs. per square inch, according to the size of the tip being used. It is best to follow the instructions given by the maker of the particular apparatus in use. Usually one additional pound per square inch of pressure is added to that called for in setting the oxygen regulator, to compensate for the fall in pressure due to a continuous flow of gas. The final adjustment is made with the torch valve.

To light the blowpipe, first open the valves of the acetylene and oxygen tanks, then turn on the oxygen valve

on the blowpipe. Set the oxygen regulator to the pressure given on the chart. Close the oxygen valve on the blow-

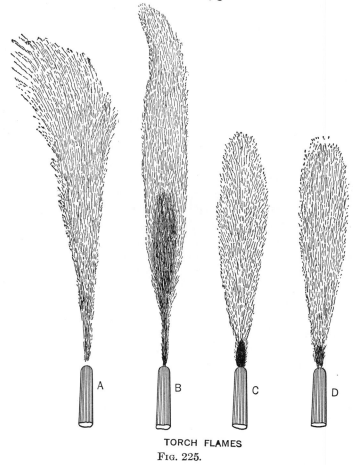

TORCH FLAMES
FIG. 225.

pipe. Open the acetylene valve on the blowpipe slightly, then light the gas. Then open the valve gradually and set the acetylene regulator to the pressure given on the chart.

Open the acetylene valve until the flame separates a trifle from the tip as shown in Fig. 225A. The acetylene flame is light yellow and smoky due to incomplete combustion for lack of sufficient oxygen from the air. Add some oxygen and note the change of flame as illustrated in Fig. 225B. The space between the tip and the flame has disappeared, the outline of the flame is more symmetrical, but there is still insufficient oxygen to produce the welding cone. Adjust the flame by turning the oxygen valve in the blowpipe until a neutral flame is produced as in Fig. 225C. The neutral flame is produced by adding the necessary amount of oxygen or acetylene until the central cone is sharply outlined. The color is a bright bluish green. If too much oxygen is added, the metal of the piece being welded will unite with some of it, that is, the metal will burn, with the result that a metallic oxide or scale is produced, making welding more difficult. Fig. 225D shows a cone with an excess of oxygen. In this case it is necessary to cut down the oxygen or add more acetylene. The oxide or scale produced has a white appearance and foams and blisters, while the molten metal has a cloudy appearance.

The lighting and adjusting of the blowpipe requires a few seconds only, and is easily learned by the beginner. A pair of approved colored goggles must be used, because the flame is harmful to the eyes and because it is very difficult to distinguish the molten metal from iron oxide with the naked eye.

A properly adjusted neutral flame will produce a temperature of about 6300° F. which is more than twice the temperature required to bring wrought iron or steel to the fusing point.

As soon as the work is completed for the day, shut off the blowpipe. To do this, turn off the oxygen valve first, then the acetylene valve. Next, turn off both valves on the cylinders, and then open the blowpipe valves once more to release the gases that remain in the hose and regulator.

Before putting the apparatus away, close the blowpipe valves again.

To attach to their cylinders the regulators that control the flow of oxygen and acetylene, it is advisable to open the valve of one cylinder slightly at first for a second or two to remove or blow out all dust or dirt which may have collected. Attach the regulator to the cylinder by means of the union nut provided for that purpose, and make sure that there is no leak. The union nuts are usually made of different sizes and have one a right hand, the other a left hand thread, to avoid interchanging. The regulator is a delicate device and must be handled with great care.

Do not use grease or oil in connection with the oxygen regulator; it is very dangerous, particularly in the presence of heat due to sudden compression.

The beginner should practice correct torch motion before lighting the torch. Move the torch slowly back and forth

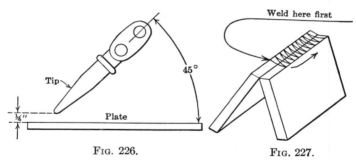

FIG. 226. FIG. 227.

across the joint, one quarter of an inch from the metal, and at an angle of about 45 degrees, the tip pointing to the left as in Fig. 226. Use right hand only for the purpose, as the left hand is needed to hold the filling rod while welding.

Problem 1.—Welding $\frac{3}{16}''$ wrought iron or soft steel plates the narrow edge up.

Use the size of tip given on the chart of your particular

make of torch. Light the blowpipe in accordance with the instructions given above. Make sure the flame is properly adjusted and neutral. Commence welding as indicated in Fig. 227.

The tip should be held at an angle of about 45 degrees. Heat the sides by moving the flame with a slow motion back and forth and across the joint until the metal is hot enough to run together. As soon as the metal commences to melt, move the torch with a swinging motion from side to side so that both edges will be melted. The flame or cone of a neutral flame is usually tapered or round at the end. The maximum temperature region of the flame is just beyond the tip of the flame. Therefore, the tip of the flame should be kept just a trifle from the metal. Continue melting and running the metal in the direction indicated by the arrow until the end of the joint is reached, then start from the other end and work in the same direction toward the point where the weld was started, until the weld is completed. The swinging motion of the blowpipe varies according to the thickness of the material and kind of work to be done. The motion may be from the right to the left or it may be a series of overlapping circles or a motion like a figure 8 extending in the direction of the weld.

The weld illustrated and explained above is very simple. The V shape on top will prevent the metal from running down the sides. This weld may be repeated as often as necessary to secure muscular training, a more steady control of hand and a training of the eyes. After this weld has been mastered the welding rod should be used.

In all oxy-acetylene welding observe the following points: Work with neutral flame at all times. Adjust the flame as often as necessary. Avoid blowholes or scale in the weld. Do not hold the flame on one side of the metal only; preheat and melt both sides at the same time. Do not bring the tip too close to the molten metal to avoid throwing off the molten metal produced by the flame.

Light stock will burn through. Do not run molten metal on top of cold metal. Such metal may adhere but it will not weld. Carry the weld from the bottom, and build up, if a filling rod is used, to insure a thorough weld. Heavy stock is usually beveled from both sides, thus carrying the weld from the center up. Turn the piece over after the first side is completed, and proceed in the same way. Make sure the surfaces to be welded and the filling rod are clean, that is free from rust, scale and dirt. Continue welding in one direction after once started and avoid going back over the weld unless absolutely necessary.

Problem 2.—Butt weld two $\frac{1}{8}''$ wrought iron or mild steel plates.

The plates about 6" in length should line up with each other; straighten or grind the sides if necessary. Use the tip given on the chart of your particular make of blow-pipe. Tack the pieces at the right end by fusing the corners down. Keep the edges of the other end $\frac{3}{16}''$ apart. Start welding at the right end as illustrated in Fig. 228. Heat the edges till a pool of molten metal is formed. Make sure the blow-pipe flame

Fig. 228.

will reach the bottom edges to insure a thorough weld. Use the welding rod to fill up the hollow, and feed in the welding rod till the joint is sufficiently reenforced, making the weld a trifle thicker than the original plates. Use $\frac{1}{16}''$ or No. 12 gauge wire for the filling in rod. The left hand should hold the welding rod at the proper angle, thus making it more convenient to add a sufficient amount of metal at the right time. See Fig. 229. The edges of the weld must be in the proper state of fusion to receive the welding rod, which is equally hot, to insure a thorough weld.

It is not necessary to bevel the edges of wrought iron or steel $\frac{1}{8}''$ or less in thickness.

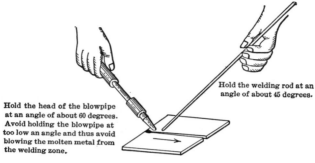

Hold the head of the blowpipe at an angle of about 60 degrees. Avoid holding the blowpipe at too low an angle and thus avoid blowing the molten metal from the welding zone.

Hold the welding rod at an angle of about 45 degrees.

FIG. 229.

NOTE.—As welding proceeds the space on the left of $\frac{3}{16}''$ between the plates will close gradually. This spacing, particularly in welding sheet metal, is made to control expansion and contraction in the sheet in order to prevent overlapping, buckling and distortion. Some welders prefer to tack each end and proceed in the manner explained above, thus leaving no space between the plates, at one side.

Tack welding.—Sheet metal or light stock are often welded by this method. The metal is " tacked " by means of spot welds at intervals just to hold the sheet in position. See Fig. 230.

After this has been done proceed with welding from one end as explained above. Welds of this kind not infrequently

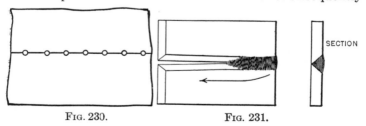

SECTION

FIG. 230. FIG. 231.

buckle or warp up and down. These irregularities may be removed by hammering or pressing.

Problem 3.—Welding $\frac{1}{2}''$ soft steel plates 6" long.

For the proper size of tip, consult the manufacturer's instructions. Bevel the edges on an emery wheel to an angle of about 45 degrees. Leave $\frac{3}{16}''$ space between the left ends of the plates to allow for expansion and to avoid excessive strains in plate welding. Tack the plates at the right end by fusing the corners down as in Fig. 231.

Use a $\frac{3}{16}''$ filling rod in this weld. This problem is practically the same as Problem 2, except that the welding here takes heavier metal and there is more surface to weld. In this case a wider swinging motion is necessary to cover the entire width of the bevel. Make sure the weld is carried from the bottom. Use the welding rod to fill up the V, making the weld a trifle thicker, as shown in the section of Fig. 231. The surplus metal may be removed on the emery wheel, heated and forged down or filed even if necessary. After the weld is once started it should be continued, but avoid going over a weld the second time without adding material by the welding rod. For more detailed instructions see Problems 2 and 1.

Heat Distribution.—To attain good results in welding it is important that each side be heated uniformly to avoid

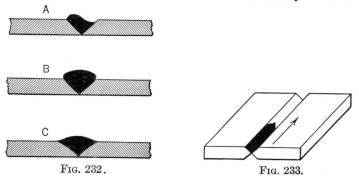

FIG. 232. FIG. 233.

unequal distribution of the metal. Fig. 232*A* shows a sectional view of a weld where the heat was not uniformly

distributed, leaving a hollow on the right. The spread of the welding heat sidewise must be a trifle beyond the top edges of the V to avoid a sharp rise of the added metal on each side of the V as shown in Fig. 232*B*. A good weld with a gradual flow over the surface is shown by Fig. 232*C*.

Problem 4.—Welding heavy soft steel plates.

Use two 1″ plates about 6″ in length. Bevel the edge on each side on an emery wheel to an angle of 60 degrees. Use the large tip. Consult the chart of your particular make. Place the plates with the beveled edges facing each other in such a manner that at one end they will touch each other. Keep the other ends $\frac{3}{16}$″ apart as shown in Fig. 233.

Use a $\frac{1}{4}$″ welding rod. Tack the plates where the edges are in touch with each other by fusing the corners down. Proceed exactly as explained in Problems 3 and 2. After one side is welded, turn the piece over and with an old file or with the welding rod, scrape off any scale that has been formed, then proceed as in welding the first side.

Types of Welded Joints

Sheet metal plates up to $\frac{1}{8}$″ thickness do not require beveling. See Fig. 234*A*.

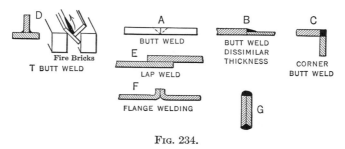

Fig. 234.

A variety of **butt welds** are shown in Fig. 234*A*, *B*, *C* and *D*. In making a corner or T butt weld, Fig. 234*C* and

D, it is always advisable if possible to place the work at an angle of 45 degrees after tacking each end, as illustrated at *D*, Fig. 234. Welding in this position confines the molten metal to the line of contact of the two pieces of metal to be welded.

Fig. 234*E* shows a **lap weld.**

Flange welding is preferred on light sheet metal. See Fig. 234*F*. The bent edges should be straight and parallel to each other. A welding rod is not necessary. Welding is carried on by fusing down the projecting edges.

The edges of sheet metal may be welded as shown in Fig. 234*G*.

Welding Rod

For wrought iron, use a good grade of soft iron wire. For steel castings, Bessemer and open hearth steel, use a filling rod of the same material. Open hearth and Bessemer steel is often called machine, structural, soft or mild steel. The proper thickness of welding rod is from $\frac{1}{32}$ to $\frac{1}{4}$ of one inch.

Welding of Leaves and Flowers

Leaves and flowers for interior decorative articles such as chandeliers, vestibule doors, stair railings, candle-sticks, tables, etc., may be made of sheet metal. For exterior work the leaves should be forged from the solid as shown in Figs. 167 and 173. Solid stock will make the leaves and stem stronger and will enable them to resist rust much longer. In order to reenforce the stem on leaves made from sheet metal it is necessary to " roll in " the stem. See Fig. 235. The joint of the leaf must be on the bottom side. The stem is always made a trifle longer. This allowance is made for fusing down the stem before welding it to the branch. See Fig. 235. The advantages gained by this method are to have solid metal at the point of union, to prevent the metal from getting overheated too readily, and to avoid the

use of the filling rod, the reenforced end making such use unnecessary.

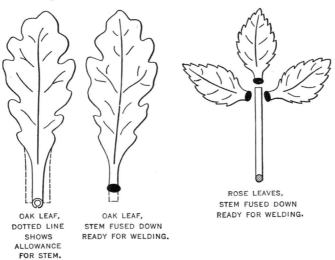

OAK LEAF, DOTTED LINE SHOWS ALLOWANCE FOR STEM.

OAK LEAF, STEM FUSED DOWN READY FOR WELDING.

ROSE LEAVES, STEM FUSED DOWN READY FOR WELDING.

FIG. 235.

The stamens for wild roses, poppies, tulips, and lilies are made of wire. The end is fused down as shown in Fig. 236, thus forming a ball at the end. For lilies the ball end is partly flattened and shaped like a bean. The flattening and shaping is done cold.

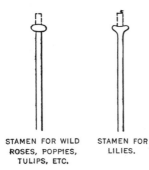

STAMEN FOR WILD ROSES, POPPIES, TULIPS, ETC.

STAMEN FOR LILIES.

FIG. 236.

All kinds of flowers are now made of sheet metal and welded by means of the oxy-acetylene torch. In Fig. 237 are shown the steps in welding the petals of a rose. Most other flowers may be made in the same way. After the petals have been

shaped on the lead block, punch a hole through the center to receive the wire or stem. Fuse one end of the wire down, thus forming a ball to prevent the wire from going through

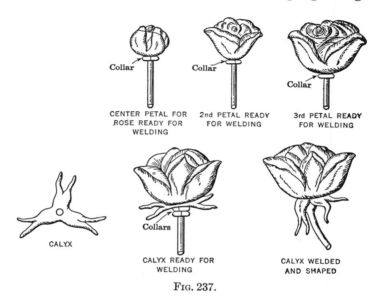

CENTER PETAL FOR
ROSE READY FOR
WELDING

2nd PETAL READY
FOR WELDING

3rd PETAL READY
FOR WELDING

CALYX

Collars

CALYX READY FOR
WELDING

CALYX WELDED
AND SHAPED

Fig. 237.

the petal. Insert the stem and drive it down on the vise with a punch. Place a $\frac{1}{16}$-inch wire collar around the stem close to the petal and weld the petal to the stem. The wire collar will make welding easier, as no welding rod is required, thus leaving the left hand free to hold and turn the work at the proper angle. Add and weld the other petals in the same manner. The calyx is welded to the stem in the same way except that two collars are placed around the stem to reenforce it, and to give it the proper shape and form as illustrated.

Welding Cast Iron

It is somewhat more difficult to weld cast iron than to weld wrought iron or steel. Cast iron has a lower melting point. The temperature required is between 2000 to 2300 degrees Fahrenheit, depending upon the amount of carbon and other impurities present in the iron. A flux is always used in welding cast iron to prevent oxidation and to remove impurities. The flame should point at the same angle as in welding steel, but instead of welding in layers, cast iron should be welded in puddles. Hold the welding rod in the molten metal, move it sideways back and forth, thus working *outward* to the surface sand and other impurities.

Welding Aluminum

Welding aluminum is still more difficult than welding cast iron or thin sheet metal, due to the great avidity that this metal has for oxygen as soon as it is lightly heated. The film of aluminum oxide forms as soon as the metal is heated and continues to form into a thicker and thicker layer. The surface oxidation of the metal is as rapid as the oxidation which takes place on the surface of quicksilver. This difficulty has been largely overcome by a special flux which was invented in 1906 by a Swiss chemist, M. U. Schoop. This flux dissolves the aluminum oxide just before the metal reaches the melting point, insuring a thorough weld. The ingredients of this flux are calcium chloride, sodium chloride and calcium sulphate. It may be applied in powder form or as a pasty mass; the latter is preferable.

While welding thin stock, hold the flame almost horizontal, as aluminum melts very easily at a much lower temperature than iron or steel. Pointing the flame down will burn a hole through the metal. On heavier stock a paddle should be used made of $\frac{3}{16}''$ round iron wire. The end is flattened and allowed to spread. Remove all rough edges

on the paddle with a file or on a grinder, and bend the paddle to an angle of about 45 degrees. This will make it more convenient to handle. Play the flame on the metal until it melts, use the paddle and stir or mix, moving the paddle sideways back and forth, thus breaking up the aluminum oxide and bringing the metal together. As soon as this is done, lay the paddle aside and use the filling rod.

Brazing or hard soldering is also done with the oxy-acetylene torch. Preheat the sides to be brazed first and then play the flame upon the brazing spelter, thus fusing the metal together. Borax is most commonly used as a flux. For more detailed instructions see page 251.

Oxy-Acetylene Cutting

The cutting blowpipe is provided with a heavier regulator and hose for the oxygen cylinder. The tip or nozzle has several holes instead of one, surrounding a larger, central hole. From the smaller holes, a mixture of oxy-acetylene is used for preheating, while from the central hole pure oxygen is used for cutting. Three valves are necessary for the cutting blowpipe. One valve controls the acetylene, one the oxygen for the heating flame and the third controls the oxygen for the cutting flame in the center. Regulate the two first valves so that they will produce a neutral flame. Set the oxygen pressure before turning on the acetylene, and follow the instruction given by the maker of the particular apparatus in use. The angle for cutting should be between 45 and 60 degrees. The plate to be cut should be marked with chalk, soapstone, center punch or chisel marks. For a straight cut, a bar of iron may be clamped upon the plate. Hold the blowpipe against the side to steady your hand and insure a straight cut. Curved lines may be cut more accurately by using a template clamped upon the plate. Move the flame along steadily (after cutting has been once

started) $\frac{1}{8}''$ or $\frac{1}{4}''$ from the plate; the distance depends upon the size of tip in use.

The skill and knowledge necessary to cut metal neatly and accurately may be acquired in a few days, and the operator improves with practice.

The Use of Benzole

Benzole and oxygen under pressure may also be used for welding and cutting. Benzole requires a special torch to preheat and vaporize it before it unites with the oxygen.

Hardening a Scriber

Heat the tool slowly to a red heat, as it is very easy to burn the steel on account of its thinness. Thrust the heated scriber quickly into a piece of wood, with the grain, heating it several times and thrusting it each time into the hole formed. After the last thrust, cool quickly in water.

Special Springs

Special springs for locks or other pieces of work are turned out in large quantities by factories, but it often happens that the practical man is called

FIG. 238.

upon to make one. A spiral spring, as shown in Fig. 238, is made of spring steel. The end which is to be bent to fit the square pin is first annealed by gripping it with a pair of heated tongs. To get uniform spacing in the spiral, the steel may be wound around a thin strip of leather, or the inside of the spring may be wet with oil, and sifted sand or filings sprinkled on the oil so as to obtain a uniform coat. This coat will make even spacing in the finished spiral, and when the spring opens, the oil and sand may be wiped off with a rag.

Making a Countersink

The two sides of the head of a standard machine screw or wood screw make an angle of 90°. Fig. 239 illustrates a countersink shaped and ground to form exactly a right

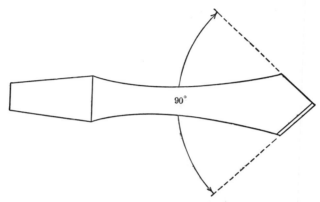

90°

Fig. 239.—Proper Angle for a Countersink.

angle. The opposite end is shaped round or square to fit either a drill chuck, a ratchet, or a brace.

Screw-driver

In Fig. 240 is shown a screw-driver of a different type and design from those generally used. It is made from flat stock, and is considerably wider at the center, so that a hole may be drilled to allow a pin or punch to pass through, thus affording more leverage than is ordinarily obtained by a force applied at the handle as with common screw-driver. The ends may be shaped for two different sizes of screws, and are fitted into a wooden handle.

Fig. 240.

Angle Screw-drivers

When fastening scrolls by means of screws, it is rather difficult to turn the screws with a common screw-driver, as the space may be very narrow. To meet this difficulty an angle screw-driver such as is shown in Fig. 241 may be used. A piece of flat stock is split so as to form two arms. One of these arms is bent to the right, and the other is bent to the left. About $\frac{1}{4}$ in. of stock is bent up at each end to form a tooth. These teeth are made to face each other at right angles, so that if one fails to answer the purpose in a certain job, the other will not.

Fig. 241.

A second kind of angle screw-driver differing from the above in respect to its shape and the stock used is shown in Fig. 242. It may be made from either square or flat

Fig. 242.

stock, and is straight and not split. It has no handle, for it is used where the space is limited, and projections from the top would render it useless. The teeth of this angle screw-driver are also made to face each other at right angles.

TABLE I

PROPERTIES OF WROUGHT IRON, STEEL, AND OTHER METALS

Metals.	Melting-points, Fahr.	Tensile Strength in Lbs. per Sq. in.	Specific Gravity.
Wrought iron.	about 2920	50,000	7.7
Open-hearth and Bessemer steel.	about 2600	65,000	7.82
Crucible or tool steel.	about 2450	50,000	7.81
Cast iron (gray and white pig). .	2000–2300	16,000–18,000	7.21
Copper. .	1925	36,000	8.9
Bronze (ordinary).	1692	36,000	8.8
Brass (castings).	1692	24,000	8.4
Aluminum.	1472	20,000	2.56
Lead. .	625	3,000	11.35
Tin. .	445	4,600	7.3
Zinc. .	775	7,500	6.8

TABLE II

WEIGHTS OF IRON AND STEEL

The weight of wrought iron is 480 pounds per cubic foot;
cast iron is 450 pounds per cubic foot;
steel is 490 pounds per cubic foot.

TABLE III

Weight of Round and Square Iron per Foot

Size in Inches	Rounds. Weight, Lbs.	Squares. Weight, Lbs.	Size in Inches	Rounds. Weight, Lbs.	Squares. Weight, Lbs.
$\frac{3}{16}$.092	.118	3	23.56	30.00
$\frac{1}{4}$.164	.208	$3\frac{1}{8}$	25.57	32.55
$\frac{5}{16}$.257	.325	$3\frac{1}{4}$	27.65	35.20
$\frac{3}{8}$.368	.468	$3\frac{3}{8}$	29.82	37.96
$\frac{7}{16}$.501	.638	$3\frac{1}{2}$	32.07	40.83
$\frac{1}{2}$.654	.833	$3\frac{5}{8}$	34.40	43.80
$\frac{9}{16}$.828	1.055	$3\frac{3}{4}$	36.82	46.88
$\frac{5}{8}$	1.023	1.300	$3\frac{7}{8}$	39.31	50.05
$\frac{11}{16}$	1.237	1.576	4	41.88	53.33
$\frac{3}{4}$	1.473	1.875	$4\frac{1}{8}$	44.55	56.72
$\frac{13}{16}$	1.728	2.200	$4\frac{1}{4}$	47.28	60.20
$\frac{7}{8}$	2.000	2.552	$4\frac{3}{8}$	50.11	63.80
$\frac{15}{16}$	2.300	2.930	$4\frac{1}{2}$	53.01	67.50
1	2.618	3.333	$4\frac{5}{8}$	56.00	71.30
$1\frac{1}{16}$	2.955	3.763	$4\frac{3}{4}$	59.06	75.20
$1\frac{1}{8}$	3.313	4.219	$4\frac{7}{8}$	62.21	79.21
$1\frac{3}{16}$	3.692	4.701	5	65.45	83.33
$1\frac{1}{4}$	4.090	5.208	$5\frac{1}{8}$	68.76	87.55
$1\frac{5}{16}$	4.510	5.742	$5\frac{1}{4}$	72.17	91.88
$1\frac{3}{8}$	4.950	6.300	$5\frac{3}{8}$	75.64	96.30
$1\frac{7}{16}$	5.410	6.888	$5\frac{1}{2}$	79.19	100.02
$1\frac{1}{2}$	5.890	7.500	$5\frac{5}{8}$	82.83	105.50
$1\frac{9}{16}$	6.392	8.138	$5\frac{3}{4}$	86.56	110.20
$1\frac{5}{8}$	6.913	8.802	$5\frac{7}{8}$	90.36	115.10
$1\frac{11}{16}$	7.455	9.492	6	94.25	120.00
$1\frac{3}{4}$	8.018	10.21	$6\frac{1}{4}$	102.00	130.00
$1\frac{13}{16}$	8.60	10.95	$6\frac{1}{2}$	110.60	140.80
$1\frac{7}{8}$	9.20	11.72	$6\frac{3}{4}$	119.30	151.90
$1\frac{15}{16}$	9.83	12.51	7	128.30	163.30
2	10.47	13.33	$7\frac{1}{4}$	137.60	175.20
$2\frac{1}{8}$	11.82	15.05	$7\frac{1}{2}$	147.30	187.50
$2\frac{1}{4}$	13.25	16.88	$7\frac{3}{4}$	157.20	200.00
$2\frac{3}{8}$	14.78	18.80	8	167.6	213.3
$2\frac{1}{2}$	16.36	20.83	$8\frac{1}{4}$	178.2	226.9
$2\frac{5}{8}$	18.04	22.97	$8\frac{1}{2}$	189.2	240.8
$2\frac{3}{4}$	19.80	25.21	$8\frac{3}{4}$	200.4	255.2
$2\frac{7}{8}$	21.64	27.55	9	212.1	270.0

TABLE IV

Weight of Flat Iron per Lineal Foot

Width in Inches.	Thickness. $\frac{1}{8}$	Thickness. $\frac{3}{16}$	Thickness. $\frac{1}{4}$	Thickness. $\frac{5}{16}$	Thickness. $\frac{3}{8}$	Thickness. $\frac{7}{16}$	Thickness. $\frac{1}{2}$	Thickness. $\frac{5}{8}$	Thickness. $\frac{3}{4}$	Thickness. $\frac{7}{8}$	Thickness. 1
$\frac{1}{2}$.21	.31	.42	.53	.63	.73					
$\frac{5}{8}$.27	.40	.53	.66	.79	.92	1.05				
$\frac{3}{4}$.32	.48	.63	.79	.95	1.11	1.27	1.57			
$\frac{7}{8}$.37	.56	.74	.92	1.10	1.29	1.48	1.85	2.20		
1	.42	.63	.84	1.05	1.26	1.48	1.69	2.11	2.50	2.91	
1$\frac{1}{8}$.47	.71	.93	1.17	1.40	1.64	1.87	2.34	2.81	3.28	3.75
1$\frac{1}{4}$.52	.79	1.04	1.30	1.56	1.82	2.08	2.60	3.12	3.64	4.16
1$\frac{3}{8}$.58	.87	1.14	1.44	1.71	2.00	2.29	2.85	3.43	4.01	4.58
1$\frac{1}{2}$.63	.95	1.26	1.57	1.87	2.19	2.50	3.12	3.75	4.37	5.00
1$\frac{3}{4}$.74	1.11	1.45	1.82	2.18	2.55	2.91	3.64	4.37	5.10	5.83
2	.84	1.27	1.66	2.08	2.50	2.92	3.33	4.16	5.00	5.83	6.66
2$\frac{1}{4}$.95	1.42	1.90	2.36	2.81	3.28	3.75	4.68	5.62	6.56	7.50
2$\frac{1}{2}$	1.04	1.58	2.10	2.61	3.12	3.64	4.16	5.20	6.25	7.29	8.33
2$\frac{3}{4}$	1.16	1.74	2.32	2.88	3.43	4.00	4.58	5.72	6.87	8.02	9.16
3	1.25	1.90	2.50	3.13	3.75	4.38	5.00	6.25	7.50	8.75	10.00
3$\frac{1}{4}$	1.35	2.06	2.70	3.38	4.06	4.74	5.41	6.77	8.12	9.47	10.83
3$\frac{1}{2}$	1.46	2.22	2.92	3.65	4.37	5.10	5.83	7.29	8.75	10.20	11.66
3$\frac{3}{4}$	1.56	2.38	3.12	3.90	4.68	5.47	6.25	7.80	9.37	10.93	12.50
4	1.67	2.50	3.33	4.17	5.00	5.83	6.66	8.32	10.00	11.66	13.33
4$\frac{1}{4}$	1.77	2.66	3.54	4.43	5.31	6.20	7.08	8.85	10.63	12.40	14.18
4$\frac{1}{2}$	1.88	2.81	3.75	4.69	5.62	6.56	7.50	9.36	11.25	13.12	15.00
4$\frac{3}{4}$	1.98	2.97	3.96	4.95	5.94	6.93	7.92	9.90	11.88	13.85	15.83
5	2.08	3.13	4.17	5.21	6.25	7.29	8.32	10.41	12.05	14.58	16.66
5$\frac{1}{4}$	2.19	3.28	4.38	5.47	6.56	7.66	8.75	10.94	13.13	15.31	17.50
5$\frac{1}{2}$	2.29	3.44	4.58	5.73	6.88	8.02	9.16	11.45	13.75	16.04	18.32
5$\frac{3}{4}$	2.40	3.59	4.79	5.99	7.19	8.39	9.58	11.98	14.38	16.77	19.17
6	2.50	3.75	5.00	6.25	7.50	8.75	10.00	12.50	15.00	17.50	20.00
7	2.92	4.38	5.83	7.29	8.75	10.21	11.67	14.58	17.50	20.42	23.33
8	3.33	5.00	6.67	8.34	10.00	11.67	13.33	16.67	20.00	23.33	26.67
9	3.75	5.63	7.50	9.38	11.25	13.13	15.00	18.75	22.50	26.25	30.00
10	4.17	6.25	8.33	10.42	12.50	14.59	16.67	20.83	25.00	29.17	33.33
11	4.58	6.88	9.17	11.46	13.75	16.54	18.33	22.90	27.50	32.08	36.67
12	5.00	7.50	10.00	12.50	15.00	17.50	20.00	25.00	30.00	35.00	40.00

TABLE V

Weight of Round and Square Steel

Size in Inches.	Rounds. Lbs. per Ft.	Squares. Lbs. per Ft.	Size in Inches.	Rounds. Lbs. per Ft.	Squares. Lbs. per Ft.
$\frac{3}{16}$.0939	.1195	$2\frac{1}{2}$	16.6898	21.250
$\frac{1}{4}$.1669	.2125	$2\frac{9}{16}$	17.5347	22.326
$\frac{5}{16}$.2608	.3320	$2\frac{5}{8}$	18.4004	23.428
$\frac{3}{8}$.3755	.4781	$2\frac{11}{16}$	19.2871	24.557
$\frac{7}{16}$.5111	.6508	$2\frac{3}{4}$	20.1946	25.713
$\frac{1}{2}$.6676	.8500	$2\frac{13}{16}$	21.123	26.895
$\frac{9}{16}$.8449	1.0758	$2\frac{7}{8}$	22.072	28.103
$\frac{5}{8}$	1.0431	1.3281	$2\frac{15}{16}$	23.042	29.338
$\frac{11}{16}$	1.2622	1.6070	3	24.033	30.600
$\frac{3}{4}$	1.5021	1.9125	$3\frac{1}{8}$	26.078	33.203
$\frac{13}{16}$	1.7629	2.2445	$3\frac{1}{4}$	28.206	35.913
$\frac{7}{8}$	2.0445	2.6031	$3\frac{3}{8}$	30.417	38.728
$\frac{15}{16}$	2.3470	2.9883	$3\frac{1}{2}$	32.712	41.650
1	2.6704	3.4000	$3\frac{5}{8}$	35.090	44.678
$1\frac{1}{16}$	3.0146	3.838	$3\frac{3}{4}$	37.552	47.813
$1\frac{1}{8}$	3.3797	4.303	$3\frac{7}{8}$	40.097	51.053
$1\frac{3}{16}$	3.7656	4.795	4	42.726	54.400
$1\frac{1}{4}$	4.1724	5.313	$4\frac{1}{8}$	45.438	57.853
$1\frac{5}{16}$	4.6001	5.857	$4\frac{1}{4}$	48.233	61.413
$1\frac{3}{8}$	5.0486	6.428	$4\frac{3}{8}$	51.112	65.078
$1\frac{7}{16}$	5.5180	7.026	$4\frac{1}{2}$	54.075	68.850
$1\frac{1}{2}$	6.0083	7.650	$4\frac{5}{8}$	57.121	72.728
$1\frac{9}{16}$	6.5194	8.301	$4\frac{3}{4}$	60.250	76.713
$1\frac{5}{8}$	7.0514	8.978	$4\frac{7}{8}$	63.473	80.803
$1\frac{11}{16}$	7.6043	9.682	5	66.759	85.000
$1\frac{3}{4}$	8.1780	10.413	$5\frac{1}{8}$	70.139	87.138
$1\frac{13}{16}$	8.7725	11.170	$5\frac{1}{4}$	73.602	93.713
$1\frac{7}{8}$	9.3880	11.953	$5\frac{3}{8}$	77.148	98.228
$1\frac{15}{16}$	10.0243	12.763	$5\frac{1}{2}$	80.778	102.850
2	10.6814	13.600	$5\frac{5}{8}$	84.49	107.58
$2\frac{1}{16}$	11.3595	14.463	$5\frac{3}{4}$	88.29	112.41
$2\frac{1}{8}$	12.0583	15.353	$5\frac{7}{8}$	92.17	117.35
$2\frac{3}{16}$	12.7781	16.270	6	96.13	122.40
$2\frac{1}{4}$	13.5187	17.213	$6\frac{1}{8}$	100.18	127.55
$2\frac{5}{16}$	14.2802	18.182	$6\frac{1}{4}$	104.31	132.81
$2\frac{3}{8}$	15.0625	19.178	$6\frac{3}{8}$	108.53	138.18
$2\frac{7}{16}$	15.8657	20.201	$6\frac{1}{2}$	112.82	143.65

TABLE V—*Continued*

WEIGHT OF ROUND AND SQUARE STEEL

Size in Inches.	ROUNDS. Lbs. per Ft.	SQUARES. Lbs. per Ft.	Size in Inches.	ROUNDS. Lbs. per Ft.	SQUARES. Lbs. per Ft.
$6\frac{5}{8}$	117.20	149.23	$9\frac{3}{8}$	234.7	298.8
$6\frac{3}{4}$	121.67	154.91	$9\frac{1}{2}$	241.0	306.9
$6\frac{7}{8}$	126.22	160.70	$9\frac{5}{8}$	247.4	315.0
7	130.85	166.60	$9\frac{3}{4}$	253.8	323.2
$7\frac{1}{8}$	135.56	172.60	$9\frac{7}{8}$	260.4	331.6
$7\frac{1}{4}$	140.36	178.71	10	267.0	340.0
$7\frac{3}{8}$	145.24	184.93	$10\frac{1}{8}$	273.8	348.6
$7\frac{1}{2}$	150.21	191.25	$10\frac{1}{4}$	280.6	357.2
$7\frac{5}{8}$	155.26	197.68	$10\frac{3}{8}$	287.4	366.0
$7\frac{3}{4}$	160.39	204.21	$10\frac{1}{2}$	294.4	374.9
$7\frac{7}{8}$	165.60	210.85	$10\frac{5}{8}$	301.5	383.8
8	170.90	217.60	$10\frac{3}{4}$	308.6	392.9
$8\frac{1}{8}$	176.29	224.45	$10\frac{7}{8}$	315.8	402.1
$8\frac{1}{4}$	181.75	231.41	11	323.1	411.4
$8\frac{3}{8}$	187.30	238.48	$11\frac{1}{8}$	330.5	420.8
$8\frac{1}{2}$	192.93	245.65	$11\frac{1}{4}$	338.0	430.3
$8\frac{5}{8}$	198.65	252.93	$11\frac{3}{8}$	345.5	439.9
$8\frac{3}{4}$	204.45	260.31	$11\frac{1}{2}$	353.2	449.7
$8\frac{7}{8}$	210.33	267.80	$11\frac{5}{8}$	360.9	459.5
9	216.30	275.40	$11\frac{3}{4}$	368.7	469.4
$9\frac{1}{8}$	222.30		$11\frac{7}{8}$	376.6	479.5
$9\frac{1}{4}$	228.5		12	380.5	489.6

TABLE VI

Weight of Flat Steel per Foot

Width in Inches	Thickness $\frac{1}{8}$	Thickness $\frac{3}{16}$	Thickness $\frac{1}{4}$	Thickness $\frac{5}{16}$	Thickness $\frac{3}{8}$	Thickness $\frac{7}{16}$	Thickness $\frac{1}{2}$	Thickness $\frac{5}{8}$	Thickness $\frac{3}{4}$	Thickness $\frac{7}{8}$	Thickness 1
$\frac{3}{8}$.159	.239	.319	.40							
$\frac{1}{2}$.212	.319	.425	.53	.64	.745	.85				
$\frac{5}{8}$.265	.40	.53	.67	.80	.93	1.06	1.33			
$\frac{3}{4}$.32	.48	.64	.80	.96	1.12	1.28	1.60	1.92		
$\frac{7}{8}$.38	.56	.75	.93	1.12	1.30	1.49	1.86	2.24	2.60	
1	.425	.638	.85	1.06	1.28	1.49	1.70	2.12	2.55	2.98	3.40
$1\frac{1}{8}$.48	.72	.96	1.20	1.44	1.68	1.92	2.39	2.87	3.35	3.83
$1\frac{1}{4}$.53	.80	1.06	1.33	1.59	1.86	2.12	2.65	3.19	3.72	4.25
$1\frac{3}{8}$.59	.88	1.17	1.46	1.75	2.05	2.34	2.92	3.51	4.10	4.68
$1\frac{1}{2}$.64	.96	1.28	1.59	1.92	2.23	2.55	3.19	3.83	4.47	5.10
$1\frac{5}{8}$.69	1.04	1.39	1.73	2.08	2.42	2.77	3.46	4.15	4.84	5.53
$1\frac{3}{4}$.75	1.11	1.49	1.86	2.23	2.60	2.98	3.72	4.47	5.20	5.95
2	.85	1.28	1.70	2.12	2.55	2.98	3.40	4.25	5.10	5.95	6.80
$2\frac{1}{4}$.96	1.44	1.91	2.39	2.87	3.35	3.83	4.78	5.75	6.69	7.65
$2\frac{1}{2}$	1.06	1.59	2.12	2.65	3.19	3.72	4.25	5.31	6.38	7.44	8.50
$2\frac{3}{4}$	1.17	1.75	2.34	2.92	3.51	4.09	4.67	5.84	7.02	8.18	9.35
3	1.28	1.91	2.55	3.19	3.83	4.46	5.10	6.38	7.65	8.93	10.20
$3\frac{1}{4}$	1.38	2.07	2.76	3.45	4.15	4.83	5.53	6.91	8.29	9.67	11.05
$3\frac{1}{2}$	1.49	2.23	2.98	3.72	4.47	5.20	5.95	7.44	8.93	10.41	11.90
$3\frac{3}{4}$	1.60	2.39	3.19	3.99	4.78	5.58	6.38	7.97	9.57	11.16	12.75
4	1.70	2.55	3.40	4.25	5.10	5.95	6.80	8.50	10.20	11.90	13.60
$4\frac{1}{4}$	1.80	2.71	3.61	4.52	5.42	6.32	7.22	9.03	10.84	12.65	14.45
$4\frac{1}{2}$	1.92	2.87	3.83	4.78	5.74	6.70	7.65	9.57	11.48	13.39	15.30
$4\frac{3}{4}$	2.02	3.03	4.04	5.05	6.06	7.07	8.08	10.10	12.12	14.13	16.15
5	2.13	3.19	4.25	5.31	6.38	7.44	8.50	10.63	12.75	14.87	17.00
$5\frac{1}{4}$	2.23	3.35	4.46	5.58	6.69	7.81	8.93	11.16	13.39	15.62	17.85
$5\frac{1}{2}$	2.34	3.51	4.67	5.84	7.02	8.18	9.35	11.69	14.03	16.36	18.70
$5\frac{3}{4}$	2.45	3.67	4.89	6.11	7.34	8.56	9.77	12.22	14.67	17.10	19.55
6	2.55	3.83	5.10	6.38	7.65	8.93	10.20	12.75	15.30	17.85	20.40
7	2.98	4.46	5.95	7.44	8.93	10.41	11.90	14.87	17.85	20.83	23.80
8	3.40	5.10	6.80	8.50	10.20	11.90	13.60	17.00	20.40	23.80	27.20
9	3.83	5.74	7.65	9.56	11.48	13.40	15.30	19.13	22.96	26.78	30.60
10	4.25	6.38	8.50	10.62	12.75	14.88	17.00	21.25	25.50	29.75	34.00
11	4.67	7.02	9.34	11.68	14.03	16.36	18.70	23.38	28.05	32.72	37.40
12	5.10	7.65	10.20	12.75	15.30	17.85	20.40	25.50	30.60	35.70	40.80

INDEX